Victorian Art Criticism and the
Woman Writer

Victorian Art Criticism and the Woman Writer

John Paul M. Kanwit

THE OHIO STATE UNIVERSITY PRESS
COLUMBUS

Library of Congress Cataloging-in-Publication Data

Kanwit, John Paul M., 1972–
Victorian art criticism and the woman writer / John Paul M. Kanwit.
 p. cm.
Includes bibliographical references and index.
ISBN 978-0-8142-1218-9 (cloth : alk. paper) — ISBN 978-0-8142-9319-5 (cd)
1. Art criticism—Great Britain—History—19th century. 2. Women art critics—Great Brit-
ain—History—19th century. 3. English literature—Women authors—History and criticism. I.
Title.
N7485.G7K36 2013
701'.180820941—dc23
2013002295

Cover and text design by Juliet Williams
Type set in Adobe Granjon and ITC Galliard
Printed by Thomson-Shore, Inc.

♾ The paper used in this publication meets the minimum requirements of the American Na-
tional Standard for Information Sciences—Permanence of Paper for Printed Library Materials.
ANSI Z39.48-1992.

9 8 7 6 5 4 3 2 1

To Alissa Boyd Kanwit
and
Andrew, Graham, and William

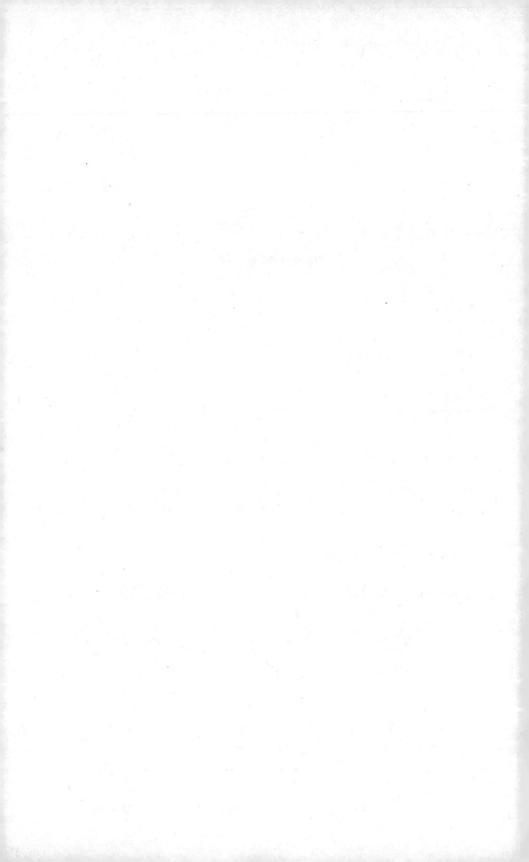

CONTENTS

❧

ILLUSTRATIONS

cᎪ℗ᎪᎧ

ACKNOWLEDGMENTS

This book began as dissertation work at Indiana University, Bloomington. There, I had as good a dissertation committee as any graduate student could wish for: Andrew Miller, Patrick Brantlinger, Joss Marsh, and Nick Williams. Particular thanks are due to my director, Andrew Miller, who read many drafts of the dissertation with patience and a critical eye. I am also indebted to Ivan Kreilkamp, who has provided excellent advice and a critical reading of an earlier version of chapter 3.

In undertaking the greatly revised and extended book project, I have received much assistance along the way. Two anonymous peer reviewers gave detailed and extremely useful comments. Ohio Northern University provided financial support, particularly for research that I conducted in London on Elizabeth Eastlake. My colleagues in the English Department at Ohio Northern University have been very encouraging over the past several years while I worked on this project. I have very much enjoyed working with my editor, Sandy Crooms, as well as with the entire staff at The Ohio State University Press.

An earlier version of chapter 2, titled "'Mere Outward Appearances'?: Household Taste and Social Perception in Elizabeth Gaskell's *North and South* and Contemporary Art Commentary," was published in *Victorian Review* 35.1 (Spring 2009) and appears here by kind permission of the publisher. Portions of chapter 3 were published in *Nineteenth-Century Prose* 40.1 (Spring 2013) under the title "'My name is the *right one*': Lady Elizabeth (Rigby) Eastlake's Professional Art Criticism." Thanks are due to the

publisher for permission to reprint this essay. An earlier version of chapter 4, titled "'I have often wished in vain for another's judgment': Ideal Aesthetic Commentary and Anne Brontë's *The Tenant of Wildfell Hall*," was published in *Victorians: A Journal of Culture and Literature* (Spring 2012) and appears here by agreement with the publisher.

My parents and parents-in-law have provided much encouragement and support as I worked on this project during the past decade. In particular, I would like to thank Alissa Kanwit, who is both an excellent editor and a broad conceptual thinker.

INTRODUCTION

❧

ictorian Art Criticism and the Woman Writer examines the development of specialized art commentary in a period when art education became a national concern in Britain. The explosion of Victorian visual culture—evident in the rapid expansion of galleries and museums, the technological innovations of which photography is only the most famous, the public debates over household design, and the high profile granted to such developments as the aesthetic movement—provided art critics unprecedented social power. Scholarship to date, however, has often been restricted to a narrow collection of writers on art: John Ruskin, Walter Pater, William Morris, and Oscar Wilde. By including influential but now less well-known critics such as Anna Jameson, Elizabeth Eastlake, and Emilia Dilke, and by focusing on critical debates rather than celebrated figures, *Victorian Art Criticism and the Woman Writer* offers a more penetrating and accurate understanding of this pervasive aspect of Victorian society.

In discussing eighteenth- and nineteenth-century aesthetics, recent scholarship has often stumbled on a reductive binary: writings on art either function in the service of state and social hegemony or allow the individual some interpretive freedom. The most useful of these recent commentaries acknowledge that art criticism can serve both purposes, but such a

1

formulation still ignores much of the material's possibilities. Victorian art criticism *is* both controlling and liberating, but scholarship that merely classifies the genre within this binary fails to capture what is distinctive about the individual responses made by authors and texts to cultural and institutional changes in the British art world. Victorian writers on art display unique voices, literary styles, and approaches to their subject that are simply not accounted for by studies solely intent on classifying their ideological function. Of course, critics had their own thematic preoccupations and rhetorical tactics, but they also situated themselves within their institutional environments in quite distinct fashions. The cumulative effect of these varied responses from the 1840s on was to increase the quality of art commentary, redefine the standards used to evaluate art and its criticism, and elevate the art critic in society. The activities of art critics—their commentary on art, their disagreements with each other, their emergent relations with newly created government bureaucracies—had institutional as well as aesthetic effects that cannot be reduced to schematic evaluation.

The increased social importance granted to the exhibition of art was marked by a proliferation of parliamentary hearings in the early- and mid-Victorian periods. The first such parliamentary body, the Select Committee on the State of Arts and Manufactures (1835–36), hoped to educate a broad public about the arts. The committee's recommendations—especially its injunction to provide written guidance for viewers within museums—marked, I argue, a decisive turn from the eighteenth-century assumption that viewers could appreciate artworks without verbal direction. This claim qualifies much recent scholarship on nineteenth-century aesthetics, which asserts that little changed from the elitist and controlling views of the eighteenth century. According to Terry Eagleton, eighteenth-century aesthetic theorists, facing the destabilizing threat of increased democratization, hoped to replace the external control of an authoritarian state with an internal adherence to shared ideas of beauty.[1] This *sensus communis* was based on the values of the elite, not on common sense. In her more historically specific study, Linda Dowling has shown how Victorian art commentary repeated the authoritarian, aristocratic type of connoisseurship that Eagleton associates with Kantian aesthetics. While Eagleton and Dowling usefully identify this aristocratic strain of connoisseurship, their arguments fail to account for what did change in the Victorian period.

The 1835–36 select committee, in identifying the needs for written guidance and specialized expertise, actually helped fragment the authority that had been concentrated in the male connoisseur. While eighteenth-century painters and writers believed that visual art should be appreciated with-

out any sort of guidance, many nineteenth-century critics advocated verbal mediation. We thus see a shift away from the Kantian assumption of an inherent, generally shared aesthetic faculty to the notion that taste could be taught. Moreover, the connoisseur could, in a kind of circular logic, judge any art based on his own good taste; the select committee desired a professional class of museum directors trained in specific types or periods of art. Art commentators referred to traditional standards of taste throughout the nineteenth century, but they also sought to base their judgments on more scientific criteria and to prompt viewers to interpret artworks on their own. Although the committee and witnesses took for granted that this expertise would be practiced by men, their recommendations facilitated the careers of the women art critics who are a major focus of this book.

As Dowling, James Eli Adams, and other scholars have recently recognized, the now-canonical Victorian art critics modeled their careers on the traditional values of the gentlemen. But the gentleman-critic was only one of many figures defined by Victorian writers on the arts. Women art critics demonstrate with particular force the kinds of varied careers that were available as the genre became a more lucrative profession from the 1840s on. Ruskin, Morris, Pater, and Wilde were all from privileged class positions and had the luxury of institutional affiliations not available to women at the time. Ruskin, for example, was blessed with family money, a degree from Oxford, and, eventually, a teaching post there. Money and stable employment protected these men from the need to make a living from their art criticism.

In tracing the critical interventions of women critics alongside canonical and lesser-known male critics, this book attempts a feminist reconsideration of a genre that helped shape the most crucial debates of the Victorian period—including those about taste, class, gender, and the very need for guidance. By taking this approach, however, I do not mean to propose that a single theory unites these diverse writers. My method is empirical, studying the different ways in which these writers consciously established their careers despite the tendency of male writers to define the field as masculine. Moreover, these women were involved in and/or wrote about feminist causes for women—again, with individual views of what greater rights for women might mean. Jameson and Eastlake believed that a woman should be equipped with the means to earn a living, but that her ideal place was in the home; Dilke was more radical in advocating equal careers and political rights for women.

Although scholars have recognized these activities and, less commonly, the important careers fashioned by these writers, they have generally denied

the existence of a feminist aesthetic in women's art criticism. This assumption seems related to the misconception that I identify earlier: that Victorian art criticism was an essentially conservative genre, little changed from the class- and gender-based eighteenth-century models. Kate Flint insightfully writes that "it is hard to detect anything like a feminist agenda" in art criticism by women (*Victorians* 193). Yet feminist views are often embedded in the stories that women writers tell about artworks. In an extremely important example of a feminist approach, Dilke emphasizes the unhappiness of female artistic subjects who are under the control of men—a thinly veiled critique of the limited rights afforded to married women in Victorian society. In describing François Clouet's seemingly emotionless portrait of Elisabeth of Austria, she comments as follows on the pitfalls of marriage for young women: "the frank and simple life, the girlish eagerness which breathes in the delicate lines of this portrait, seem instinct with pathetic appeal, when we remember the fate to which the original was already committed. . . . Four years of a miserable marriage" (*The Renaissance of Art in France* 1: 349). It is difficult, notes Kali Israel, not to read Elisabeth's misery as an autobiographical reference to Dilke's unhappy first marriage to Mark Pattison. Dilke's account of Clouet's painting conveys not only personal feeling but, more broadly, the despair that many Victorian women experienced in a society that primarily prized them as wives. Dilke's re-creation of Elisabeth's history in moving words provokes sympathy for the painting's subject and perhaps prompted readers to question Victorian marriage conventions. There is, however, no single feminist aesthetic that applies to all four of these writers. For example, Eastlake does not display in her commentary the kind of emergent feminist perspective that we see in art critical stories by Dilke and Jameson.

As a result of these stories about artworks and the shift toward written mediation of art, this book takes literary studies rather than art history as its focus. Indeed, most Victorian art critics considered their practice to be a branch of literature. For art critics and their audiences, art criticism was an act of imaginative recreation. While recent scholarship on the professionalization of art criticism has attempted to separate a more popular, narrative strand of criticism from a supposedly later mode focused on form, all the writers I examine display what can be called literary preoccupations. Influential women critics were especially likely to combine formal analysis with stories about artworks. As she became a specialist on art in the 1840s, Jameson exhibited both an attention to narrative concerns *and* a mastery of formal features some thirty years before the period commonly associated with the development of a technical vocabulary for art in Britain.

Engaging readers with stories and formal expertise, critics also defend the complexity of great artworks—a quality that they define in terms of literary practice. They often label such works "poetic" to emphasize the intricacy of their imaginative conceptions. While "poetic" had been used before the nineteenth century to describe imaginative art, the Victorian art critical conception of the word underscores the primacy of verbal over visual art. Judith Johnston notes that for Jameson and Ruskin, the term "reverse[s] the traditional overreading of *ut pictura poesis* from Horace's *Ars Poetica* . . . that poetry should be like painting. Rather, for these two Victorian critics, painting should be like poetry" (161). The critics I examine use this formulation in their own writing: they posit the difficulty of translating visual sights while also suggesting that only through their words is the imaginative potential of art realized—a move that serves to explain the need for their expertise. However, by providing stories as well as didactic information and by equating their practice with poetic thought, they indicate that much remains for the reader to interpret. Again, the sources of authority and the ways in which readers can participate are too numerous in this art critical conception of the literary to fit neatly into a controlling-liberating binary.

Victorian art criticism, then, was discussed throughout the period in some of the same terms used to evaluate literature. Similarly to some other forms of criticism, it was also appreciated as literature itself, and a distinctive style was an additional and important way for a writer to claim authority. Recognizing this, Wilde wrote in his 1890 "The Critic as Artist" that the best criticism "treats the work of art simply as a starting-point for a new creation" (142). Modern assessments of Victorian art criticism have continued to appreciate the genre as literature, but only in considerations of the canonical male art critics. The styles of Pater and Ruskin have received as much attention as those of any other nineteenth-century writers, and Pater has additionally been considered a forerunner of literary modernism. Harold Bloom refers to Pater and his impressionism as the "hinge upon which turns the single gate" (qtd. in Matz 434) between Arnoldian objectivism and modernist literary styles. The contributions of lesser-known writers to art criticism's developing use of literary terms and to its status as literature remain undervalued. Jameson, for instance, conceived of artworks as "poetic" as early as 1826—well before Ruskin, the figure commonly associated with the use of that term in the arts (J. Johnston 160). To take an example even more consequential for the history of literary practice, Vernon Lee was, according to the *Oxford English Dictionary,* the first writer to use the term "impressionism" in the literary sense, defining reality as filtered

through individual perceptions rather than the representation of "a thing in itself" ("impressionism"). If, as Bloom suggests, art criticism helped form twentieth-century conceptions of realism, both canonical and noncanonical critics deserve credit for this development.

The feminist lens I employ in examining women's careers and art commentary also informs my readings of Victorian novels by women. While the rich interchange between literature and the visual arts has been well studied, the influences of Victorian art critics on literary representations have received less attention. Women novelists including Charlotte Brontë, Anne Brontë, Elizabeth Gaskell, and George Eliot evidently read Victorian art critics and used their lessons to reconfigure the power relationships represented in key moments of spectatorship in *Villette, The Tenant of Wildfell Hall, North and South,* and *Middlemarch.* These novelists engage contemporary art critical concerns such as household taste, the scholarly attribution of artworks, the instruction of viewers in art galleries, and the professionalization of painting and art criticism. Similarly to art critics, they exhibit a fascination with stories about art even as they acknowledge the increased importance of formal and attributional concerns. But these novelists resist what they saw as the coercive role that some mainstream mid-Victorian art criticism was assuming. While many art critics hoped to improve national taste by directing viewers to buy certain products and appreciate particular artworks—often in ways that reinforced class and gender divisions—the novelists aim to subvert traditional ways of seeing.

Most notably, aesthetic commentary and education are often used to sensitize key men in these novels. Mr. Thornton's developing perception in matters of household taste, guided by Margaret Hale, helps him understand the complex dynamics between masters and men in *North and South.* In *The Tenant of Wildfell Hall,* Gilbert Markham's astute commentary on Helen Huntingdon's art marks him as a potentially suitable partner for her. Likewise, in *Middlemarch,* Will Ladislaw's growing ability to see art as more than simply pedantic allows him to help Dorothea better understand the art that surrounds her. By contrast, Edward Casaubon's lack of aesthetic enthusiasm conflicts with Dorothea's desire to develop a genuine feeling for art. In all of these more positive examples, women help male figures develop latent aesthetic sensibilities into something personally and sometimes even socially transforming.[2]

My first chapter, "Encouraging Visual Literacy," focuses on the 1835–36 Select Committee on the State of Arts and Manufactures. This committee hoped to improve British national taste through widespread art education. By advocating written guidance and professional expertise, the committee

helped professional art critics—including women writers—to take precedence over traditional connoisseurs. While their specific recommendations were slowly and sporadically implemented, they quickly led to a greater acceptance of written guidance by art critics. However, despite this emphasis on teaching a broader public through written instruction, the visual literacy imagined by the committee and by later art critical discourse betrayed considerable anxiety about class mobility, particularly as that mobility was expressed through middle-class consumption of industrial art.

Chapter 2 examines Elizabeth Gaskell's *North and South* in the context of contemporary debates about household taste. While some prominent Victorian writers hoped to keep them separate, domestic and public life were in fact intimately connected throughout the period. In ways that even recent criticism has only begun to understand, Elizabeth Gaskell uses household details in her novels to effect profound political statements. Class conflicts in *North and South,* I assert, are substantially addressed through the development of perceptive household taste by some middle-class characters. Though Gaskell treats problems of industrialization and the working class in all her novels, and though the link between taste and morality is a central concern elsewhere as well (as it was for many nineteenth-century novelists), *North and South* is the only novel in which Gaskell demonstrates how a master can learn to confront social problems through sensitivity to the domestic.

The third chapter studies Elizabeth Eastlake as an important and neglected example of an early professional woman art critic. While the critic-as-artist was the predominant model in the eighteenth century, specialists in certain areas of the arts became much more commonplace in the Victorian period. Women art critics shaped the profession in some particularly striking ways, especially in their creation of literary styles that could convey serious historical scholarship. In their emphasis on precise attribution, Elizabeth Eastlake and Anna Jameson—already respected literary stylists at the time—helped originate the modern practice of art history. In so doing, these women revise our perspective of when and how art criticism became a professional practice in Britain. While most scholarship dates the movement from the late 1860s—largely as a result of male writers—Jameson and Eastlake began to define the disciplines of both art criticism and art history in the 1840s.

The professional art commentary developed by women prose writers provided an avenue of both intellectual and financial independence. Anne Brontë's *The Tenant of Wildfell Hall* (1848), the focus of chapter 4, addresses this topic in a parallel fashion. Despite recent attention to Helen Hunting-

don's painting in *Tenant,* aesthetic commentary in Anne's novels remains underexamined. *The Tenant of Wildfell Hall* as well as *Agnes Grey* reveals that Anne shared with Charlotte a vision of ideal external criticism as both educated and rational, criticism that is best exemplified by *Tenant*'s Gilbert Markham. But Anne also suggests, primarily through Helen's diary entries, that the artist is sometimes best served by her own commentary. Against the Victorian stereotype that equated serious criticism with an external male voice, Helen objectively assesses both her own artworks and those of others. Through Helen's selective use of aesthetic commentary, Anne Brontë provides an implicit answer to complaints that she either failed to heed any artistic advice or that she did not understand her own aesthetic choices in *Tenant.*

My fifth chapter studies the Manchester Art Treasures Exhibition of 1857 and the mid-Victorian debates concerning the National Gallery. Seeking to teach the history of art, critics such as Anna Jameson, John Ruskin, Henry Cole, G. F. Waagen, and A. H. Layard tried to manage how visitors walked through existing exhibition spaces and to influence the design of new ones. These critics believed that the proper identification of artworks was integral to an exhibition's educative potential, and so I return here to a central problem examined in previous chapters: attribution. Ignoring the fad for reattribution that this concern provoked, Ruskin hoped viewers would labor to see the truths in a few excellent paintings.

Chapter 6 assays representations of art galleries in two novels, Charlotte Brontë's *Villette* (1853) and George Eliot's *Middlemarch* (1874). Charlotte Brontë and George Eliot engage Ruskinian realism and the emphasis on proper attribution—strikingly, while each depicting artworks called "Cleopatra"—but in ways that invite readers to dissent from the opinions of restrictive guides. Most notably, they promote the interpretation of artworks as complicated symbols. Names of artworks are not only important for questions of attribution and authenticity, but are also linked to the identities of characters and to the authors who brought them to life. Perhaps surprisingly, *Villette, Middlemarch,* and the commentary surrounding Victorian art exhibitions reveal a nostalgia for private art galleries, a desire I link to the novelists' desire for privacy in writing under pseudonyms.

"Sensational Sentiments," chapter 7, examines the reception of both literary and visual impressionism by British art critics. Such controversies as those surrounding Pater's *Studies in the History of the Renaissance* (1873) and the *Whistler v. Ruskin* trial (1878) demonstrate an increasing fear among writers that artists and some art critics were pandering to public tastes. Impressionism was viewed as both a contributor to and a potential solu-

tion for this problem. Because they often depicted common subjects and purported to represent feelings through what seemed a hasty technique, impressionist painters were seen as encouraging viewers to identify too easily with works of art—a democratization of the arts that was linked to social revolution. Likewise, for Dilke and some other critics, Pater's impressionist *Renaissance* further popularized an already fashionable subject through his emphasis on feeling over historical reality. As a woman art historian, Dilke was particularly careful to differentiate her own precise scholarship from what she characterized as Pater's sentimentalism. At the same time, Dilke and other critics believed that some impressionist works were sufficiently complex and subtle to be labeled as great art. It is this kind of suggestiveness—as opposed to the obvious, easily accessible appeal of some impressionist works—that critics hoped to model in their own writing. Despite their differences from one another, Ruskin, Dilke, Pater, and Lee all claim that art critics cannot completely illuminate the lives or works of even the most famous artists. Instead of lessening the authority of the art critic, this reticence to describe highlights the expertise needed to penetrate great artworks.

In my conclusion, I briefly consider commentaries about art and architectural projects for the World Trade Center site after September 11. Though the United States in the twenty-first century does not have the same fear of revolution as did nineteenth-century Britain, many of these commentaries reveal a familiar urge to order the public through high aesthetic culture. Moreover, while ostensibly democratizing the arts, these critics reject works that seem to pander to public tastes, much like Victorian writers facing the onslaught of impressionism. In another similarity to Victorian debates, some of these recent writers seek to propagandize national values through these buildings, while others decry such obvious symbolism. The commercial nature of many of the new buildings at the World Trade Center site coupled with its memorial function have also led to stark disagreements among critics. While some claim in Ruskinian fashion that good architecture cannot stem from commercial impulses, others celebrate the economic development of the site. Despite the ideological and conflicting nature of these commentaries, they do seek to connect readers with the arts in ways reminiscent of the best Victorian critics.

"The 19th century, afflicted with doubts, made conscientious efforts to educate popular taste," writes John Steegman in *Victorian Taste*. "The 18th century on the other hand, did not discuss whether its taste was good or bad, and 'education' in taste never occurred to it" (4). Steegman's description of this shift, formulated in 1950, is still a productive way of viewing

Victorian art criticism and its relationship to developing art institutions. As a result of this new emphasis on education, both traditional institutions such as the Royal Academy and newly created ones such as the National Gallery were increasingly viewed in terms of their use in improving public taste. Victorian art critics were a logical extension of the national movement to teach visual literacy. Equally important is Steegman's mention of the doubts that surrounded nineteenth-century discussions of taste. While Victorian commentaries on art can seem contradictory to a modern reader, this lack of coherency is better understood as a distinctive feature rather than a flaw of the genre. Unlike eighteenth-century writers who often intellectualized art, Victorian critics endeavored to connect the arts with lived experience. Their opinions thus differed as they confronted new developments and situations (a quality that makes the writings of even a single critic a good register of the period's complex beliefs). By contrast, as Steegman noted in 1950, modern art criticism is closer to the intellectualizing tendency of the eighteenth century, a trend that he hoped would soon reverse itself (6). Twenty-first-century art criticism, however, remains preoccupied with formal features and artistic movements. As I hope to show in the following pages, Victorian art critics provide a strong counterpoint to such limited concerns.

c⅏ɔ

Encouraging Visual Literacy

EARLY-VICTORIAN
STATE SPONSORSHIP OF THE ARTS AND THE
GROWING NEED FOR EXPERT ART COMMENTARY

*E*arly nineteenth-century Britain witnessed a revolution in state spon-
sorship of the arts. After decades of discussion, the National Gal-
lery of London was finally founded in 1824—well after similar institutions
developed in Italy, Austria, and France in the eighteenth century. While a
permanent building for the National Gallery was being constructed in Tra-
falgar Square, a Select Committee on the State of Arts and Manufactures
(1835–36) sought to support both academic painters and designers so that
they could compete with their European counterparts. As a result of these
hearings, the government created the first British schools of design, which
provided art education to women and working-class artists.[1] In addition to
the National Gallery, another large building project encouraged govern-
ment intervention. After the Houses of Parliament burned in 1834, an 1841
Royal Commission decided to adorn the new gothic building with large-
scale fresco murals depicting English historical and literary themes. In a
public and popular competition, prominent British artists sought the right
to decorate the new Houses of Parliament.

Despite this unprecedented state and public interest, the arts remained
defined by traditional class and gender roles. Though ostensibly a public
venue, the National Gallery was not open when many in the working class

could attend. Likewise, most of the artworks installed in the new Houses of Parliament were off-limits to the general public. Moreover, because public artworks were usually displayed in the early-Victorian period without any accompanying verbal information, they tended to alienate less educated viewers. The 1835–36 select committee hearings and the resulting schools of design betrayed both sexist and class-based ideologies. Most prominently, the select committee ignored the women artists and art commentators who were practicing during this time; not a single woman testified among the many artists, collectors, and other experts called as witnesses. Although the schools of design included women and those from the working class, they also segregated narrowly based on class and gender.

These class and gender biases notwithstanding, state sponsorship of the arts in the early-Victorian period created some very significant changes that fostered careers for both men and women. Most prominently, the government's increasing advocacy of public venues, expertise in specific areas of the arts, and verbal mediation for visual art created a greater need for specialized art commentary. While some of the women writers whom I will discuss in this book had already begun their careers by the 1830s, they benefited from the greater emphasis on educating a broader public in the arts.

In discussing these developments, I complicate recent scholarship, which often argues that nineteenth-century art commentary simply repeats elitist notions from the eighteenth century. The committee's recommendations—especially its injunction to provide written guidance for viewers within museums—marked a decisive turn from the eighteenth-century assumption that viewers could appreciate artworks without verbal direction. Because there was no centralized art authority such as that found in France, art institutions in Britain also tended to work against the use of the arts for social control. By challenging the primary art institution (the Royal Academy) and the traditional arbiter of taste (the aristocratic connoisseur), the committee fragmented what had already been a fairly decentralized British art world. During the Victorian period, art institutions proliferated in Britain, and the proper figure to judge art was widely debated. In many respects, the art critic was a perfect solution to the problem of providing art education without the controlling bureaucracy that so many Victorians feared. Because art critics varied widely in the instruction that they provided, they could not be accused of creating what liberal thinkers such as John Stuart Mill most feared about state centralization: narrowness of opinion.

The 1835–36 parliamentary hearings, dominated by progressive ideas and liberal Members of Parliament, helped diffuse institutional control

over the arts by attacking such authorities as the government and the Royal Academy. Benthamite William Ewart of Liverpool, well-known for his previous challenges to the Royal Academy, the Bank of England, and the East India Company, created and chaired the committee (King 6). In a letter to the history painter Benjamin Robert Haydon (October 2, 1836), Ewart informed him that the report was "as liberal a one as it was possible for me to draw under the control of the Committee" (qtd. in Bell 57). In reality, the 1836 committee seems to have provided little "control" over Ewart's liberal tendencies. The 1835 committee had at least sixteen radicals out of forty-eight members; the 1836 committee of fifteen contained nine radicals (King 6). As Parliament became much less radical in subsequent years, many of the specific recommendations proposed by the committee were not fully instituted. Still, the ideas expressed in these hearings had a profound effect on the Victorian art world.

Working within an ideological framework of classical liberalism, the committee sought solutions to the problems that plagued British artistic production but argued for as little government involvement as possible. Thus, in principle, the committee agreed with J. S. Mill's representative warning that "every departure from the laissez-faire principle, unless required by some great good, is a certain evil" (qtd. in Green 253). In its 1836 report, the committee clearly believed that the development of the arts was a "great good" and thus worth *limited* government intervention: "the interposition of the Government should not extend to interference; it should aim at the development and extension of art; but it should neither control its action nor force its cultivation" (v). Witnesses and committee members complained that prior government interference—in the form of taxes on bricks, plate glass, and paper (which was said to depress periodicals on the arts)—had impeded the competitiveness of British design. The 1836 report argued that the market would supply most of the stimulus for improving the arts, but the government should provide financial assistance when absolutely necessary (for example, to support large history paintings or very expensive illustrated books).[2] In order to avoid too much control by the national government, the 1835–36 committee entrusted the development of a network of art schools to local governments. Local control over schools was the norm in British education—not just in art instruction—until the late-Victorian period.

Despite endorsing a limited and decentralized form of government involvement to encourage the arts, the committee also demonstrated its belief in more purely free-market principles. According to the committee's 1836 report:

> From the highest branches of poetical design down to the lowest connexion
> between design and manufactures, the Arts have received little encourage-
> ment in this country. . . . In many despotic countries far more development
> has been given to genius; and greater encouragement to industry, by a more
> *liberal diffusion* of the enlightening influence of the Arts. (iii, emphasis
> mine)

Britain, a democratic and industrialized country, had not accomplished
what countries with less-developed political and economic systems (i.e.,
autocratic, not free-market) had managed. The diffusion of the "enlighten-
ing influence of the Arts" would improve the nation's economy and cultural
standing by elevating both the supply of and demand for British products.
Workers would learn to create better-designed products while consumers
would begin to appreciate this craftsmanship.

The liberal members of the 1835–36 select committee were surprisingly
unequivocal about the importance and preferred method of art education.
Ewart, his colleagues, and most of the witnesses called before the com-
mittee were well convinced that the free distribution of such knowledge
would improve workers' contributions to society. The paternalism of this
view was inherited from older liberal conceptions of education. Describing
the benefits of education more generally, Smith's *Wealth of Nations* argues
that popular education increases the morality and productivity of work-
ers, in large part because they learn not to challenge the government: "An
instructed and intelligent people . . . are always more decent and orderly
than an ignorant one" (qtd. in Green 249). Indeed, liberal thought often
envisioned workers as children who needed education before they could
participate in the political system, participation that was often delayed
indefinitely (Mehta 59). Accordingly, some witnesses and writers in the
popular press argued against widespread arts education, worrying that
such instruction could lead to immorality or subversion of the social order.[3]
These detractors believed that workers might visit art galleries instead of
working or view art that was socially or politically transgressive.

Witnesses suggested that not only would arts education improve moral-
ity, but it would also benefit workers who were less skilled with verbal
language. For example, J. C. Robertson, editor of *Mechanics' Magazine,* tes-
tified, "It is a common saying among them [workers], that they can com-
prehend any form of construction better from a drawing than from the
best written description. . . . They can *read* drawings, if I may so speak,
and understand them thoroughly, though they cannot themselves draw"

(1835, 126, emphasis mine). Robertson's tentative notion of visual literacy—
"read[ing] drawings"—would become well accepted by the mid-Victorian
period, when narrative painting became the most popular genre. But while
increased visual literary may have helped workers understand drawings,
it may have also delayed a fuller push for verbal literacy. Moreover, much
as parents would speak for their children in the paternalistic mode of lib-
eral education, Robertson and other witnesses represented the views of the
working class. Witnesses suggested that increased education in the visual
arts would play into the learning strengths of workers and give them what
they needed and wanted, but no workers testified to corroborate these
assertions.

THE ROYAL ACADEMY

As I note previously, the 1835–36 select committee challenged the Royal
Academy's (RA) status as the central arbiter of taste. In its emphasis on the
arts as both economically useful and morally enlightening for a broad pub-
lic, the committee found that the RA was serving only a few artists and a
narrow section of the public. The committee was particularly concerned
that the RA had done little to encourage the design of British manufac-
tures. While the RA had been challenged prior to 1835, the select commit-
tee's practical aims heightened complaints about the institution's privileges
and exclusivity.

The RA operated as a virtual monopoly before 1835. While some popu-
lar artists were not academicians, those who were members and/or exhib-
ited at the annual show generally enjoyed greater success. The appellation
"RA" was the most sought-after title for artists, a fact that did not change
in the Victorian period. But, while the RA maintained a limited member-
ship, an increasing number of successful artists were not academicians.
Rival galleries and shows were created throughout the nineteenth century,
and these catered to diverse audiences. For example, as I discuss in chapter
7, the Grosvenor Gallery (founded in 1877) attracted both avant-garde and
more established artists, including James McNeill Whistler and Sir John
Everett Millais. The RA's annual exhibition itself began to draw a more
varied crowd. Because of this improved access to a greater number of gal-
leries, the public began to rely on art critical commentary for guidance.
Reviews of exhibitions appeared in all the major periodicals as well as in
a number that focused exclusively on art—the *Art Journal* and *Art-Union*

Monthly Journal—among others. These commentaries structured the experiences of readers who visited the exhibitions and allowed armchair visitors to participate in what was becoming a popular British pastime.

Complaints about the Royal Academy occupied much of the 1836 hearings, and the institution's detractors were the primary forces behind the creation of the initial committee in 1835. Witnesses argued that the RA had failed for three major reasons. First, the RA had educated neither the general public nor the great mass of artists who did not practice the fine arts, many of whom were designers. Second, the public did not need such an institution to tell it which art and artists to appreciate. Third, members and nonmembers were not given equal opportunity to participate in the RA's shows (King 22). Faith in the value of competition informed all three complaints. "Political economists have denied the advantages of such institutions" because, remarked the 1836 report, "the academic system gives an artificial elevation to mediocrity" (viii). The report expressed the hope "that the principle of free competition in art (as in commerce) will ultimately triumph over all artificial institutions" (viii). Instead of one central institution, the committee wanted various arts societies to compete with each other. The assumption that an art institution could be assessed based on contemporary economic theory went largely unquestioned during these hearings—with the notable exception of the president of the Royal Academy, Sir Martin Archer Shee, who claimed that "the principle of commerce and the principle of art are in direct opposition the one to the other.... The moment you make art a trade you destroy it" (1836, 162). But most witnesses asserted that the market, not an institution, should decide on the merits of artists and artworks. As the art commentaries and novels discussed in this book will make clear, the notion that an educated public could judge art for itself was increasingly accepted in the Victorian public. However, as this public became more confident in its judgments and, at times, in its ability to buy some of the art under discussion, art critics worried that the new art market would erode standards of taste.

For many of the nonaffiliated artists who testified at the 1835–36 hearings, the RA had already corrupted public taste through its tacit support of portrait painting, which supposedly demonstrated the institution's rampant commercialism. However, these artists seemed most concerned with their own lack of access to the economic opportunities enjoyed by academicians. If the artists had genuinely believed in the public's ability to judge, they would not have worried about the RA's detrimental effect on national taste. Such contradictions appear in many of the period's writings on art—

complaints about vulgar commercialism are usually informed by capitalist ideology and, despite professing the contrary, betray a lack of faith in individual judgment.

The dramatic shift in early-Victorian art patronage helps explain artists' twin concerns about national taste and their own economic survival. In the eighteenth century, most artworks shown at the RA had already been sold to wealthy individuals. By contrast, much of the art exhibited during the Victorian period was for sale. Victorian artists often painted what they thought would appeal to the middle-class buyer, the figure who increasingly drove the nineteenth-century art market. Notes Alan Staley, "Eighteenth-century patrons came to the artist and told him what they wanted; nineteenth-century patrons saw pictures exhibited and purchased what they liked" (8). The portrait was the most popular form of painting still created upon request in the nineteenth century; more than half of the 1,278 artworks at the 1830 Royal Academy exhibition were portraits (Wood 274). The genre was not only popular but also lucrative for artists. Traditional history painters, whose style was unpopular with the middle class, often shunned portraiture. Many of these history painters were not Royal academicians and thus lacked certain privileges that would have helped them sell their works. The works of academicians were frequently hung "on the line"—the most favorable location at eye level around the main gallery— while paintings of other artists, *if* they were accepted, were often placed too high ("skied") or were otherwise difficult to see. Haydon testified before the select committee that his *Dentatus* was moved to an inferior position in order to make room for a portrait. He ostensibly complained because the RA, by belittling his painting, was ignoring its founding mission: the encouragement of history painting. But Haydon also worried about the economic effects of this snub. Haydon claimed that he "never had another commission for 16 years" after this incident (1836, 90).

Like Haydon, John Martin testified that the academy's preference for portraits "misleads the public altogether; it gives a fashion to portrait painting, and depresses the higher branches of art" (1836, 72). But while singling out this particular genre as overly commercial, witnesses did not reject the larger idea that they needed more aggressive marketing of their own works. Martin testified that he started to exhibit at the British Institution, not because of a philosophical objection to portrait painting, but because his works were better hung in that venue. His *Joshua* was not placed "on the line" at the Royal Academy and was thus little noticed; the same picture was displayed properly at the British Institution, and Martin said he

"received the principal premium of that year" (1836, 71). In effect, artists wanted to make their own genre of painting as fashionable with consumers as portraits had become.

In addition to the problem of visibility for nonacademicians, witnesses argued that academies, because of their systemic nature, prevented the development of individual artistic innovation. Such ideology—the advocacy of invention over the artificial control of rules—was borrowed from classical economic and educational theory and reflected a modern conception of the subject as developing apart from institutions (Kaiser 15). Eighteenth-century writers on education such as Joseph Priestley and William Godwin argued against monolithic academies, which they saw as the bastion of standardization (Green 245). Similarly, the 1836 report argued that academies "damp the moral independence of the artist and narrow the proper basis of all intellectual experience—mental freedom" (viii). Consistent with larger British ideas of education, the committee wanted to rely on an apprenticeship system to train artists. The report argued that "the restriction of academic rules prevents the artist from catching the feeling and spirit of the great master whom he studies" (viii). Witnesses asserted that continental art suffered from a depressing uniformity as a result of following these academic rules. This belief in the individual genius of the artist would be powerfully echoed by later art criticism. Most famously, Ruskin complained about the prioritization of mere technique over thought and feeling in *Modern Painters,* Volume 1. Other writers, in thinly veiled propaganda for contemporary progressivism, celebrated the supposed freedom of the artist in the Renaissance.

But in their haste to attack the RA, witnesses and committee members failed to acknowledge the variety in its curriculum. In fact, as Staley has noted, commentators on the academy often viewed its relatively weak standardization of instruction as a strength because British artists were allowed to develop their own styles. Because students were taught by "a rotating series of Academicians," they learned diverse styles rather than a uniform model (Staley 10). The committee was clearly against the idea of academies in general, as evidenced by its unfavorable parallels between the RA and old literary academies. The 1836 report compared the stultifying academic rules of art academies with "the regulations of those literary institutions of former times which set more value on scanning the metres of ancients than on transfusing into the mind the thoughts and feelings of the poet" (viii). The model of artistic appreciation advocated by the report seems based on the Shaftesburian notion of right reason; rational individuals will easily understand great poetry without the teachings of an institution.

Contrary to the committee's individualistic view, some prominent Victorian intellectuals believed that the masses needed institutional arbiters of taste. While Matthew Arnold's later defense of high culture has been read as conservative if not ultimately antidemocratic, his views on literary academies attempt to balance personal freedom and institutional control. In "The Literary Influence of Academies" (1864), Arnold argues that good criticism displays the kind of style and original ideas that a more centralized academy would accept: "Where there is no centre like an academy, if you have genius and powerful ideas, you are apt not to have the best style going; if you have precision of style and not genius, you are apt not to have the best ideas going" (50). Just as the select committee addressed consumers as well as producers, Arnold asserts that academies can educate readers to appreciate good prose. He partly forgives the extravagances of writers who feel themselves to be addressing an ignorant public. In the same way that the select committee faulted consumers for buying inferior designs, Arnold suggests that some writers are merely catering to their uneducated audience.

Shee, the president of the RA, provided an Arnoldian definition of the institution's founding mission as one intended to educate public taste by distinguishing only the best artists. During the 1835–36 hearings, Shee defended the distinction bestowed on artists by the appellation "RA" by arguing that "every man does not show his wisdom in his face, nor are his virtues blazoned on his breast; a mark of honour or distinction, therefore, is a stamp set upon merit, for the purpose of pointing it out to those who have no other means of ascertaining it" (1836, 154). Contrary to much of the testimony before the committee, Shee asserted that the public could not satisfactorily judge a work of art. The label "RA" would tell viewers that a particular work was worthy of notice. Further, Shee testified that the Royal Academy educated the public about the importance of the arts: "It enables an ignorant and uncivilized population to acquire some respect for the arts; it gives them an idea that they are objects of some consequence . . . and that they produce a serious influence on the whole scheme and structure of society" (1836, 160). While the moral importance of art was widely accepted in the early-Victorian period, Shee's contention that Britain's "uncivilized population" could not understand this significance without the "honors and distinctions" of the RA was vigorously contested. The RA maintained an important influence on Victorian taste, but art critics such as Ruskin and Anna Jameson assumed the central role in educating gallery visitors. Still, while unrealized, Shee's basis for defending the Royal Academy—that it served the public—marked an important conceptual shift in envisioning the role of art institutions.

THE NATIONAL GALLERY

The committee's emphasis on the arts as a practical enterprise (that is, one that would provide both economic and moral improvement) helped create a wide variety of art institutions that were designed to educate a broad public. New institutions, most prominently the National Gallery, were created to educate this expanded audience. Much of this new emphasis fit squarely into the Victorian "self-help" doctrine; witnesses and art critics argued that workers and the middle class could improve both themselves and their careers by viewing artworks and by being trained in the arts. In addressing the National Gallery's role in public art education, the select committee and its witnesses highlighted the need for a new, specialized kind of expertise to guide decisions about acquisitions, arrangement, and restoration. Such decisions had previously been made in private, by individuals who often lacked the requisite knowledge. Many witnesses believed that the current holdings were inadequate and that gallery officials were doing little to acquire the best works. According to the testimony of the gallery's architect, the collection contained only 126 paintings in 1836 (133). The situation would soon change. The 1853 Parliamentary Select Committee on the National Gallery struggled to organize a rapidly exploding and heterogeneous national collection (Siegel, *Desire and Excess* 133). By 1888, Ruskin remarked that the National Gallery was "without question now the most important collection of paintings in Europe for the purposes of the general student" (qtd. in E. T. Cook, *Handbook* vii). But the gallery in the 1830s was uncertainly conceptualized and had a very anemic collection compared with the public galleries of Europe. Most witnesses before the 1835–36 committee advocated the acquisition of works from two areas: the High Renaissance and contemporary British art. But while there was agreement on the most important schools and time periods, there was much disagreement over individual works of art. In the past, donated works had been accepted without any sort of professional judgment. Witnesses, many of whom were art dealers or artists, argued that a body of experts such as themselves—not the gallery's board of trustees—needed to judge these works. Art critics were not called as witnesses and so did not have the opportunity to promote their emergent expertise. Nevertheless, while artists and dealers continued to shape public taste, art critics would increasingly fill much of the need for specialized knowledge created by these parliamentary discussions.

In addition to judging the artistic value of potential acquisitions, art experts became more and more influential in debates about the maintenance and restoration of artworks. Witnesses testified during the 1835–36

hearings that paintings had been improperly maintained in the National Gallery. The committee spent much time questioning William Seguier, the keeper of the National Gallery, about the condition of the gallery's pictures and the need for restoration. In an attempt to embarrass Seguier, Ewart asked the keeper about a specific painting—the *Sebastian del Piombo*. Seguier admitted that the painting had worms around its edge, but asserted that relining was unnecessary because the insects posed no threat to the work as a whole. Ewart then produced a letter from "a person celebrated for his knowledge in this particular branch of the lining of pictures," who argued that the painting was infested with a variety of insects and was in danger of complete destruction (1836, 130). By quoting this expert, Ewart implied that Seguier lacked the specific knowledge to judge the painting's condition. Ewart also suggested that Seguier had neglected to restore paintings that had been darkened by dirt and varnish. For Ewart, the state of these pictures caused the public to be "insensible to the merits of Italian pictures, and [to instead] prefer more modern and more gaudy [that is, brighter] pictures of inferior masters" (1836, 131). Supposedly, the lightening of these old paintings would make them more popular and thus elevate public taste.

At stake in this debate about restoration was a larger Victorian epistemological question about the possibility of uncovering originary fact. Ewart believed that such facts could and should be determined in building the nation's collection. He asked Seguier whether the gallery's most important (that is, older) works "do not possess the real original colours which the masters intended to bestow upon them" (1836, 131). Ewart suggested that these colors were facts merely waiting to be unearthed by the proper cleaning. But as recent controversies surrounding the restoration of old masters by modern experts and technologies suggest, cleaning is a subjective process. Ewart's belief seems influenced by the early nineteenth-century craze for ancient artifacts, what Jonah Siegel has described as "the turn of the century characteristic response to the heterogenous art objects uncovered by archaeology . . . [which was] the desire to look beyond them, to identify some coherent lost original" (*Desire and Excess* 135). Reflecting this quest for originary fact, Ewart asked Seguier, "Is it not very desirable indeed to form a national collection, not through the mere instrumentality of connoisseurship, but by an historical investigation [into] whether the pictures are the works of the men to whom they are attributed, and have been handed down as such since their original first painting?" (1836, 131). Ewart hoped to replace the subjective judgments of art dealers and collectors with the objective facts of a historical investigation. Although contested, Ewart's

demand for historical evidence over traditional connoisseurship indicated a significant change in the way that art was evaluated. Some prominent art experts began to use historical research and new technologies (most prominently photography) to question the attribution of artworks, which sparked the development of modern art history. As I discuss more fully in chapter 3, women writers were at the forefront of this art historical movement.

In order to make the best use of the gallery's holdings, the committee discussed ways to maximize public education. Witnesses generally agreed that the gallery should be open on Sundays and holidays so that workers could attend. But simply getting workers to the gallery was not sufficient; how to instruct an audience with little knowledge about the arts was debated in these early hearings and throughout the nineteenth century. Ewart viewed the gallery's arrangement as crucial to its educative function and thus an issue of national importance: "Is this building (which ought to be on a great and comprehensive plan, to be an eternal monument of the arts in this country), to be merely a gallery where pictures are to be placed without due distribution, and not a gallery worthy of this nation?" (1836, 133). Dr. G. F. Waagen, the well-respected director of the Berlin Gallery, suggested a "historical arrangement" in order "to combine taste with instruction" (1836, 5). Waagen's juxtaposition of taste and instruction would have seemed strange to many eighteenth-century commentators, who would have assumed that good taste was naturally obtained.

Most significantly for my purposes in this chapter, the committee and witnesses also suggested the use of written aids to help viewers understand the logic of these arrangements. Waagen recommended providing viewers with two kinds of catalogues so that they would understand his historical organization: one that would give the title, date, and artist of a painting, and another that would provide brief lessons on the history of art (1836, 12; King 15). Further, Waagen testified that, in the Berlin Gallery, he also hung up "a little paper, containing the pictures in each division, with the name of the artist and subject of the picture, and the date, arranged under the head of the school" (1836, 12). These catalogues and wall signs would, in Waagen's words, allow the visitor to "*see* the historical development of art" (1836, 5, emphasis mine). For Waagen, seeing was enhanced by written information, an increasingly accepted idea that helped Victorian art criticism proliferate. Waagen was himself instrumental in developing this written guidance for viewers. As I discuss in chapter 5, Waagen wrote *A Companion to the Official Catalogue* for the Manchester Art Treasures Exhibition of 1857, which was designed to supplement the somewhat uneven official catalogue. Waagen's notion of catalogues and wall labels seems

commonplace to us, but the practice of furnishing such information was a new idea in Britain at the time of these hearings and, as King notes, demonstrates an altered conception of gallery visitors: "When art was intended to be seen only by connoisseurs, there was no need for these kinds of aid" (15). In his 1880 "A Museum or Picture Gallery: Its Functions and Formations," Ruskin argues for the importance of written information, coupled with a logical organization, for teaching the public about art and museum exhibitions. Taking animals at the British Museum as his example, Ruskin writes, "If every one of these had . . . a plain English ticket, with ten words of common sense on it, saying where and how the beast lived, and a number (unchangeable) referring to the properly arranged manual," visitors would leave the museum much more knowledgeable (*Works* 34: 248).

Ruskin's comments in 1880 show that these written aids were slowly and unevenly distributed in galleries and museums. Their use was particularly controversial in mediating the fine arts. Some witnesses before the 1835–36 committee clung to the traditional notion that works of art should stand alone. Royal academicians often told their students that they should not provide any written information with their paintings (Altick, *Paintings* 186). As a result of this elitist notion, wall placards were not widely used until the twentieth century (Waterfield 101). A detailed catalogue designed to assist the general public in the National Gallery was not published until 1844 (Gillett 276n). Earlier catalogues tended to rhapsodize about the national importance of the arts and included "minimal historical or explanatory information" (Taylor 43). This lack of comprehensive information in catalogues meant that the guides written by art critics were essential. William Hazlitt and P. G. Patmore, for example, published well-known guides to the National Gallery in 1824 (Waterfield 101). Jameson and other Victorian critics also published such aids, often correcting the attributions that romantic critics unquestioningly took from earlier writers. When they were available, catalogues were frequently too expensive for working-class visitors. Some witnesses before the 1850 select committee on the National Gallery even suggested the mandatory purchase of a catalogue as a way of keeping out undesirables (Gillett 227). In the Royal Academy exhibition, the catalogue effectively doubled the price of admission (from one shilling to two). The catalogue was necessary for most visitors because artist and title were not listed next to the picture on the kind of placard recommended by Waagen (Gillett 222). Those sufficiently educated to do without the catalogue could probably afford to buy it. In short, catalogues could assist the masses, but they also tended to exclude those unable to pay for them.

An 1870 edition of the *Descriptive and Historical Catalogue of the Pictures in the National Gallery* demonstrates how this written guidance had developed by the middle of the Victorian period. Already in its fifty-fifth edition, the 1870 catalogue was "approved by the director" and written by the keeper and secretary of the gallery, Ralph Wornum. However, priced at one shilling, the catalogue was too expensive for the visitors who most needed it. Noting the importance of "historical knowledge" about art, Wornum writes, "The information thus offered, without superseding individual predilections, may sometimes assist in the formation of correct judgment, which is the basis of correct taste" (3). While (significantly) acknowledging some leeway for individual opinions, Wornum suggests that only those fully educated or in possession of his catalogue could really have "correct taste." In addition to his own authority on these historical matters, Wornum cites in his guide "the opinions of eminent critics on the merits of particular masters" (3). Implicitly, Wornum thus argues for the preeminence of the specialist writer on the arts, which would have seemed unusual to readers less than a half century earlier. In a dynamic that we will see throughout the Victorian period, specialist opinions trump those of the general public, even as the public is allowed some right to judge art.

Despite this elitism, the 1870 catalogue is representative of serious attempts to educate a broader public. The catalogue notes that there was time for some in the working class to view the gallery's collections: on Saturdays from 10:00 to 5:00 (Wornum 4). According to an engraving from the *Illustrated London News* dated August 6, 1870, workers did in fact attend (fig. 1). Brandon Taylor writes that "rare but uncoordinated visits to the National Gallery were planned in the late 1860s and 1870s by the Working Men's Club and Institute Union," which was designed to acculturate workers and thus keep them out of the pubs (79). While the catalogue was too expensive for most working-class visitors (the workers in fig. 1 rely instead on a guide), it was useful for a middle-class audience. In a section on "The Schools of Painting" in the 1870 catalogue, Wornum defines the term "school" for a more general audience and proceeds to list major artistic movements and their distinctive characteristics (12). Moreover, the discussions of individual artists and their works are meant to both inform and engage viewers. In describing Fra Angelico, who was an important figure for the renewed Victorian interest in early-Italian art, Wornum relates his biography as well as an interesting anecdote: "Fra Giovanni Angelico, says Vasari, was a man of such fervent piety, that he never commenced painting without prayer" (24). Writing several years before the adaptation of Vasari in Pater's *The Renaissance,* Wornum already registers the Victorian art

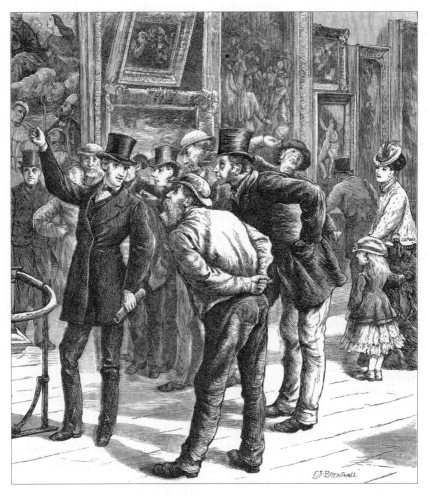

Figure 1
Brewtnall, E. F. "A Party of Working Men at the National Gallery, London, 1870." 22 × 25 cm. Grosvenor Gallery of Fine Art. © *Illustrated London News Ltd*/Mary Evans.

critical fascination with legends. But, in discussing Fra Angelico's individual paintings, Wornum also notes appropriate Bible passages and descriptions so that viewers will apprehend both the story depicted and the work's iconography. Moreover, Wornum lists such technical facts as medium, size, and the provenance of the painting. In its attention to legends about artists, stories about individual artworks, and researched art historical knowledge, Wornum's catalogue is representative of the hybrid form that much Victorian art commentary took.

THE WESTMINSTER COMPETITIONS AND THE SUPERIORITY OF BRITISH ARTISTIC TALENT

As my analysis of such written guides should make clear, even mid-Victorian art critical discourse was somewhat ambivalent about the extent to which taste could or should be taught to a general public with an increasing interest in the visual arts. I have argued that these conflicts were present at the very beginning of the period, especially during the 1835–36 hearings. Indeed, this ambiguity about educating popular taste applied to conceptions of the country's working-class designers as well as to its viewing public. Asserting that British artists were naturally better than their European counterparts, the committee rejected the kind of state-controlled education system that could have provided workers with an even more comprehensive education in the arts.[4] The hearings suggested that British designers required only a level playing field to compete with, and beat, their European counterparts. Like many of the witnesses called before the committee, J. C. Robertson argued that designers had the raw ability but lacked the exposure to good art that would improve their skills: "The English artisan [can] do anything you can put him to as well, if not better, than any other artisan in the world" (1835, 126). The repeated insistence of ingrained British talent betrayed considerable anxiety about the status of the country's art and design.

The assertion of native artistic ability recurred during important events and exhibitions throughout the Victorian period; the most studied example is the Great Exhibition of 1851. During that event, commentators felt particularly threatened by French and American designs. This compensatory strategy was also employed to deal with a problem contemporary to and much influenced by the 1835–36 hearings. The Houses of Parliament burned in 1834 and were subsequently rebuilt in the gothic style by Sir Charles Barry and A. W. Pugin. An 1841 Royal Commission formed by Sir Robert Peel, headed by Prince Albert and with the painter Sir Charles Eastlake as secretary, addressed, as Peel put it, "whether the Construction of the New Houses of Parliament can be taken advantage of for the encouragement of British art" (qtd. in Treuherz 42). Large-scale fresco murals depicting English historical and literary themes were chosen, in part to demonstrate that British artists could handle both a difficult medium and grand subjects. Although British artists were not well-trained in fresco, the commission believed that they could learn; fresco would thus prove a perfect technique to demonstrate the native superiority of the British artist.

In defending the commission's decision to exclude foreign artists from the competition, Eastlake remarked:

> To trust to our own resources should be, under any circumstances, the only course. Ability, if wanting, would of necessity follow. Many may remember the time before the British army had opportunities to distinguish itself, when continental scoffers affected to despise our pretensions to military skill. In the arts, as in arms, discipline, practice and opportunities are necessary to the acquisition of skill and confidence. . . . but nothing could lead to failure in both more effectually than the absence of sympathy and moral support on the part of the country. (qtd. in Cole, "Decoration" 182)

Just as the military had shown skeptics—"continental scoffers"—the character of the British soldier, British artists would similarly triumph in this cultural war. Supporting British artists, Eastlake suggested, was a question of national and, therefore, moral importance.

Victorian art critics often took a similarly bellicose tone in championing British art. Ruskin's defense of J. M. W. Turner and British landscape painting—the project that sparked his writing of *Modern Painters,* Volume 1—is the most famous example. "Now, what Turner did in contest with Claude, he did with every other then-known master of landscape, each in his turn," writes Ruskin in an 1853 lecture. "He challenged and vanquished, each in his own peculiar field" (*Works* 12: 127). As Eastlake's soldier metaphor and Ruskin's list of defeated foreign male artists reveal, British masculinity as well as cultural superiority was at stake in mastering certain artistic forms. Similarly, Cole defended the use of fresco for the Westminster decorations by explaining that "in fresco painting, what is to be done must be done, once for all, correctly; there is no remedy for errors. In oils, you may touch and retouch until you reach your standard of perfection. Michael Angelo used to say oil-painting was only fit for women and children" ("Decoration" 187). Like Ruskin, Cole demonstrates that art and art commentary were highly gendered in the early-Victorian period. Cole and Ruskin sought to define the practice of serious art and art criticism as male. But the boundaries of these practices were often shifting—for example, while Cole labels oil painting as feminine, the medium was usually stereotyped in the nineteenth century as more masculine than the supposedly feminine watercolors. What changed little throughout the period were the attempts by male commentators to belittle women's artistic practice. Yet as women critics and artists were already making clear by

the 1830s, this equation of maleness with serious practice was an assumption, not a reality.

Despite and perhaps because of the sexist and nationalist rhetoric surrounding the Westminster competitions, the proposed designs attracted considerable public interest. Paula Gillett writes that the "cartoon drawings for the frescoes that were to decorate the new Houses of Parliament attracted twenty to thirty thousand viewers a day" (223) at the Royal Academy. The show was eventually opened free to the public, apparently without incident. Moreover, planners made provisions for catalogues to assist viewers in interpreting the artworks. In what would become a fairly standard practice throughout the nineteenth century, these catalogue entries often contained relevant quotations from British literary works. The painter Charles Eastlake remarked that such "catalogues in the hands of so many thousands would be the first introduction of many to an acquaintance with our best poets and writers" (qtd. in Altick, *Paintings* 185). Of course, Eastlake assumes that most gallery visitors could read; while Britain's literacy rate rose throughout the Victorian period, many workers would still have had limited reading skills in the 1830s and 1840s.[5] Catalogues and placards would have been most useful to a middle-class audience that could read but that had gaps in its knowledge about art. Still, the planners hoped to make both art and literature more accessible through these catalogues, an aim that would have been unlikely before the 1835–36 select committee.

The public interest in the competitions notwithstanding, the classical history paintings advocated by the 1835–36 committee and by Cole, Eastlake, and others during the Westminster competitions proved much less accessible to the general public once the artworks were actually executed and installed. Cultural preferences and the British government's sporadic support of the arts contributed to the eventual unpopularity of these artworks. The deaths of Prince Albert in 1861 and Charles Eastlake in 1865 left classical history paintings and the Westminster project in general without their main proponents (Wood 28). Unlike France, Britain had no tradition of state or church support of such large-scale historical works. While the French government sponsored competitions to reward the best history painters (for example, sending the best artists to Italy through the Prix de Rome), Britain provided no such encouragement. By the 1840s, most middle-class viewers would have sympathized with William Makepeace Thackeray's assessment of academic history painting as "representing for the most part personages who never existed . . . performing actions that never occurred, and dressed in costumes they could never have worn" (qtd. in Wood 26). The Victorian middle class wanted smaller, "anecdotal"

paintings that could be hung in their homes (Wood 24). By contrast, the themes, locations, and fresco medium selected for these Westminster paintings made them unappealing to the middle class.[6] Though the problem of the middle-class art market as arbiter of taste was much debated during the 1835–36 hearings, the question was effectively answered, at least in practice, by the 1840s.

Central to their lack of popularity, these paintings proved difficult to interpret. For example, Daniel Maclise's *The Spirit of Chivalry* (oil, 1845; fresco, 1847) relies upon iconography that would have required explanation for even educated Victorian viewers. The painting is an abstract allegory of chivalry with little narrative action. In his catalogue for a 1972 exhibition of Maclise works, Richard Ormond describes the figures in the oil version of the work: "In the centre, the Spirit of chivalry, represented by an ideal Madonna-like figure . . . stands beside an altar supported by carved angels, the centre of chivalric devotion. On either side of her are figures personifying the military, religious and civil powers" (85). While the painting would have appealed to the Victorian interest in the Middle Ages and the chivalric code, it does not depict familiar events (for example, stories about King Arthur). Although split in their overall opinion of the work, reviewers in the popular press noted its highly abstract quality. The *Art-Union* (1845, 257) reviewer applauded "the refined intellect which lights each set of features," while the *Athenaeum* (July 5, 1845, 664) remarked, "This is one of the most mannered and least original works by its master. . . . We fear he is cheered by 'a congregation' who are dazzled by his brilliant hand-work into forgetting that an arabesque is one thing—a painter's composition another" (qtd. in R. Ormond 85). This writer's implication that Maclise was too focused on mere technique was commonly used by other Victorian art critics to denigrate paintings. Reviewers were more uniformly complimentary of Maclise's later *The Spirit of Justice* (1849), noting improvements in the way he conveyed his subject. But this painting was similarly abstract. Maclise's highly decorative and architectonic style, which was heavily influenced by German painting, was unlikely to appeal to popular Victorian tastes. While some frescoes by Maclise and other Westminster artists were more accessible in subject matter, they were not physically available to most of the Victorian public. A set of William Dyce frescoes, for example, depicts scenes from Sir Thomas Malory's well-known *Morte d'Arthur* but was placed in the Royal Robing Room of the Houses of Parliament. At a time when public exhibitions were becoming more widespread, these publicly funded works were not located in places that would attract a large audience and thus instruct them in classical history painting.

In addition to the inaccessible themes and locations of many of these parliamentary works, the fragility of the fresco technique contributed to this project's failure. While proponents hoped to complement the high themes of these paintings with a classical medium, the wet climate of London quickly degraded the murals. Interest in these public commissions waned by the 1860s and, as Wood has remarked, "The Westminster Decorations, the most grandiose public commission of the Victorian era, came to an ignominious and disappointing end" (29). Although Britain would follow Continental Europe's lead in public art education and exhibitions, state or religious commissions for works of art were never much of a factor in the Victorian art world. In advocating such state-sponsored projects, the 1835–36 select committee was already out of step with the rise of middle-class patronage. It was thus unable to achieve one of its central goals: educating the public about traditional methods of painting.

Despite the eventual failure of the Westminster project, the interest in the arts sparked by the competitions surely encouraged at least some viewers to visit the other art venues that would proliferate during the Victorian period. What was true of the Westminster project was true more generally of the 1835–36 select committee's influence: though some of its projects failed or were hopelessly sexist and class based, the committee's advocacy of verbal mediation for visual art and creation of the schools of design created profound, long-term changes. Though currently faced with deep cuts, many government schools of design still exist in Great Britain. As the remaining chapters of this book should make clear, the art critical mediation encouraged by the committee permanently changed how art was interpreted by a growing public audience. Though many of these critical writings retained the class-based and sexist ideologies inherent in the 1835–36 hearings and Westminster competitions, they also encouraged a broader public to appreciate and understand art.

CHAPTER 2

⚜

"Mere outward appearances"?

TEACHING HOUSEHOLD TASTE
AND SOCIAL PERCEPTION IN
ELIZABETH GASKELL'S *NORTH AND SOUTH*
AND CONTEMPORARY ART COMMENTARY

*M*any twentieth-century readers have critiqued Elizabeth Gas-
kell's *North and South* (1854–55) for its apparent conventional-
ity. Raymond Williams complains that the novel follows a typical Victorian
pattern in solving class conflicts with money. Sally Shuttleworth argues
that the novel's ending "in the safe surroundings of a middle-class draw-
ing-room" (xxxiv) implies an ultimate avoidance of political problems.
While recognizing in *North and South* the importance of private life in the
public realm, Catherine Gallagher nevertheless concludes that the text's
families are ultimately separate "from the larger society" (148). As Deidre
d'Albertis, Hilary Schor, and other critics have more recently shown, such
readings assume that Gaskell was more interested in household details
than in political change.[1] For Susan Johnston, the critique of Gaskell as
primarily a domestic novelist relies on the erroneous idea that domestic and
public life were distinct in the nineteenth century. While some prominent
Victorian writers hoped to institute this separation, domestic and public
life were in fact intimately connected throughout the period. As a result,
claims Johnston, even "avowedly political fiction . . . [like *North and South*]
depends on the originary and intimate space of the household in order to
make its claims" (103). In ways that even recent criticism has only begun to

understand, Gaskell uses household details in her novels to effect profound political statements.

In tracing Gaskell's argument for political change through the domestic, this chapter examines *North and South* and some of Gaskell's other novels in the context of mid-Victorian writings on household taste. In doing so, I expand on a theme that I introduce in chapter 1: the notion that improving taste in the high arts, but also in the realm of everyday manufacture and design, would have profound economic and moral effects on the country. As my discussion of government hearings in chapter 1 demonstrates, conceptions of taste were always politically inflected, especially in issues involving working-class designers and middle-class consumers. Class conflicts in *North and South,* I assert in this chapter, are substantially addressed through the development of perceptive household taste by some middle-class characters. Though Gaskell treats problems of industrialization and the working class in all her novels, *North and South* is the only novel in which Gaskell demonstrates how a master can learn to confront social problems through sensitivity to the domestic. Patsy Stoneman perceptively notices that "*North and South* focuses on mill-owner rather than worker [as in *Mary Barton*] precisely because Elizabeth Gaskell has recognized the workers' impotence to control the terms of the class struggle" (83). While many studies of *North and South* focus solely on the heroine Margaret Hale, I follow Stoneman in considering the intertwined development of both Margaret and the mill owner, John Thornton.

An example will suggest the prominent way in which Gaskell symbolizes Thornton's evolving taste. At the novel's close, Thornton "draw[s] out his pocket-book, in which were treasured up some dead flowers" (436), and presents the dried roses to his lover, Margaret.[2] The roses may seem an unlikely indication of Gaskell's ability to think beyond the mere preservation of middle-class domestic spaces, a preservation that Shuttleworth and others view as the primary aim of the conclusion. The roses, however, indicate Thornton's newfound ability to see people in both his public and private life—especially Margaret and the mill hands—as more than mere stereotypes. At first, Thornton sees Margaret as primarily an aesthetic object, much as Margaret's first suitor, the superficial Henry Lennox, fetishizes Margaret by describing her "eyes so lustrous and yet so soft . . . lips so ripe and red" (415).[3] *North and South* states explicitly that Margaret is not comparable to a hothouse flower. In the second chapter, the narrator notes that "her mouth was wide; no rosebud that could only open just enough to let out a 'yes' and 'no,' and 'an't please you, sir'" (17). In chapter 16, Margaret remarks that she does not want to be "one of those poor sickly women who

likes to lie on rose leaves, and be fanned all day" (128). Indeed, Margaret's inherited money and her active care for workers as individuals make possible the plan for productive dialogue between masters and men at the end of the novel (Stoneman 79). Though Henry objectifies Margaret throughout the novel, Thornton begins to see her in more complex terms, appreciating her care for workers rather than evaluating her based solely on her appearances and gestures. The roses, then, symbolize this new complex understanding.

Just as Thornton once stereotyped Margaret, he first views workers in stereotypical terms. While showing sensitivity to Margaret and her family, he disregards the suffering of some workers as "but the natural punishment of dishonestly-enjoyed pleasure, at some former period of their lives" (85). In offering the roses to Margaret, Thornton shows his understanding of Margaret's more personal vision. After looking intently at the roses, Margaret remarks, "They are from Helstone, are they not? I know the deep indentations around the leaves" (436). Thornton's gesture indicates that he has learned to see in a similarly detailed way (though he does not yet articulate this understanding) and will no longer look at social problems from one point of view. What seems, then, a very private, even conservative, middle-class romantic gesture has in Gaskell's imagination a larger significance for English society. In her introduction to *Wives and Daughters,* Pam Morris notes that the recurring references to roses in that novel suggest that, in addition to masculine strength, "Englishness might also involve qualities that are fragile, sensitive, associated with love, beauty and poetry" (xxix). In *North and South,* I argue, the roses indicate Thornton's suitability for what Gaskell envisions as a kinder version of capitalism, led by captains of industry who possess perceptive taste both within and outside of the home.

The kind of household taste that Thornton develops became a national goal during the debates of the 1835–36 Select Committee on the State of Arts and Manufactures. While also concerned with the high arts, the hearings focused on the improvement of British manufactures. Witnesses argued that the current inadequacy was not a question of talent but one of learned skill. In order to elevate the tastes of the workers and the consumers who would buy their products, the committee advocated free public galleries and government-run art schools. These institutions would teach workers to create better-designed products and consumers to appreciate this craftsmanship. The consumer's freedom to select industrial products of high taste, the committee suggested, would demonstrate Britain's commitment to democracy.

While interested in training workers, the committee was far more concerned with educating middle-class consumers. Written some twenty years after the hearings, Gaskell's *North and South* would echo this emphasis on improved taste for the middle class. According to witnesses before the 1835–36 committee, the British consumer, like the British artist, already had a natural propensity for good taste. "I think we have instances of as much fine taste in this country as has been exhibited in any part of the globe," opined Charles Toplis, vice president of the London Mechanics' Institution (119). However, some witnesses testified that consumers had been misled by fashion, which favored inferior goods. J. C. Robertson, editor of *Mechanics' Magazine,* argued that French designs were popular in Britain because of "a vulgar taste for what is far-fetched and high-priced" (128). Robertson's charge would have an increasing resonance in the decades to come. As more of the middle class acquired products that had previously been restricted to the rich, commentators often labeled their tastes "vulgar" to differentiate them from those of the upper class. *North and South* betrays a similar anxiety about middle-class social climbers who superficially display what they wrongly assume is tasteful. According to early commentators, educating British consumers would provide the country's manufacturers with a more suitable market than that created by vulgar fashion. Yet this education never achieved its desired effect; commentators complained throughout the Victorian period that British taste, despite its natural potential, was in need of correction.

Following the committee's lead, Victorian art criticism regularly sought to help consumers make the right decisions about household goods. John Ruskin is now best known for his assessments of painting and architecture, but he also believed that such personal decisions as dress and home decoration were important to the strength of the British nation: "There is no national value, small or great," he asserts in "Traffic" (1864), "which is not manifestly expressed in *all the art* which circumstances enable the people possessing that virtue to produce" (*Works* 18: 437, emphasis mine). Ruskin and other writers posited a close connection between architecture and interior decoration. Owen Jones asserts in his highly influential *Grammar of Ornament* (1856) that the "Decorative Arts arise from, and should be properly attendant upon, Architecture" (5). Although Ruskin's "Traffic" takes architecture as its focus, the lecture provides one very significant example of household taste—consideration of the hypothetical gentleman who cannot spend money on the interior decorations recommended by Ruskin because he is engaged in a war with his neighbor. Ruskin suggests that the gentleman would be acting morally if, rather than waging war, he

spent money on wallpaper, fresco, and damask curtains (*Works* 18: 438–39). Considering Ruskin's frequent advocacy of friendly relations between Britain and France and a pacifist approach to other countries, it seems that a concern with interiors is at least a partial solution to what he saw as Britain's reliance on military solutions. Gaskell was thus not the only Victorian writer to attach political and national importance to household taste.

In Ruskin's hierarchical conception of society, the upper class was primarily responsible for modeling good taste, a view consistent with liberal notions of education inherited from John Locke and others. As we will see, Gaskell assigns this role to the middle class. Ruskin warns in "Modern Manufacture and Design" (1859) that the British upper-class desire for gaudy dress—a fashion motivated by the desire to display wealth—threatens the power structure more than any political clubs or agitators: "The wasteful and vain expenses at present indulged in by the upper classes are hastening the advance of republicanism more than any other element of modern change" (*Works* 16: 343). By example, the upper class has convinced the lower class to wear clothing that Ruskin faults for its "flimsiness and gaudiness" (343). The insubstantiality of these garments points to Ruskin's unease about the destabilizing effects of modern goods; thus, a question of taste becomes a spark for political revolution. While Ruskin sought throughout his career to democratize the high arts, he seems less certain here about the ramifications of equal access to household goods.

Other writers who focused on both architecture and household taste were similarly made uneasy by modern consumer society and so hoped to protect more traditional, class-based conceptions of taste. In *The True Principles of Pointed or Christian Architecture* (1841), A. W. Pugin writes that "cheap deceptions of magnificence encourage persons to assume a semblance of decoration far beyond either their means or their station, and it is to this cause we may assign all that mockery of splendour which pervades even the dwellings of the lower classes of society" (30). Pugin believed that homeowners should decorate according to their class. While arguing for greater access to such decorations than does Pugin, the architect Charles Eastlake (nephew of the more famous painter) sets certain limits in *A History of the Gothic Revival* (1872): "To drag Gothic down to the level of a cockney villa, to parody its characteristic features in plaster and cast iron . . . would be intolerable" (371–72). Eastlake's well-known *Hints on Household Taste in Furniture, Upholstery and Other Details* (1869) expresses a similar desire to preserve traditional class boundaries within the home. Like many other contemporary manuals on household goods, Eastlake's book teaches middle-class women to buy economical products in good

taste. Eastlake claims that his notions are based on "excellence which we might expect to be derived from common sense" (1), but they are in fact designed to distinguish his audience from the lower class. He remarks, for example, on a type of bedcover: "From an artistic point of view the counterpanes now manufactured for servants' bed-rooms . . . are very suggestive in colour, but I fear that any approach to this style of coverlid would be regarded as objectionable in the 'best' bed-rooms" (190). For Eastlake, anything associated with the lower class cannot ultimately be in good taste.

Thus far, the story I have been telling about Victorian household goods seems to confirm the usual assumption that taste and class were closely linked. Judith Flanders representatively remarks in *Inside the Victorian Home* that "the greatest good [in decorating one's home] was knowing one's place and living up to it precisely" (170). But some influential critics, and particularly women writers, were more flexible. Lady Mary Anne Barker, who wrote a series of well-known books on household taste, was much influenced by Eastlake and other earlier critics. Barker, however, is much less rigid in her conception of the relationship between class and taste than are the male writers I discuss previously. While these critics complain about cheap products made to look expensive, Barker would rather have her readers display good taste than admit their lack of money. "This is a humble arrangement," she writes of simple drapes for the bathroom in her 1878 *Bedroom and Boudoir,* "but it can be made as effective as if it cost pounds instead of pence. And this is one of the strong points in all hints on decoration, that they should be of so elastic a nature as to be capable of expansion under favourable circumstances, though not beyond the reach of extremely slender resources" (78–79). Here, Barker sounds more like Gaskell's narrator in *Cranford* (as I discuss shortly) than a critic worried about the blurring of class lines.

Barker also differs from male critics by claiming a distinct role for women in domestic taste. This assumption was challenged in the Victorian period; in *Hints on Household Taste,* Eastlake argues that women have no such special qualifications. But Barker complains of rooms that mimic the seventeenth century: "You scarcely ever feel as if any one lived in them— there are seldom any signs of occupation, especially feminine occupation" (92). Emilia Dilke, a well-known expert on French art history, similarly argued for the creative importance of women. "The refinements wrought into these pleasures," she writes of domestic decoration in *The Renaissance of Art in France* (1879), "as well as into every other art of life, were enhanced by the presence of women at the Court" (26). Contemporary reviewers belittled Dilke's "womanly" focus on upholstery (Fraser, "Women" 82), but

hers was a strategy to write women back into the history of art. Gaskell's aims are similar in *North and South:* Margaret's influence on Thornton's taste turns out to have profound political significance, allowing him to see Margaret and his workers in less reductive ways.

Like her comments on women's aesthetic perception in home decoration, Barker's attitude toward the supposedly strict correlation between class and household cleanliness challenged conventional wisdom. In *Hints on Household Taste,* Eastlake claims that avoiding draperies "saves something in the weekly washing bill" (192) and thus allows middle-class homemakers to differentiate themselves from the lower class through superior cleanliness. Barker, too, argues for the importance of buying products that are easy to clean. But Barker is less interested than Eastlake in making sure that her middle-class audience acts middle class (and not like the rich or the dirty poor) than she is in suggesting ways that those with limited means can have homes as clean as the rich. To be sure, says Barker, upper-class homes are clean because they employ the kind of servants—"strong-armed old-fashioned housemaids"—who "had been taught how to wipe dust off and carry it bodily away" (5–6). However, even without such an army, the middle-class homemaker can have a house just as clean by adhering to Barker's advice.

While it is difficult to determine how much contemporary writing on household taste Gaskell read, she was very familiar with Ruskin's art criticism. In her letters, Gaskell eagerly anticipates his lectures and classes. She certainly read *The Seven Lamps of Architecture* and was acquainted with *The Stones of Venice* (Chapple and Pollard 161). She corresponded with Ruskin regarding artistic matters, thanking him in 1865 for his approval of *Cranford* and writing in the same year to ask for his help on behalf of an architect, Alfred Waterhouse, who had been excluded from a list of finalists to design the new law courts in London (Chapple and Pollard 742, 747). In her own domestic life, Gaskell was preoccupied with how household goods indicated class. Her letter to Charles Eliot Norton in 1859 betrays a concern with the fashion of her own home:

> Yes! we have got our drawing-room chairs & sofas covered with new chintz. Such a pretty ones [*sic*], with little rosebuds & carnations on the white ground. . . . but you'll be happy to hear we are not rich enough to make many or grand changes. Indeed I don't think I should like to do it, even if one could. The house is to be painted and papered (passages & bedrooms) in May, but we shall rather adhere to the old colours. (Chapple and Pollard 536)

Gaskell here seems to follow her stricture in *Cranford* and *North and South* that the middle class can have nice possessions if they are not too showy. But she also envied the fancier household goods of Charles Dickens, which indicated to her his financial success as an author. Writing to Emily Tagart in 1851, Gaskell verifies a rumor about "the splendour of Mr[.] Dickens' house" by noting that a friend who dined with him "writes me word that the Dickens [*sic*] have brought a dinner-service of *gold* plate" (Chapple and Pollard 175). Gaskell was well aware of the extent to which her own books could increase her purchasing power, and at times evaluated their worth in terms of her effort and the works' potential popularity. She argued, for example, that *The Life of Charlotte Brontë* should earn her more than the six hundred pounds she received for *North and South* because "the amount of labour bestowed on that Biography, (to say nothing of anxiety in various ways,) has been more than double at least what the novel cost me; and I think that the Biography is likely to interest a wider class of readers, and to be in more permanent demand" (Chapple and Pollard 430). Notably, Gaskell omits any discussion here of intrinsic literary merit. Though her novels express anxiety about the spending power of the professional middle class, her own letters demonstrate a degree of acquisitiveness following her growing success as an author.

However, Gaskell is more flexible than some contemporary male writers in sometimes allowing her lower- and middle-class homeowners to mimic those in higher positions. *Cranford* (1853) shows the possibility of class mobility for the lower middle classes through proper "etiquette practices" (Langland, *Nobody's Angels* 130). One of Gaskell's central goals in *Cranford,* notes Jenny Uglow, is to argue against social status as an indicator of a person's character (285). Gaskell often effects such arguments by focusing on the small details that many critics have dismissed as insignificant: "The technique of juxtaposing the profound to the everyday is brilliantly employed in *Cranford,* both to puncture pretension and to reconcile comic surface with emotional depth" (Uglow 289). To take a well-known example, the Cranford women hide their "very moderate means" by practicing what the narrator calls "elegant economy," embodied in such social rules as not serving elaborate food to guests (*Cranford* 3–4). The phrase "elegant economy" demonstrates Gaskell's knowledge of household books, as Eliza Acton's well-known *Modern Cookery* (1845) contains a recipe for "The Elegant Economist's Pudding" (C. Mitchell 181). For Cranford residents, "Economy was always 'elegant' and money-spending always 'vulgar and ostentatious'" (4). Gaskell's affection for these practices indicates that she would have sympathized with Barker's adaptable hints. Admitting one's

limited means—as more rigid household taste manuals urged their readers to do—is viewed as vulgar in Cranford. Captain Brown offends the women of Cranford by doing so, though even violating this rule does not preclude Brown from Cranford society; he is later "respected" and "his opinions [are] quoted as authority" (4).

Gaskell's first novel, *Mary Barton: A Tale of Manchester Life* (1848), is likewise more flexible than most contemporary manuals in linking class and taste. Among Gaskell's novels, *Mary Barton* stands out for its focus on the lower class. The novel does, however, feature one prominent example of middle-class taste. The mill owner, Mr. Carson, shows the kind of refinement that Thornton develops in *North and South:* "In addition to lavish expenditure, there was much taste shown, and many articles chosen for their beauty and elegance adorned his rooms" (*Mary Barton* 75). But, unlike Thornton, Mr. Carson is not positioned by Gaskell to solve social problems. The murder of Carson's son Henry demonstrates Gaskell's focus on class antagonism itself in *Mary Barton* rather than the possibility of philanthropy by cultured mill owners.

While *North and South* posits the middle class as the best hope for alleviating social problems, *Mary Barton* suggests that less fortunate laborers can be helped by other working-class families. Gaskell's descriptions of interior spaces indicate that the Bartons and Wilsons are able to provide assistance and that the Davenports are clearly in need of it. The Davenport family is unable to separate dirt from their below-ground living space. At street level, "women from their doors tossed household slops of *every* description into the gutter; they ran into the next pool, which over-flowed and stagnated" (66). Visitors to the Davenport home "went down one step even from the foul area into the cellar in which a family of human beings lived" amid a "fetid" smell (66). The sewage from above easily infects the Davenport's cellar, causing disease and symbolizing their low state.

By contrast, the Barton home is described as a clean, pleasant place for visitors: "Check curtains . . . shut in the friends [who] met [in the house] to enjoy themselves" (13). Gaskell separates dirt in the Barton home from these living spaces; behind a door there is a "little back kitchen, where dirty work, such as washing up dishes, might be done" (13). Another door hides the "coal-hole" (13). In contrast to the sparsely decorated and dirty working-class homes in *North and South,* the Bartons' furniture and knick-knacks attest to their relative comfort. For Uglow, "The minute description of this [the Bartons'] room, seen through Mrs. Barton's proud eyes, displays the harmony that will be lost" (196). Uglow reads such domestic interiors as supporting a central theme in the novel: that rich and poor families "were

not so different" in spite of the pressures of industrialization (194). Yet the decorations seem nevertheless to distinguish this poor family from those above them and thus support a familiar narrative about the relationship between taste and class. Although the furniture appears luxurious, the narrator tells us that one table is made of "humble material" and that a tea tray is "japanned," or made to look like Japanese lacquer (Wright 477). Like Barker, the narrator seems to approve of interior spaces that look somewhat nicer than they really are. But Gaskell, through her use of such words as "japanned" and "humble," is careful to remind readers that these are people of limited means. Further, we are told that the room is charming in a naïve way: "The fire-light danced merrily on [the japanned tea-tray] and really (setting all taste but that of a child's aside) it gave a richness of colouring to that side of the room" (13). As sympathetic as she is to the Bartons, especially in their willingness to help others, Gaskell reinforces contemporary liberal ideology by patronizing their tastes.

Like the Barton home, Alice Wilson's cellar is "the perfection of cleanliness" (15), but is clearly set apart (as are its inhabitants) from what higher classes might enjoy. The Wilsons have protected their cellar from the filth and other dangers of the street above: "As the cellar window looked into an area in the street, down which boys might throw stones, it was protected by an outside shutter" (15). Still, we are reminded—as in the description of the Barton home—of the humbleness of the Wilsons' interior. Alice's bed is "modest-looking" (there is only one check curtain where there should be two) and the floor is always damp. The narrator also seems to confirm a stereotype about some poor women's superstitious, almost witch-like use of "field plants, which we are accustomed to call valueless, but which have a powerful effect either for good or for evil, and are consequently much used among the poor" (15). These plants "oddly festooned" (15) Alice Wilson's cellar window. The use of flora to decorate middle- and upper-class homes was depicted quite differently by Gaskell and other mid-Victorian commentators on household taste.

As my references to *Mary Barton* and *Cranford* should make clear, *North and South* is not unique in ascribing social importance to taste. While *Mary Barton* employs household cleanliness to differentiate among members of the working class, other novels critique those in the middle class who are obsessed with household goods. We will see this dynamic in *North and South,* but it is equally evident in Gaskell's last novel, *Wives and Daughters* (1866). For Susan Johnston, there are no "trifles" in *Wives and Daughters* but rather household goods that carry real political significance (Johnston 95; qtd. in Stoneman 156–57). To take one prominent example,

Hyacinth (Clare) Kirkpatrick's pervasive attention to household decorations indicates her superficiality, which is not insignificant to the novel as a whole: Clare's "mistaken adherence to fortune and rank as the ends of life, rather than to the cultivation of those mental qualities wealth and status may afford, functions in the novel as a danger to the community" (Johnston 95; qtd. in Stoneman 156–57).[4] Early in the novel, when Clare is still a schoolteacher, Gaskell's narrator is sympathetic to her desire for more lavish surroundings, much as the narrator of *Cranford* presents the wishes of the townswomen in a positive light. Visiting the "Towers" house at the invitation of Lady Cumnor, Clare wonders, "One would think it was an easy thing to deck a looking-glass like that with muslin and pink ribbons; and yet how hard it is to keep up!. . . . It is so difficult to earn money to renew them; and when one has got the money one hasn't the heart to spend it all at once" (97). Through Clare's reference to the generic "one," Gaskell invites readers to identify with Clare. But once Clare becomes Mrs. Gibson after marrying the prominent village doctor, her all-consuming interest in household goods becomes evident. In order to keep up appearances, Clare redecorates her new stepdaughter's room despite Molly Gibson's protestations that she wants no such thing (214). Perhaps most tellingly, Clare "buys new dresses for show," but fails to update her small and worn collection of underwear (Uglow 592). By contrast, Molly learns a simplicity of taste that correlates with her greater acceptance of the poor. Gaskell suggests in all her novels that the development of one's own style—rather than following mere fashion—is an indicator of a character's growing ability to effect political change.[5] As I will demonstrate in later chapters, this emphasis on individual perception would become even more prominent towards the end of the century.

In its depiction of the interactions between the traditional upper class (the Cumnors) and an emergent professional class (the respected doctor, Mr. Gibson), *Wives and Daughters* examines some of the same issues regarding household taste found in Gaskell's earlier novels. However, taste in *Wives and Daughters* does not function to alleviate class struggles between masters and workers as it does in *North and South*. Mr. Gibson seems uninterested in household decorations and does not concern himself much with class problems. The professional men of science in *Wives and Daughters,* Mr. Gibson and Roger Hamley, often make the wrong decisions, as Pam Morris notes in her introduction to the Penguin Classics edition of the novel (xi). Morris convincingly argues that *Wives and Daughters* addresses issues larger than the local class struggles that occupy Gaskell's previous novels. These more global issues in *Wives and Daughters* include the interrelations

between Darwinism and imperialism: "In her earlier social-problem novels Gaskell could only offer the solution of individual reconciliation for class divisions; the myth of racial history developed in the 1860s allows her to construct a narrative that looks forward to an enlightened national unity in the guise of evolutionary progress" (xxv). Though Gaskell's thinking may have changed by the time she penned her last novel, she clearly viewed the intervention by cultured middle-class individuals as a primary solution in her earlier works.

Despite this attention to taste in *North and South,* Gaskell does not simply follow popular midcentury guidance. Significantly, she seems ambivalent about the moral importance of good architecture, an idea that was much in vogue in the 1850s and that was reflected in the writings on household taste that I discuss previously. Responding to Mr. Bell's sarcastic question about whether Milton can serve as a model of good architecture, Thornton says, "We've been too busy to attend to mere outward appearances" (334). In light of the novel's interest in aesthetic perception, Thornton's position is certainly reductive. Indeed, Mr. Hale responds to Thornton in Ruskinian fashion: "Don't say *mere* outward appearances. . . . They impress us all, from childhood upward—every day of our life" (334). Hale, however, fails to convince Thornton; he expresses his opinion "gently" (334), without explaining why architecture is significant—a surprising silence from an author who so admired Ruskin's lectures on the subject. Earlier in the novel, we learn that Hale is equally incapable of convincing workers of the moral importance of good architecture; the lesson that he plans on ecclesiastical buildings is "rather more in accordance with his own taste and knowledge" (141) than the interests of his working-class audience. Unlike Ruskin, Gaskell shows that architecture appeals only to already cultured individuals, not to masters and men.

Learning about other forms of culture is, however, presented as important for the middle class. For all the novel's objections to the superficial uses of visual art, Gaskell suggests an important role for the exhibition of well-used books, which was reflected in contemporary discourse on household taste. As Mary Anne Barker advised her middle-class readers, "To my mind books are always the best ornaments in any room, and I never feel at home in any place until my beloved and often shabby old friends are unpacked and ranged in their recess" (89). Barker's description of her books as "shabby" hints at her learning; she both displays and reads them. "'Reading,'" notes Uglow, "in all senses is a clue to the argument of Gaskell's later works—*Sylvia's Lovers, Cousin Phillis,* and *Wives and Daughters*" (590). Literature provides similar insights into the characters of *North and*

South. Most important, the well-used literary works indicate their owners' depth. The Hales' home at Helstone might want the newest fashions, but the family's books indicate their cultured status. Upon first visiting Helstone, Henry Lennox picks up Dante's *Paradiso,* which just happens to be lying on a table in the drawing room. Next to *Paradiso* is a dictionary from which Margaret has copied words. Not surprisingly, the superficial Henry sees these as "a dull list of words" (23). But the words indicate Margaret's active engagement with, not mere show of, books. Similarly, in the Hales' new drawing room in the manufacturing town of Milton, "books, not cared for on account of their binding solely, lay on one table, as if recently put down" (79). In contrast to the Hales' bookish interiors, the Thorntons' dining room contains, except for the Bible, "not a book about the room" (76)— an absence that the novel equates with a lack of understanding. Mrs. Hale's dislike of books, for example, is connected with her failure to empathize with her husband. Mrs. Thornton's overly practical household arrangement is counteracted by her son's willingness to learn about classical literature from his tutor, Mr. Hale, a project of acculturation that further divorces him from the purely commercial stereotype of the businessman and that points to his worthiness as both a mate for Margaret and a Carlylean captain of industry.

While some forms of high culture hold obvious significance in *North and South,* household taste is Gaskell's primary way of differentiating between those who have the perception to solve social problems and those who do not. Gaskell often, but not always, connects household taste with class in this novel. Criticisms of *Mary Barton* as too allied with working-class interests may have influenced Gaskell's somewhat more stringent differentiation of classes—primarily through the binary of dirt and cleanliness—in *North and South.* Middle-class homes are invariably clean in this novel. Writing in *The Victorians and the Visual Imagination,* Kate Flint notices that Mrs. Thornton uses "dust-sheets" to protect her furniture from the Milton air (45). Moreover, following mid-Victorian advice about cleanliness, Mrs. Thornton criticizes the Hales for a drawing room "altogether full of knick-knacks, which must take a long time to dust; and time to people of limited income was money" (96). However, though the Hales' decorations might require more work, there is no indication that their house is anything but clean.

By contrast, dirt seems inescapable for the working class. Flint writes that Mrs. Thornton's "pragmatic middle-class angst [about dust] is put into perspective by Bessy Higgins telling of the conditions in the mill, where the air is full of bits of fluff, "'as fly off fro' the cotton, when they're card-

ing it, and fill the air till it looks all fine white dust. They say it winds round the lungs, and tightens them up'" (45). Bessy's sickness causes Margaret to realize the plight of industrial workers (Uglow 372). But factory dirt was also closely connected to unclean homes: contemporaries argued that working-class women like Bessy neglected their domestic duties while working in factories (Shuttleworth xxv). Indeed, the Higginses' home is dirty when Margaret visits, despite the attempts of Mary Higgins—Bessy's "slatternly younger sister" (99)—to clean it. Margaret does not realize that Mary has tried to clean the house with "rough-stoning" and has also built a fire "as a sign of hospitable welcome," a fire not needed because of the heat of the day (99). *North and South* shows that, despite such efforts, lower-class homemakers do not have the means or taste to keep clean homes and welcome guests with appropriate gestures. Thus, while sympathizing with factory-induced disease, the novel differentiates the dusty working-class home from the washed middle-class interior. *North and South*'s binary of dirt and cleanliness reflects a pervasive Victorian discourse that was used to marginalize the lower class. "Dirt," writes Mary Douglas, "is never a unique, isolated event. Where there is dirt there is a system. Dirt is the by-product of a systemic ordering and classification of matter, in so far as ordering involves rejecting inappropriate elements" (qtd. in Flint 46).[6] As discussions about the working class visiting art galleries and museums make clear, dirt was frequently associated with the "low," even as proper taste was viewed as morally uplifting.

Despite her more stringent association of dirt with the lower-class home in *North and South,* Gaskell does not always correlate characters' taste with their class. Though coming from somewhat humble origins, John Thornton exhibits both good taste and a relative indifference to household goods, characteristics that mark him as suitable for a higher-class position. His mother, by contrast, is obsessed with household goods. Mrs. Thornton may follow contemporary household manuals in criticizing the Hales' knick-knacks, but Gaskell associates the Hales with good taste. The Hales—recently reduced in class stature—appreciate nature, high culture, and household goods that are in good taste. Gaskell's distinctions among these middle-class characters cannot simply be reduced to a traditional/nouveau-riche binary, as some readers have claimed.[7] As the often-washed curtains and chair covers that they move from Helstone to Milton indicate, the Hales lack the money to decorate a home according to most contemporary guidance. The differences between John Thornton and his mother further demonstrate that characters in one class—here the nouveau riche—do not necessarily share the same tastes.

Gaskell's contrast between those characters with perceptive taste and those who focus on mere appearances is tellingly played out in the drawing rooms of *North and South*. Johnston usefully remarks that the drawing room—as "the locus of both household intimacy and the household's negotiations with outsiders" (129)—is central to Gaskell's claim that the household and the outer world were closely connected, not separate spheres.[8] Mrs. Thornton's drawing room serves to create surface appearances, something noticed by both outside visitors and her own son. Upon visiting the Thorntons' drawing room, Margaret observes, "Wherever she looked there was . . . not care and labour to procure ease, to help on habits of tranquil home employment; [but] solely to ornament, and then to preserve ornament from dirt or destruction" (112). Margaret's perspective on the ideal drawing room as conducive to "tranquil home employment" suggests its role as mediator between outside and inside: far from being isolated from the world of work, this domestic space requires and allows real "labour," albeit in a comfortable setting. Thornton realizes that his mother's drawing room is "twice—twenty times as fine" as the same room in the Hales' modest Milton home but "not one quarter as comfortable. Here [in the Hales' Milton drawing room] were no mirrors, not even a scrap of glass to reflect the light, and answer the same purpose as water in a landscape painting; no gilding; a warm, sober breadth of colouring, well relieved by the dear old Helstone chintz curtains and chair covers" (78–79). Similar to their use of knickknacks, the Hales' neglect of the mirrors commonly used in decorating upper-class homes and associated with popular (especially after Ruskin's *Modern Painters*) landscape paintings violates contemporary manuals on household taste. But, despite her adherence to contemporary household advice, Mrs. Thornton's use of mirrors is superficial, "a picture intended to be gazed upon and not lived in" (Johnston 130). Moreover, the mirrors provide insight into Mrs. Thornton's character by reflecting her "false front"—her presentation of a self much more confident than she really is (Uglow 376). The Hales instead display their actual origins to outsiders while also providing comfort, decorating their Milton drawing room with their "homey" Helstone curtains and chair covers.

Like Mrs. Thornton, Henry Lennox is too practical in his view of domestic decoration. In the novel's critique of Henry, Gaskell seems to depart from the 1835–36 select committee's view of design as important for primarily economic reasons. Though the narrator notes in chapter 1 that Henry has tastes similar to those of Margaret—"he liked and disliked pretty nearly the same things she did" (10)—his superficial appraisal of household goods indicates his ultimate incompatibility with her. In this

instance, Gaskell seems to depart from Ruskin's famous stricture in "Traffic" that "taste . . . is the ONLY morality" (*Works* 18: 434). Though they like "the same things" (10), Henry and Margaret have very different values. Tellingly, Henry focuses on the monetary value of the Hales' drawing room at Helstone rather than on its natural beauty—the attribute that Margaret most loves. Henry observes that "the carpet was far from new; the chintz had been often washed; the whole apartment was smaller and shabbier than he had expected, as back-ground and frame-work for Margaret, herself so queenly" (23). Though Margaret had earlier acknowledged her home's modest furnishings to Henry, he nevertheless expects more from a woman with a "good family" (23). Henry believes that he can provide a better "frame" (23) for a woman whom he envisions as an aesthetic object. Henry's later hope of winning Margaret when she gains her fortune suggests that he is motivated by superficial concerns: "He was fully aware of the rise which it would immediately enable him, the poor barrister to take. . . . He had seen that much additional value was yearly accruing to the lands and tenements which she owned in that prosperous and increasing town [Milton]" (415). Henry, a member of an ascending profession, obsesses about overt displays of wealth and raising his class stature—attributes that would have led many contemporaries to call him "vulgar." In *Modern Painters,* Volume 5, Ruskin representatively defines vulgarity as "an undue regard to appearances and manners . . . by persons in inferior stations of life" (*Works* 7: 353–54). Gaskell too seems preoccupied with this class-based conception of vulgarity, which was a pervasive concern in discussions about taste.

The tag of "vulgarity" would surely apply to the new family that moves into the Helstone vicarage after Mr. Hale resigns his position. The narrator mocks this family for "spending an immense deal of money" with little taste or judgment (393). As Margaret and Mr. Bell tour Margaret's old home, Bell sarcastically compliments what Mrs. Hepworth, the new vicar's wife, refers to as "improvements" (392–93). The narrator wryly comments that the new family is "not troubled with much delicacy of perception," and so Mrs. Hepworth fails to realize that "Mr. Bell was playing upon her, in the admiration he thought fit to express for everything that especially grated on his taste" (393). Though Mr. Bell's views are not always endorsed by the novel, his tastes here are clearly superior to those of Mrs. Hepworth. In addition to explaining her obliviousness to Bell's sarcasm, the family's perceptive shortcoming also applies to Mrs. Hepworth's household taste and larger domestic management.

Thornton sets himself apart from what Catherine Gallagher calls the "prefabricated association between trade and vulgarity" (182) by his selfless

and perceptive appraisal of household decoration. Unlike Mrs. Hepworth, Henry, or his mother, Thornton is not a middle-class social climber intent on displaying his own wealth. He convinces the Hales' Milton landlord to change the wallpaper after hearing Mr. Hale's complaint.[9] Despite his occupation as mill owner, Thornton had already recognized "a certain vulgarity" (62) in the house that seems improper for Margaret once he meets her. Thornton never tells the Hales that the change was his decision and so never receives credit for his beneficence. By emphasizing Thornton's good taste through this selfless action, Gaskell shows that he has the potential, even early in the novel, to be more than a typical master. Margaret herself associates the wallpaper with "vulgarity and commonness" (65)—the same terms she connects with tradesmen. Margaret perceives Thornton's difference from this stereotype: "With such an expression of resolution or power, no face, however plain in feature, could be either vulgar or common" (64–65). Still, seemingly influenced by the contemporary belief in physiognomy as well as by Thornton's occupation, Margaret terms Thornton "not quite a gentleman," noting that his face "is neither exactly plain, nor yet handsome, nothing remarkable" (64). She further stereotypes him based on physical appearances and occupation in remarking, "I should not like to have to bargain with him; he looks very inflexible. Altogether a man who seems made for his niche, . . . sagacious, and strong, as becomes a great tradesman" (65). A central part of Margaret's character development is her growing appreciation of Thornton's strengths as an individual, rather than simply as a quality specimen of his profession. Her perceptiveness allows her to examine and reexamine Thornton and eventually to see him in less stereotypical terms.

Thornton's good taste in changing the wallpaper points to his compatibility with Margaret but also underscores a problem early in the novel. Like Henry Lennox, Thornton views Margaret as an aesthetic object. He thinks the Milton house unsuitable for Margaret after seeing "her superb ways of moving and looking" (62). Despite Thornton's attraction to Margaret's beauty, he is subsequently repulsed by a physical gesture—her unwillingness to shake hands with him, which he attributes to her pride: "'Even her great beauty is blotted out of one's memory by her scornful ways'" (86). Thornton's equation of physical beauty and proper gesture further demonstrates that he views Margaret in aesthetic terms. Just as household decorations could supposedly be read to identify the purchaser's values, manners were (and still are) equated with one's inner character. Margaret has failed to conform to the code of manners associated with her new industrial home, a code that purports to represent acknowledgment between

equals.[10] As Terry Eagleton has argued, the Shaftesburian combination of ethical conduct and aesthetics "is most evident in the concept of manners. . . . that meticulous disciplining of the body which converts morality to style, deconstructing the opposition between the proper and the pleasurable. . . . Like the work of art, the human subject introjects the codes which govern it as the very source of its free autonomy" (41). Margaret has not yet learned to view such physical contact—a gesture that seems natural to Thornton—as pleasurable. But Thornton sees her failure to shake hands as an aesthetic shortcoming, an indication of her pride or lack of manners. A central barrier to their relationship is thus a misunderstanding about two different, class-based aesthetic perspectives: the democratic equality signified by Thornton's handshake and the feudal, hierarchical model of Margaret's parting bows. Thornton's presentation of the Helstone roses at the end of the novel indicates the increased aesthetic understanding between the two.

Most important, the roses indicate the status accorded in Gaskell's novels to nature, which was central to conceptions of household taste in the mid-Victorian period. As John Steegman notes, the ideal was to bring garden and interior into an "intimacy" with one another through the introduction of cut flowers, "by the use of french-windows and verandas[,] . . . [and] by so designing the garden that all its qualities were immediately visible from indoors" (316). Lady Cumnor's room in *Wives and Daughters* features "freshly gathered roses of every shade and colour" and chairs "covered with French chintz that mimicked the real flowers in the garden below" (97). As is evident from *Wives and Daughters,* which represents England before the Reform Bill of 1832, this careful relationship was influenced by older, aristocratic notions of gardens and was most often realized in upper-class homes. But some commentators—and especially women writers—sought to show middle-class readers that an intimacy with nature was also possible for those with more limited means. The art historian Anna Jameson begins her 1829 article on Althorpe and its art gallery by describing the mansion's somewhat modest family and natural environment: "It has altogether a look of compactness and comfort, *without pretension,* which, with the pastoral beauty of the landscape, and *low situation,* recall the ancient vocation of the family, whose grandeur was first founded . . . on the multitude of flocks and herds" (81, emphases mine). Writing later in the century, Barker extends Jameson's suggestion that such a home is in reach of the middle class: because of the availability of floral decorations and the beautiful views outside the windows, "in the country it is every one's own fault if they have not a lovely bedroom" (11). For Barker, all decorations in good

taste "should be in harmony with even the view from the windows" (13). "I
know a rural bedroom," she writes approvingly, "with a paper represent-
ing a trellis and Noisette roses climbing over it . . . and outside the window
a spreading bush of the same dear old-fashioned rose blooms three parts
of the year" (11). Of course, Barker's homeowners, like Jameson's, have at
least the money to possess and fashionably decorate a country home; her
advice would not be practicable for the lower classes.

As these commentaries make clear, nature itself is at least as important
as any household goods. Similarly, Gaskell's foregrounding of nature in her
novels indicates her distrust of the commercialization of art and the spend-
ing power of the new middle class. In *North and South,* roses and other
flora brought into the house, the countryside itself, and even household
landscapes are more significant than purchased commodities. Thornton's
changing of the wallpaper, along with the chintz brought from Helstone,
helps the Hales settle into Milton, but it is not enough to make them fully
comfortable: "It needed the pretty light papering of the rooms to reconcile
them to Milton. It needed more—more that could not be had" (65). Gaskell
avoids reducing the problems of displacement to mere proper decoration.
The Hales could, of course, use more money to adorn their new home, but
the narrator's "more that could not be had" (65) suggests the need for less
concrete goods as well.

Nature brought into their Milton home is one way that the Hales miti-
gate the smoky city that so depresses them upon their move. A china vase in
the drawing room contains "wreaths of English ivy, pale-green birch, and
copper-coloured beech-leaves" (79). This use of nature provides the color
lacking in Mrs. Thornton's drawing room. Moreover, the colors are not
the artificial ones of the roses in the Milton wallpaper, about which Mar-
garet complains, "Pink and blue roses, with yellow leaves!" (65). Toward
the end of the century, writers including Oscar Wilde and James Whistler
would claim that artists could creatively improve on nature. Here, follow-
ing Ruskin's earlier strictures, Gaskell criticizes the false representation of
nature, especially when commodified as a tasteless decoration, while posit-
ing truth to nature as a kind of national virtue. The ivy in the Hales' Milton
drawing room, like the roses with which Gaskell ends her novel, suggests
the national significance of tasteful, natural home decoration. The ivy is
not generic but specifically English. In addition, by representing the Hales'
ability to decorate even their Milton home with nature, Gaskell hopes to
show the possible connections between the English countryside and the
city, and between the English north and south.[11] Above all, the Hales' coun-
try home at Helstone was intimate with a cared-for landscape: "The mid-

dle window in the bow was opened, and clustering roses and the scarlet honeysuckle came peeping round the corner; the small lawn was gorgeous with verbenas and geraniums of all bright colors" (23). The Hales lack this kind of lawn in the city of Milton, but they are still able to include nature in their home decoration and thus provide a link with their old home in the southern English countryside.

A certain mark of superficial characters in *North and South* is their inability to perceive the importance of nature. The new family at the Helstone vicarage, in its zeal to build up the house, has neglected these natural surroundings. The children's playthings have caused "the destruction of a long beautiful tender branch laden with [roses], which in former days [that is, when the Hales lived there] would have been trained up tenderly, as if beloved" (392). This mismanagement of nature is linked to Mrs. Hepworth's faults as a mother; her failure to train the branch of flowers suggests that she has violated the popular Victorian adage of child rearing: "Train up a child" (Holy Bible, Revised Standard Version, Prov. 22:6). For Stoneman, the "care of children is Elizabeth Gaskell's crucial test of moral values; . . . it takes precedence over all other responsibilities" (33). In her emphasis on material possessions, Mrs. Hepworth fails this test; she is building a nursery but seemingly to emphasize her husband's ability to spend money rather than for her children's care. Indeed, Mrs. Hepworth's many children seem, like their playthings, to be strewn about the vicarage.

While Mrs. Hepworth ignores nature, Henry appreciates it in a trite way. He notices the flowers outside Margaret's Helstone window but then rapidly moves to appraising the monetary worth of the interior as insufficient for either Margaret's queenly appearance or her family's origins. Detailing Helstone before Henry's visit, Margaret warns him, "I am not making a picture. I am trying to describe Helstone as it really is" (12). Nevertheless, upon arrival, Henry describes a fixed landscape painting: "Such crimson and amber foliage, so perfectly motionless" (28). In her reading of this scene, Johnston claims that Margaret and Henry are alike in their tendency to romanticize Helstone (108). But Johnston omits Margaret's quick response to Henry's description: "You must please to remember that our skies are not always as deep blue as they are now" (28). Gaskell clearly intends Margaret to be more perceptive than Henry—to be less focused on mere appearances. Henry's pat phrases about art and nature point to a larger problem in art appreciation: the topic had become very fashionable by midcentury, particularly after Ruskin's discussion of landscape in the first volume of *Modern Painters* (1843). To be sure, Henry is more perceptive than most of his family and friends, though he lacks the deeper vision

of Thornton. Margaret complains that most of the Lennoxes and their din-
ner guests "talked about art in a merely sensuous way, dwelling on outside
effects, instead of allowing themselves to learn what it has to teach. . . . They
squandered their capabilities of appreciation into a mere flow of appropri-
ate words" (407). As I discuss in chapter 7, this worry about facile sensuality
would become even more pronounced as critics encountered impressionist
art. While later critics confronted this problem by emphasizing the diffi-
culty of great art, Gaskell hopes her reader will, in Ruskinian fashion, see
the truths nature has to offer rather than displaying a veneer of fashionable
culture.

Unlike Henry and his family—who employ a "mere flow of appropri-
ate words" (407) in discussing art and nature—Margaret and Thornton
use the English countryside as a solitary place to reflect on their feelings
for each other. Margaret walks in the country in an attempt to forget her
mortifying talk with Mrs. Thornton, who accuses her of public impropri-
ety for being out alone with a man late at night (Mrs. Thornton does not
know that the man is Margaret's brother, Frederick). Though Margaret
cares little for Mrs. Thornton's opinion, she constantly thinks about John
Thornton's estimation during this journey in the countryside. This reflec-
tion helps her realize how much Thornton means to her. Similarly, Thorn-
ton's walk in the country helps "relieve" (208) his mind in a way that reveals
his own feelings about Margaret. He walks in an effort to forget Margaret
after she rejects him. But the journey only reinforces his "vivid conviction
that there never was, never could be, anyone like Margaret" (208). For Gas-
kell, both art and nature have something to teach that will be lost for those
who simply talk without experiencing them.

Thornton and Margaret's closing remarks about the Helstone roses,
like their earlier solitary walks in the countryside, suggest the importance
of memory and the discovery of personal identity in the novel. Margaret's
gradual realization that Thornton is more than a tradesman is intimately
connected with her understanding of his personal history—his humble
beginnings and subsequent rise to a famous master. Thornton's gift of the
roses shows that he, unlike Henry, sought to understand Margaret's iden-
tity through her connection with Helstone, a place she consistently recalls
throughout the novel despite her father's attempts to forget it. Thornton
tells Margaret that he visited Helstone because he "wanted to see the place
where Margaret grew to what she is, even at the worst time of all, when I
had no hope of ever calling her mine" (436). Thornton remembers what
Margaret had said earlier about her origins and seeks to discover them for
himself. When Margaret and Thornton come together at the end of the

novel, it is in the context of their collective memories about their embrace during the riot, memories both delicious and embarrassing to both of them. Embracing Margaret for the first time since the riot, Thornton asks, "Do you remember, love? . . . And how I requited you with my insolence the next day?" Margaret responds, "I remember how wrongly I spoke to you,—that is all" (436). The roses, which Thornton presents immediately after this exchange, symbolize the couple's ability to get beyond these personal embarrassments to a mutual understanding rooted in more positive memories.

But, as I have argued, the rose is a social as well as a personal gesture. Thornton's serious attempts to elevate his taste and culture—of which his appreciation of the roses is a part—help him learn to read the complexities of Milton's social problems as well as those of Margaret. As Susan Johnston remarks, "It is possible that modern critics have misread Victorian attentiveness to the household. . . . The foregrounding of the domestic, even in political resolutions, is not simply a rhetorical move that privatizes and therefore contains political problems, but one that presents the so-called private sphere as the originary space of civil society" (87). Johnston has in mind the transformative power of Thornton's dining-room scheme, in which masters and men discuss as equals serious problems while eating, a literal representation of taste. For Johnston, one of Gaskell's central arguments is "that the space of the marketplace will always be one of [merely] unlimited acquisition, with everything it entails, unless the intimate space of the household is brought into the market itself" (130). I have claimed that household taste and the related appreciation of nature, not just the dining-room solution, help bring the domestic into the market in *North and South*. The Helstone roses, like the decorations in the novel's drawing rooms, are but one prominent example of good taste that mediates between the inside and outside world, between the personal and the political. Thornton's more complex mode of perception—demonstrated through his presentation of the Helstone roses—will enable him to create productive dialogues with workers rather than polarizing stereotypes.

CHAPTER 3

✿

"My name is the *right one*"

LADY ELIZABETH (RIGBY) EASTLAKE AND
THE STORY OF PROFESSIONAL ART CRITICISM

*W*riting in her 1876 essay "The Letters and Works of Michael Angelo," Elizabeth (Rigby) Eastlake (1809–93) argues that Michelangelo's letters help us to see the artist and the Renaissance without the "highly coloured glasses" used by prior art historians, who superficially "obscure the faults of the period" (124). Eastlake aims to see beyond the legends promulgated by Giorgio Vasari and his Victorian followers, considering the actual challenges faced by famous Renaissance artists. Michelangelo's preoccupation with money—his constant struggles to be paid by Italy's rulers—is in Eastlake's analysis indicative of a culture that failed to provide financial independence to even its best artists. As we will see, Eastlake's criticisms of the Italian Renaissance betray an anti-Catholic bias. However, she was primarily motivated by a desire to establish herself as an art historian focused on expertise and carefully researched facts about artists and artworks.

Eastlake's emphasis on the art historical fact was central to her strategy of establishing herself as a professional essayist. Eastlake began her career in the 1830s and early 1840s as a travel writer and translator, two common ways in which women entered the publishing world. Women, with their supposedly more keen observational skills, were thought to be especially

suitable for travel writing, a genre that often referenced local artworks and that was important to the later development of art criticism. But as art writing became increasingly masculinized, beginning with the emergence of John Ruskin in 1843, women critics sought to differentiate themselves. As she began to focus on art writing in the 1840s, Eastlake claimed to be more committed to the art historical fact than such canonical male critics as Ruskin and Vasari. This factualism included the precise attribution of artworks as well as the analysis of the material conditions under which artworks were produced. This art historical expertise, pioneered by Anna Jameson and significantly formulated by Eastlake and Emilia Dilke, threatened male art critics (Ruskin belittled the contributions of all three) and exacerbated at least one Victorian fear about professionalization: that women would lose their feminine qualities by catering to the culture's growing need for scholarly expertise. As a result, women critics were often both sexualized by their male counterparts and criticized for their factual approaches.

While distinguishing herself from Vasari and Ruskin, Eastlake helped shape two developments in professional Victorian art criticism: the analysis of artistic form and an art critical writing style that could rival even the most famous artworks for the attention of readers and viewers. Eastlake argued that she was both a more precise writer and more concerned with formal analysis than Ruskin, the figure often considered the first professional art critic in Britain. Beginning her career as an essayist on a variety of subjects, Eastlake gradually gained expertise in specific art historical fields, especially German culture. In doing so, Eastlake marks a key change in the nineteenth-century essay: from a focus on the reporting of observations to the conveyance of specialized knowledge in prose accessible to a broad audience. Despite her status as one of the earliest professional art critics in Britain, Eastlake has rarely been studied in the twentieth and twenty-first centuries. My aim in this chapter, however, is not simply to recover Eastlake as a neglected woman writer but to show her larger importance to Victorian art commentary. While we usually imagine professional Victorian art criticism as dominated by Ruskin, Walter Pater, Oscar Wilde, and their male followers, Eastlake demonstrates both the early influence of women critics and an alternative aesthetic approach centered on the history of art.

Elizabeth Eastlake (fig. 2) was born in 1809 to Dr. Edward Rigby, an obstetrician, and his second wife, Anne (Palgrave) Rigby. Beginning in 1827, Elizabeth spent two years in Heidelberg, learning the German language and culture. She traveled to Reval, Russia, in 1841 to visit her sister, a journey that formed the basis of her well-received first book, *A Residence on the Shores of the Baltic Told in Letters* (1841). The book gained the attention

of John Lockhart, who convinced her to begin writing for the *Quarterly* ("Eastlake, Elizabeth," *DNB* 598). Eastlake published twenty-one articles, reviews, and books on a variety of topics, including art, prior to marrying in 1849 the painter and first director of the National Gallery, Sir Charles Eastlake (Sheldon, *Letters* 643). Eastlake's partnership with Sir Charles furthered some of her already established interests in the arts. Roughly one-third of the approximately seventy-five books and articles that she produced during her career addressed art, and many of these were written during her marriage. This focus on art is striking given the variety of subjects—including literary criticism, children's literature, biography, and general cultural topics—that Eastlake addressed. Eastlake was in fact one of only a handful of Victorian women writers who were both highly published and specialists in something other than novel writing. Writing in her essay "The Hero as Man of Letters," Carol T. Christ notes that many of the some fifteen hundred women included in the *Wellesley Index to Victorian Periodicals* wrote just a single entry: "Only eleven women in the entire index have more than fifty entries to their name, and four of them are novelists" (Christ 21). Of the seven remaining prolific women writers who were not novelists, Christ lists Elizabeth Eastlake as the only specialist in art history.[1]

As was common for women growing up in early nineteenth-century Britain, Eastlake did not attend any kind of formal school, art or otherwise. Because of growing national interest in improving the arts and design, the situation soon changed for women. To take the most prominent midcentury example, Emilia Dilke (who became the foremost French art historian in Britain) graduated from the South Kensington Art School in 1861, where she received an education in the arts almost on par with that enjoyed by male students. Eastlake, by contrast, was educated by a governess, though "largely self-taught" (Lochhead 2). On her own, Eastlake began drawing at the age of eight (Lochhead 3). Like her predecessor Anna Jameson, Eastlake gained her knowledge about the arts through wide travels that were unusual for a middle-class family at that time. During these travels, she developed her "habit of sketching and painting which she retained throughout her adult life" (Nunn 112). Indeed, though Eastlake had no formal training in the arts, her sketches attest to her skill.

Despite her lack of formal schooling, Eastlake quickly established herself as a respected specialist on the arts. John Steegman remarks that in the 1840s and 1850s, "[John] Ruskin had by no means reached the position of revered authority that he attained later, while the position of Lady Eastlake, though of quite a different kind, was a remarkably strong one" (7). Steegman's *Victorian Taste,* a reissue of his 1950 *Consort of Taste,* was

Figure 2
Adamson, Robert (1841–48), and David Octavius Hill (1802–70). *Lady Elizabeth Eastlake*, c. 1844. Gelatin and silver print. 20.6 × 15.5 cm. Gift of Mr. and Mrs. H. Barr, Jr. The Museum of Modern Art, New York. Digital Image © The Museum of Modern Art/ Licensed by Scala/ Art Resource, NY.

published in 1970. There has since been no sustained consideration of East-lake's influence on British taste. The only book entirely devoted to Eastlake is Marion Lochhead's 1961 biography. Studies of Eastlake for the past thirty years or so have either considered only her literary criticism (and that usu-ally excerpted and out of context) or have briefly listed her among other art historians.[2] Neither approach accounts for her full cultural influence. Despite this particular neglect of Eastlake, recent scholarship in art history and literary studies demonstrates a growing interest in Victorian women's art criticism.[3] Meaghan Clarke's *Critical Voices: Women and Art Criticism in Britain 1880–1905* studies the late-Victorian critics Alice Meynell, Florence Fenwick-Miller, and Elizabeth Robins Pennell. Judith Johnston and Kali Israel have written book-length studies of the earlier critics Anna Jameson and Emilia Dilke, respectively. Recently, there has been renewed interest in Eastlake as well.[4] However, a more comprehensive account of the contribu-tions of early-Victorian women art critics remains to be written.

Although Eastlake remained influential up until her death in 1893, she failed to achieve the notoriety enjoyed by well-known male critics in the late-Victorian period, and she was rarely studied during the first half of the twentieth century. This oversight is in part due to the self-promotional strategies of some male critics, including Ruskin himself. Most Victorian art critics were, by the 1870s, celebrating Ruskin and other male critics at the expense of women's contributions. Sidney Colvin, Slade Professor of Fine Art at Cambridge, representatively wrote in 1879, "It has come to pass from a variety of causes, and not least from the stimulating power exercised by a master of letters, Mr. Ruskin, that a greater amount of intelligent interest is now directed to the works of art in England than was ever directed before; and this interest naturally reflects itself in current criticism" (211). It was certainly in Colvin's interests to claim that Ruskin, a man who held a cor-responding institutional role (the first Slade Professorship at Oxford) and whose art critical style he consciously followed, was primarily responsible for the improvement in Victorian art criticism.

For the most part, we continue to think of professional Victorian art criticism as begun by Ruskin and then consolidated by male writers in the 1870s. In *Professions of Taste,* for example, Jonathan Freedman charts a mas-culine trajectory that begins with Ruskinian moralism, proceeds to a Pate-rian "aesthetic consciousness," and ends with "Oscar Wilde's mastery of the mass market" (202). Writing in his 1985 *Paintings from Books,* Richard Altick states (in words that closely echo Colvin's previously cited quotation) what remains the standard gloss: "By the 1870s . . . the quality of English art criticism was beginning to improve. . . . The *new men* were better equipped

for their job and so were more effective in cultivating intelligent public interest in art" (237, emphasis mine). Altick attributes the rise of art criticism to William Thackeray, F. G. Stephens, Colvin, and that figure whom Altick calls the "magisterial Ruskin" (237). In other studies, when women are mentioned as professionals, they are discussed only briefly. Elizabeth Prettejohn's 1997 "Aesthetic Value and the Professionalization of Victorian Art Criticism 1837–78" cogently delineates different modes of criticism, but says little about women critics, except for half a sentence devoted to Emilia Dilke, whom Prettejohn calls "the leading expert on French eighteenth-century art" (79). Likewise, Kate Flint reserves only a paragraph for women writers in her two chapters on art criticism in *The Victorians and The Visual Imagination* (2000), though she usefully notes "the depth and extent of their knowledge, despite the fact that they lacked the formal educational background which was assumed to underpin the authority of their male counterparts" (194). Most early women writers, including Eastlake, gained their expertise from private study and firsthand experience—not from the kind of university education enjoyed by Ruskin and others. A few scholars have nevertheless recognized the early professionalization of women critics. In particular, Katharine Walke Gillespie asserts that "Eastlake's writings are first-rate examples of modern art criticism—a discipline that was then [in the 1850s] being codified" (79). However, Gillespie is still in the minority in dating professional Victorian art criticism as early as the 1840s and 1850s.[5]

The tendency to define women writers as amateurs or to leave them almost wholly out of narratives about the specialization of art criticism exposes a central problem in our understanding of Victorian professionalization. While the Victorians used the term professionalization "loosely and with changing emphasis" (Gourvish 18), we more narrowly define the movement as one marked by increasingly systematic education, specific credentials, and professional associations. These criteria are suitable for those professionals usually studied: lawyers, doctors, and clergymen. But, as women writers illustrate, the professional practices of Victorian art critics varied widely. In addition to their diverse educations and claims for expertise, art critics did not—unlike professionals in the more well-known fields—form associations until late in the nineteenth century.[6] More useful than specific criteria is the kind of sociological definition advanced by Magali Sarfatti Larson, for whom professionalism is "an attempt to translate one order of scarce resources—special knowledge and skills—into another—social and economic rewards" (xvii). Though some women critics such as Jameson relied on art criticism to provide her with an income,

others, including Eastlake, were insulated from this need and were motivated primarily by the social rewards of being considered an expert.

As Harold Perkin has demonstrated, social acceptance of the professions was by no means "natural" or uncontested despite the conditions that favored their development—increases in wealth, urbanization, population, and industrialization. Professionals had to persuade the public that they were providing expert and useful advice, not merely catering to their own needs (Perkin 260). Perkin has famously termed professionals the "forgotten middle class" because of their supposed focus on public welfare over financial rewards. Making their services seem necessary was perhaps more difficult for Victorian art critics than for professionals in other fields because they had enjoyed little respect in the eighteenth and early nineteenth centuries, and because they purported to teach something that people fancied they already knew. However, as specialized art knowledge became a necessity for both a broader public and for gallery directors, art critics were viewed as fulfilling a vital social role. Directors of emergent art institutions such as the National Gallery were increasingly expected to determine the correct attributions of their holdings, not only to be sure that they were labeled appropriately, but also to rule out copies or forgeries. While these directors were often experts in their own fields, they also relied on art critics for information. As an accomplished painter, president of the Royal Academy, and keeper of the National Gallery, Sir Charles Eastlake was already highly knowledgeable when he took over the first directorship of the National Gallery. Yet, as he sought to expand the gallery's then-meager collection, Charles surely relied on his wife's expertise in art history. John Steegman, Adele (Holcomb) Ernstrom, and early historians of the National Gallery portray Elizabeth Eastlake as an equal partner with her husband in the purchase of art.[7] By contrast, in her recent introduction to Elizabeth Eastlake's letters, Julie Sheldon argues that this "partnership" model may be "overstated" (11). However, Elizabeth's art historical expertise in German and early-Italian painting was no doubt useful to Sir Charles as he acquired some 164 paintings for the gallery during his tenure. To be sure, Charles rarely mentions his wife's role in his letters and travel diaries. But this omission seems more a function of Victorian gender codes that discouraged men in such high positions of authority from admitting that they were indebted to a woman's judgment than evidence that Elizabeth played a smaller role than scholars have previously imagined.

In fact, Elizabeth could be quite direct in asserting her particular contributions to her collaborations with Sir Charles. In 1874, almost a decade

after the death of her husband in 1865, an increasingly annoyed Elizabeth Eastlake wrote to her publisher John Murray about the revised version of Franz Kugler's *Handbook of Painting: The Italian Schools*. This was a book that Elizabeth and her husband translated together in 1850, but which she now claimed was almost solely her own work because "not a tenth part remains as in his edition" (*Letters* 396). Elizabeth was not unwilling to acknowledge that her husband had played a role in an earlier version of the book; she remarks that readers will find such a notice in her preface. However, she believed that naming her husband in the preface precluded the necessity of identifying him as the current editor: "The desire, therefore, to insert Sir Chas' name on the title page or advertisement of the work can be of no further tribute to him" (*Letters* 396). Eastlake's letters consistently demonstrate a desire for recognition of her scholarly achievements. In a savvy move that suggests that she was also attentive to market realities, Eastlake writes Murray, "There can be no doubt that my name is, in every sense, the *right one* for this work [Kugler's *Handbook*], and that it also would increase its mercantile value" (*Letters* 396). Though Sir Charles was famous as a painter and the first director of the National Gallery, he was not, as Elizabeth realized, the most well-known writer in the family. Murray compromised by maintaining Charles Eastlake as primary editor, but adding "revised and remodeled from the latest researches, by Lady Eastlake," a solution that did not satisfy Elizabeth (Ernstrom 471). Elizabeth makes a further argument for primary editorial credit by emphasizing her hard work in revising the *Handbook*: "The labour I have bestowed on it . . . has been very arduous" (*Letters* 396). Eastlake here and elsewhere challenges the stereotype of intellectual work as somehow different from physical labor. Again, Murray attempted to placate Eastlake, offering an additional £50 (*Letters* 396). Although Elizabeth accepted the money, she was surely disappointed to gain a rather small monetary reward instead of her name alone on the title page.

Further underscoring her commitment to intellectual labor, Eastlake viewed careful, firsthand study of artworks as important to the success of her writing. Due to her own stature as a critic and because of her friendship with Jameson, Eastlake was asked to complete *The History of Our Lord as Exemplified in Works of Art* (1864), which was left unfinished at the time of Jameson's death in 1860. Eastlake seems to have been motivated to complete the work both by a genuine regard for Jameson and by a desire to further her own take on the subject. In researching the book, Eastlake wrote, "I have been working *very hard* in the Gallery here (Munich): I am so constantly taking notes now for my particular object that I see no chance

of getting any sketches, unless I could have time to draw for my own pur-
poses" (*Journals and Correspondence* 2:141, emphasis mine). Eastlake's draw-
ing "for my own purposes" suggests that she views the project in large part
as her own, even though it was begun by Jameson. The time pressures that
Eastlake mentions were a result of her ambitious research agenda coupled
with her social position as the wife of the then–most prominent arts admin-
istrator in Britain. While her marriage to Sir Charles provided her with
an insider's access to art, Elizabeth found that being his social companion
took "far too much time" away from her laborious research (*Journals and
Correspondence* 2:111). The Eastlakes knew many of the most prominent
artists and art critics in Britain and abroad, a fact that certainly furthered
Elizabeth's career but that also required her to correspond frequently and
to attend numerous social functions. Further, Elizabeth traveled abroad to
assist her husband in acquiring art for the National Gallery. While these
trips surely added to Elizabeth's knowledge, they must also have made dif-
ficult her ability to focus on particular research projects.

In addition to interfering with her work schedule, Elizabeth's marriage
impeded her career by sometimes convincing others that her essays were
wholly indebted to her husband. The *London Quarterly Review* represen-
tatively claimed in 1864 that "Sir Charles is not only a distinguished artist,
but . . . a distinguished writer on art . . . To this knowledge Lady Eastlake
has of course had access" ("The History of Our Lord" 417).[8] Some recent
commentators have repeated this derivative view of her art criticism. For
Pamela Gerrish Nunn, "It was only with her marriage in 1849 . . . that art
took on a certain prominence in her writings" (112). However, it is impor-
tant to note Elizabeth's earlier interest in art, as evidenced by her 1846
article on "Modern German Painting" and her 1836 translation of J. D. Pas-
savant's *Tour of a German Artist in England with Notices of Private Galleries,
and Remarks upon the State of Art.* At times, Eastlake seems to confirm her
dependence on Sir Charles. In her preface to *Five Great Painters,* a collec-
tion of her earlier essays on Renaissance artists, she "founds her claims to
the indulgence of the reader on no study or thought of her own, but solely
on the advantages enjoyed by her for long years at the side of the late Sir
Charles L. Eastlake" (n.p.). However, despite her frequent citation and crit-
ical use of source materials in these essays, she rarely refers to her husband's
writings. Nor does she apologize for any lack of knowledge in the actual
essays that make up *Five Great Painters.* Eastlake's prefatory apologies
for her supposed lack of knowledge thus seem less factual than strategic,
allowing her early on to mollify readers who might fear an independent
and overtly scholarly woman but then to demonstrate her expertise in the

body of her works.[9] To take an important example of another woman critic employing a similar strategy, Jameson apologizes in her preface to *Sacred and Legendary Art* that she needed six years to write the book. However, her admission turns out to highlight her scholarly diligence and the resulting specialization of the book, as no other critic had managed to cover "the particular ground that I had chosen" (viii). Both Jameson and Eastlake in fact viewed themselves as producing original scholarship in the field of art history.

Eastlake's success as a professional writer was in part due to the advice of male editors, publishers, and collaborators. But there is also in these exchanges an apparent power imbalance due to Elizabeth's gender, and Elizabeth sometimes belittles herself when writing to these figures. Upon publication of her first travel book, *A Residence on the Shores of the Baltic* (1841), Eastlake valued the comments provided by her publisher John Murray, admitting that she was prone to attending only to positive reviews of her work, "for which arrogance I deserve the severest of animadversions in my eyes, namely a reproof from yourself" (*Letters* 57). Eastlake seems here a child in need of scolding from a parent. In a similar vein, Eastlake informed Murray, "'I can only wish that all novices like myself might fall into such kind and encouraging hands'" (qtd. in Lochhead 31). Although Eastlake was indeed relatively new to the publishing world, she had five years earlier translated Passavant's book and placed her first essay, "Letters to John Henry Merck, from Goethe, Herder, Wieland & C," in the *Foreign Quarterly Review* (Sheldon, *Letters* 44–45). Eastlake's epistolary comments on this essay to Dawson Turner indicate her earlier conception of herself as an emerging professional writer: "I am anxious for many reasons to persevere in such attempts, the chief of which is the hope of improving in information and style" (*Letters* 44). It is thus very possible that Eastlake was flattering her publisher in 1841 rather than professing her great need for advice.

Eastlake became more overtly independent later in her career; her disagreement with Murray over the revised Kugler book provides just one example. In February 1876, fewer than two years after the Kugler controversy, Eastlake rejected a book Murray had sent her for review: "As I imagine it may have been sent with a view to some notice in the Quarterly R:, I may venture to say that I am now engaged in reviewing M:Angelo's Letters for the Edinburgh R . . . & fearing that it might be difficult for me to remunerate you for this copy, I prefer to return it, & have ordered a copy from a bookseller" (*Letters* 413).[10] Eastlake emphasizes her reputation as a writer by letting Murray know that she is already in demand with another

publisher. Murray would not receive another letter from Eastlake for more than four years when, in March 1880, she wrote proposing a biography of another well-known woman of letters, Harriet Grote. Although Eastlake's letter is conciliatory, she reminds Murray that she is not reliant on him to publish her work: "Should you feel inclined to publish this it would make only a small, rather large printed vol: If not I think I should offer it to Macmillan, but of course I should prefer your name attached to a work on *her*" (*Letters* 485).

While she quickly became well-known in the Victorian publishing world, Eastlake did not primarily base her professional reputation on either her popularity or on her productivity as an author. Indeed, she often contrasted her art historical approach with that taken by supposedly less scientific writers. New developments such as photography and the amassing of artworks in public exhibitions and galleries made the correct attributions of paintings much easier, though far from foolproof, in the mid-nineteenth century. However, canonical Victorian art critics, including Ruskin, Pater, and Wilde, shunned this kind of historical research in favor of legends about artists. As I discuss in chapter 5, women critics were not the only figures to reject such legends in favor of correct attribution. However, Jameson and Eastlake were some of the first writers in Britain to challenge long-standing assumptions about who painted which artworks. In her 1848 *Sacred and Legendary Art,* Jameson corrects many of Vasari's biographies and attributions, reasoning, for example, that Giotto could not have painted the marriage represented in one of the frescoes: "Giotto died in 1336, and these famous espousals took place in 1347; a dry date will sometimes confound a very pretty theory" (23). Likewise, writing in her 1854 review of Gustav F. Waagen's *Treasures of Art in Great Britain,* Eastlake challenges Vasari's assertion that a painting inscribed as a Raphael is in reality a Perugino (490). On the contrary, claims Eastlake, the painting is undoubtedly Raphael's first altarpiece and his only crucifixion. Eastlake also critiques Waagen himself (the well-respected director of the Berlin Gallery and professor of art history at Berlin University) by correcting his attributions and qualifying his enthusiasm for expanding the canon of great masters by arguing for "caution" ("Treasures of Art" 484). However, she also agrees with Waagen that some paintings attributed to other Italian masters are in fact by Leonardo da Vinci or Michelangelo (488). Jonah Siegel has described the nineteenth-century fascination with attribution as one that sought "to *reduce* the number of works ascribed to a celebrated author of the past" ("Leonardo" 169). But this critical exchange between Waagen and Eastlake demonstrates the very different approaches that art

critics could take. While Waagen sought to increase the number of works ascribed to masters, Eastlake cautiously judges each work based on its own qualities. Not merely a translator, admirer, or summarizer of Waagen's work, or a follower of any particular trend in art criticism, Eastlake views careful and correct attribution as central to her factual approach.

Eastlake's attributive practice underscores the centrality of the carefully researched fact in her art historicism. This factualism was key to the most prominent aim of her writing: positioning her historical method as superior to art criticism—both Renaissance and nineteenth century—that reproduces legends. Despite the large gap in time between these two periods, art writing had changed little. Like Vasari in the sixteenth century, writers on art in the seventeenth and eighteenth centuries were usually artists themselves in the William Blake or Sir Joshua Reynolds mold. Art writing tended to be either technical advice for artists (for example, Reynolds's *Discourses on Art*) or legendary stories about artists in the Vasari vein. The independent, specialized art writer was a mid-nineteenth century development.

Seeking to highlight her own expertise, Eastlake writes in her 1875 essay on "Leonardo da Vinci" that a central problem in Renaissance Italy was that art writing was "not calculated to enlighten or encourage the man of acutely sensitive calibre" (10). By contrast, Eastlake suggests the value of her own work to educate her audience through her historical research. She implicitly appeals to her readers by including them in such a select, "sensitive" group. As in her discussions of attribution, Eastlake was critical of Vasari, noting his "puerile gossip, which throws a doubt on many of his statements" ("Leonardo" 22). She admits that *Vasari's Lives* "have sometimes the value of genuinely professional criticism," but claims that the book is "inaccurate" (11). Eastlake finds Vasari's contemporaries even less historically believable and accuses Michelangelo's early biographers of "careless inaccuracy" ("Michelangelo" 161). In these essays on Renaissance artists, Eastlake thus consistently contrasts the "inaccuracy" and "gossip" of early modern art criticism with her supposedly more factual historical method. Similarly, in *Sacred and Legendary Art,* Jameson notes that she has corrected events in the life of Giotto "in accordance with more exact chroniclers than Vasari" (24). While Jameson and Eastlake were far from alone in hoping to raise the status and quality of Victorian art criticism, they were distinctive in doing so through researched historical facts that often contradicted Vasari and other canonical critics.

Eastlake further distinguishes herself even from Jameson in describing the material conditions under which Renaissance artists worked. I note in

my opening to this chapter Eastlake's analysis of Michelangelo's preoccupa-
tion with money as indicative of his culture (as one that failed to support
artists) rather than as a personal failing. By contrast, Pater's artists tend to
occupy his *Renaissance* without regard for everyday concerns. Pater writes
of Leonardo, "We see him in his boyhood fascinating all men by his beauty,
improvising music and songs, buying the caged birds and setting them free,
as he walked the streets of Florence, fond of odd bright dresses and spirited
horses" (80). Eastlake's Leonardo is, on the other hand, often at the mercy
of the Italian aristocracy, dependent on meeting their extravagant demands
for payment. Of most concern to Eastlake, government corruption in the
High Renaissance caused the exploitation of artists by the ruling classes
and their treatment as mere tradesmen, "little differing in rigorous mat-
ter-of-fact stipulations from those we nowadays conclude with carpenter or
mason" ("Leonardo" 10). By extension, Eastlake makes a progressive and
nationalistic argument in suggesting that British Victorian artists encoun-
ter better treatment than their Italian Renaissance counterparts. However,
despite the neglect of artists in the Renaissance, art flourished, "too healthy
in her instincts and certain in her processes to be affected by conditions,
however unsympathetic, tyrannical, and even prohibitory" ("Leonardo" 11).
Eastlake here argues for a separate aesthetic sphere that is to some extent
immune from material conditions; unlike Ruskin, she does not believe that
art is necessarily a reflection of the culture in which it is produced. This
Kantian framework allows Eastlake to explain why Renaissance Italy man-
aged to produce such great artists despite corruption and the mistreatment
of artists.

Eastlake's historical method also provides insight into her most studied
essay: "*Vanity Fair, Jane Eyre* and the Governesses' Benevolent Institution
Report for 1847" (1848). Scholars have focused most on Eastlake's scath-
ing comments on *Jane Eyre* as a book written by an author who "combines
a total ignorance of the habits of society, a great coarseness of taste, and
a heathenish doctrine of religion" (94). Far less attention has been paid
to her contrasting approval of the factualism of both the Governesses'
Report and *Vanity Fair,* sections which are often omitted in anthologized
versions of the essay. In terms remarkably similar to her essay on Michel-
angelo, Eastlake describes William Thackeray's successful realism: "The
personages are too like our every-day selves and neighbors to draw any
distinct moral. . . . For it is only in fictitious characters which are highly
coloured for one definite object . . . that the course of the true moral can
be seen to run straight" (83). The "highly coloured" achieves a superfi-
cial effect rather than the insight into real people and events that Eastlake

sought—and which she believes Thackeray manages with his character interactions.

In a move that further parallels her own work, Eastlake celebrates the stories included in the Governesses' Report for their factualism. For Eastlake, these stories correct what she sees as the impossible and destabilizing romanticism of *Jane Eyre*, allowing us to sympathize with the plight of governesses, but only enough to provide financial support for those who are out of work. Eastlake does not allow for upward class mobility or even a different career for these women. In an effort to keep the governess in her place and to emphasize reason over emotion, Eastlake claims that the English governess is "a bore to almost any gentleman, as a tabooed woman" (95). Despite her conservative ideology in matters of class, Eastlake's factual method allowed her to analyze the material conditions of the governess. According to Mary Poovey, "Lady Eastlake's formulation of the governess's plight is as explicit as anything written in the 1840s about the class and moral concerns that dovetail in the governess" (148). Eastlake understood the economics of the governess problem well: because of the oversupply of governesses, the market system itself would not motivate employers to pay more. This low salary and the frequent need of governesses to support other family members prevented most of them from saving for their retirement, a fact that Eastlake reinforces in the eight case studies she cites. Eastlake realizes as well that the economic conditions that prevented governesses from making a comfortable living were the same ones that allowed the middle class to employ less-fortunate women from their own class: "The real definition of a governess, in the English sense, is a being who is our equal at birth, manners, and education, but our inferior in worldly wealth. . . . There is nothing upon the face of the thing to stamp her as having been called to a different state of life from that in which it has pleased God to place you" (94–95). On the one hand, Eastlake betrays a conservative, organic conception of society in her reference to God's pleasure. However, her comment is also subversive in calling attention to what has become a theoretical commonplace, but was much less openly discussed in Victorian times: the difficulty of distinguishing the middle-class governess from her middle-class employer.

Based almost solely on this one excerpted review of *Jane Eyre*, Elizabeth Eastlake is often stereotyped as simply conservative in matters of class and gender, a bias that has prevented her recognition as a key woman of letters. Julie Sheldon astutely remarks, "Elizabeth's now rather obscure status appears to me to stem from the perception that she was a woman writer without being a woman's writer" ("Introduction" 2). Eastlake's comments

on *Jane Eyre,* coupled with her refusal to join publicly with feminist causes (unlike Jameson and Dilke), have led some commentators to label her as antifeminist (Sheldon, "Introduction" 2). However, as my analysis of the Governesses' Report makes clear, Eastlake was an astute and sympathetic observer of the particular challenges facing middle-class women, even as she sought to prevent class mobility. She also promoted women's independence in less public but no less significant ways. Allying herself with other, more overtly feminist art critics such as Jameson and Dilke, Eastlake empowers women within her art criticism, especially in her placement of Eve as a central figure with a direct relationship with God (Ernstrom 473). Regarding women's educations and careers, Eastlake wrote to Sir A. H. Layard in January 1878, "I think they have a right to break through that ideal of feminine helplessness which gentlemen deem so attractive, and prepare for the possibility of helping themselves" (*Journals and Correspondence* 2: 255). Supporting this goal of career independence, Eastlake helped establish in 1857 the Society of Female Artists.

In addition to her historical method, which informed her particular feminist approach, Eastlake was instrumental in developing art criticism as a literary form. Hilary Fraser and Daniel Brown claim that Oscar Wilde's "'The Critic as Artist' [1890] provides an effective summation of what this genre had come to mean by the end of the century," especially in Wilde's insistence that criticism had supplanted the art object as the ultimate work of art (298). Gilbert remarks to Ernest in their dialogue,

> Who cares whether Mr. Ruskin's views on Turner are sound or not? What does it matter? That mighty and majestic prose of his, so fervid and so fiery coloured in its noble eloquence . . . is at least as great a work of art as any of those wonderful sunsets that bleach or rot on their corrupted canvases in England's gallery. . . . Who, again, cares whether Mr. Pater has put into the portrait of Mona Lisa something that Leonardo never dreamed of? (Wilde 141–42)

Fraser and Brown note that both art and literary criticism began to professionalize in the 1840s, particularly through the work of Jameson and Ruskin (*English Prose* 314–15). However, although pointing to Jameson's "highly innovative" treatment of Christian iconography, Fraser and Brown do not mention Eastlake's crucial role in finishing Jameson's *History of Our Lord* (1864) or Eastlake's originality as an art critic. Like her predecessor Jameson and also like Ruskin, Pater, and Wilde, Eastlake well understood the importance of prose that could equal the work of art under discussion.

But scholars tend to view these male art critics as almost solely respon-sible for developing a prose style that led to literary modernism. In this vein, Harold Bloom characterizes Pater as the "hinge upon which turns the single gate" (186–87) between nineteenth- and twentieth-century liter-ary styles. For Bloom, Pater represents the one moment dividing Matthew Arnold's objectivism from fin de siècle notions of individual sense impres-sions. Like Gilbert's comments in "The Critic as Artist," such a perspective occludes the role of women critics in developing an art critical style atten-tive to differing impressions of the art object.

Eastlake posits the difficulty of verbalizing visual sights while also sug-gesting that her words explain art's power—a move that serves to explain the need for her expertise. To take one example reminiscent of Pater's *Renaissance,* Eastlake notes that Michelangelo's statues in the Medici tombs "defy analysis, and have lain there for centuries without furnishing a hint of their creator's intention" (188). But Eastlake still puts their effect in words: "When all criticism is exhausted, we only the more reach the estimate of that astounding power which takes our admiration by storm—unin-spired by which, these statues would have been simply hideous or ridicu-lous" (188–89). Significantly, criticism has a role in bringing readers to this point, even if it fails to capture art's full force. Pater employs a similar tech-nique in remarking that historians have already traced Leonardo's works and writings, "but a lover of strange souls may still analyse for himself the impression made on him by those works, and try to reach through it a defi-nition of the chief elements of Leonardo's genius" (64). While remaining committed to art historical facts, Eastlake too emphasizes individual sense impressions. Also like Pater, Eastlake suggests a key role for the special-ist, through what Pater calls in his preface to the *Renaissance* the art critic's "certain kind of temperament, the power of being deeply moved by the presence of beautiful objects" (Pater xxx). Eastlake's identification of the "astounding power" of Michelangelo's statues allies her with such a disposi-tion. Writing two years after Pater's first edition of the *Renaissance* (1873), Eastlake might seem merely to be copying his style and ideas. However, art critical style and the special disposition of the true art expert were early and central preoccupations in her career.

These concerns were especially apparent in Eastlake's reviews of Ruskin. In an 1856 essay on the first three volumes of Ruskin's *Modern Painters* and his 1855 "Academy Notes," Eastlake characterizes Ruskin's work as show-casing "active thought, brilliant style, wrong reasoning, false statement, and unmannerly language" ("Modern Painters" 387). By contrast, Eastlake promises to deliver sound conclusions about art couched in the simplest

language. Scholars have failed to account for Eastlake's attempts to estab-
lish an art critical style alert to both careful language and scholarship, read-
ing her critique as instead an ad hominem attack on Ruskin. Employing a
binary of objective journalism versus personal essay to categorize Eastlake's
writings, Lochhead characterizes the review of Ruskin as one of "the great
prose-hymns of hate" (116). I would contend that Eastlake's comments on
Ruskin seek neither personal revenge nor objective journalism but a care-
fully reasoned assessment of his work. Ignoring these professional motiva-
tions, J. L. Bradley notes in his introduction to *Ruskin: The Critical Heritage*
that Eastlake was biased against Ruskin for his unfavorable review of her
husband's painting *Beatrice* in his 1855 "Academy Notes," as well as for his
mistreatment of her friend and Ruskin's wife, Effie Ruskin. Again dem-
onstrating the tendency for twentieth-century scholars to repeat the opin-
ions of canonical male critics, Bradley's assessment of Eastlake's review as
a "scurrilous piece of invective posing as criticism" mostly repeats Ruskin's
preface to his 1856 "Academy Notes" (written just after Eastlake's critique).
Ruskin suggests that Eastlake's supposed anonymity encourages bias that
demeans the profession: "A lying critic, discovered, has infected with his
own disgrace the men behind whom he stooped, and cast suspicion over the
general honour of his race" (*Works* 14: 45). However, most insiders in the
Victorian art world knew that Eastlake wrote art criticism for *The Quar-
terly Review* in these years, even though she did not sign her name to these
particular works. Ruskin assumes, as have recent scholars (for, of course,
different reasons), that signing was an indication of professionalism. Yet
individual women critics such as Eastlake wrote signed, unsigned, and
pseudonymous works; the issues of identity for women in signing are too
complex to fit neatly into a professional/amateur binary.[11]

Demonstrating her professional rather than solely personal motives,
Eastlake had found fault with Ruskin's art critical style two years before his
unfavorable review of her husband's paintings (neither Ruskin nor Brad-
ley acknowledges these earlier critiques). In her March 1854 remarks on
Waagen's *Treasures of Art in Great Britain,* Eastlake unfavorably compares
recent criticism—such as Ruskin's—with that of Waagen: "His [Waagen's]
opinion is given with a simplicity, distinctness, and temperance of language
particularly refreshing after the violence and dogmatism, the flippant and
fine writing, with which the criticism and philosophy of art has of late
been treated among us" (468). Instead, then, of reading Eastlake's review
of Ruskin as merely an act of revenge, we should consider how she defines
her own critical practice and style against those of the now-more-famous
author. Significantly, she opposes her career to Ruskin's "hobby" ("Mod-

ern Painters" 401). Her 1854 review of Waagen had, by contrast, defined professionalism in art criticism: "The education of the professed critic in art is essentially the same as that of the student in the exact sciences. Nothing is left of feeling, predilection, or wish—his stand must be taken upon a slowly gathered accumulation of facts, each one resting securely on that beneath it" (467). Though Eastlake was herself relatively prolific, she viewed much of her writing as the result of laborious study. For Eastlake, Ruskin writes merely to have something to write about rather than to cultivate his expertise: "One great proof, were there no other, of the falseness of Mr. Ruskin's reasoning, is its quantity" ("Modern Painters" 432). While earlier artist-writers such as William Blake contrasted prolific amateur critics with serious artists (that is, themselves), Eastlake relies upon a new figure: the professional critic (that is, herself).

Also like Jameson and Pater, Eastlake was adamant that the form of the artwork itself should be analyzed. Few critics have recognized, as do Andrea Broomfield and Sally Mitchell, the importance of Eastlake's formal analyses: "In her defense of the aesthetic object as meaningful in and of itself, Eastlake may be viewed as working in a line of descent which originated with Immanuel Kant and culminated in the Art-for-Art's-Sake Movement" (81). This primacy of formal analysis places Eastlake's criticism as an alternative to that of Ruskin, who tended to emphasize the social and moral dimensions of art. Eastlake chastises Ruskin and other writers for emphasizing stories about artworks, which was in midcentury the most popular form of criticism: "Every exhibition shows that the story is all the uneducated care for" ("Modern Painters" 400). Eastlake's commitment to form and her critique of narrative are striking for the early date of their expression. While, for example, James McNeill Whistler suggests that his disdain for literary interpretations in the "Ten O' Clock Lecture" (1888) is new, Eastlake directly attacks this mode as early as 1856 in her critique of Ruskin and thoroughly considers form in her 1846 article on "Modern German Painting." This 1846 article is extremely specific about the technical defects of Germany's artists: "It is impossible, in the want of unity, breadth and chiaro oscuro, and in the laboured execution of the oil-painters, not to recognise the mechanical joining of detached parts—the heavy opaque shadows—the hatchings and frequent retouchings of the same colour, inseparable from the line of fresco" ("Modern German Painting" 341–42). Eastlake's use of such terms as "chiaro oscuro" (the commonly Anglicized form of "chiaroscuro") and "hatchings" highlights her ability to educate readers about form.

In her focus on form, Eastlake's writings in fact closely fit recent definitions of professional Victorian art criticism, even though she began writing about art some twenty-five years before the date commonly assigned to the consolidation of the discipline. Flint and Prettejohn describe how formalist critics such as F. G. Stephens and Sidney Colvin appealed to society's elite in the 1860s through formal descriptions, while those who focused on stories about art—the generalist writers—continued to mediate art for the masses. According to Flint and Prettejohn, we thus see beginning at this time and continuing throughout the nineteenth century two separate and distinct strands of art criticism. However, women critics such as Eastlake tend to combine formal analyses with narrative descriptions. For example, Eastlake complains in "Modern German Painting" that Eduard Hildebrandt's inclusion of too many details ruins the story being told in his *Murder of the Young Princes in the Tower.* The princes are "fast asleep," writes Eastlake,

> while, as if purposely to heighten the effect of their peace and innocence, two figures stealthily approach—"flesht villains—bloody dogs"—their countenances full of those evil passions which give work for the painter in every line—one of them grey in crime. The bed, too, on which the children are lying, is all an artist can wish—bringing a broad mass of light into the middle of the picture, and enabling him to concentrate all attention to the figures lying upon it. (336)

Eastlake's narrative description in the first part of the quotation heightens the emotional effect of the painting (here, the contrast between the innocence of the children and the "evil passions" of the villains) in an effort to engage and instruct readers. In the second sentence, Eastlake muses about the form of the painting itself—the "broad mass of light" that provides the painting's focal point. Indeed, form seems Eastlake's primary concern as she notes that the subject of the painting allows Hildebrandt to showcase "beauty of forms, strength of contrast, and breadth of light" (336). Eastlake's delicate parallelism in this last quotation demonstrates her attentiveness to her own literary style. In short, Eastlake combines technical details about the painting with a compelling narrative description.

Despite implicitly claiming to focus on literary and painterly form, Eastlake often betrays an anti-Catholic bias, which is particularly apparent in her discussions of Renaissance painters. Like many other Protestant critics, Eastlake sought to separate the general religious inspiration of the Italian Renaissance from its specifically Catholic reference. Thus, Eastlake

writes that Leonardo's *Last Supper* "produces a really religious impression . . . because it so truly tells the awful tale; but that impression was not the necessary result of Leonardo's own spiritual aspirations—aspirations not seen in any other work by him" (61). Leonardo happened "to paint Church pictures" because of his time period, "not his own tendencies" (62). While Eastlake's approach was typical of Protestant writers, her anti-Catholicism is more overt than contemporary critics such as Jameson, who tried to avoid religious connotations altogether. "I hope it will be clearly understood," writes Jameson in her preface to the first edition of *Sacred and Legendary Art* (1848), "that I have taken throughout the aesthetic and not the religious view of Art." Religious works "may cease to be Religion, but cannot cease to be Poetry; and as poetry only I have considered them" (viii–ix). Middle class and the first writer in Britain to earn a living solely from art criticism, Jameson was necessarily careful in her prefaces and introductions to appeal to as wide an audience as possible. Because *Sacred and Legendary Art* considers many works inspired by Catholicism in its survey of Christian symbolism, Jameson was particularly worried about the strong anti-Catholic sentiments in Britain in the 1840s. Jameson's apparent focus on aesthetics—what she calls "poetry"—instead of religion was thus in part a response to this anxiety. Eastlake, by contrast, is not surprised that the Catholic Church encouraged some good painting during this time, as "Art, respectively ancient and modern, never attained such perfection as under an elaborately organised Idolatry, and a sumptuously supported Superstition" (103). Eastlake's other essays on this subject suggest that such "Idolatry" and "Superstition" are products of the Catholic Church.[12] Implicitly, Eastlake claims that her own art histories avoid such myths, focusing instead on facts and realistic stories.

Eastlake's "Modern German Painting" displays a similar anti-Catholic bias. Most strikingly, she attributes the imitative tendencies of German artists to their "going over to the Roman Church" in 1814: "Viewing this step in a moral light we have nothing to say . . . but, viewing it in an aesthetic sense, we believe that it was the worst step they could take" ("Modern German Painting" 326). Through her use of aesthetic instead of religious terms, Eastlake attempts to conceal her Protestant and nationalist biases. Because German artists merely copy Italian painters rather than creating original works inspired from nature, reasons Eastlake, they have sacrificed formal effect: "Enamoured of that religious earnestness and simplicity which they found in the early masters, they became enamoured also of their technical defects" (325). While Eastlake sought to differentiate her art critical method from that of Ruskin, she here seems close to his argument

in "The Nature of Gothic" that social conditions influence the kind of art produced. However, she is primarily motivated by a desire to censure nine-teenth-century movements that emulate older Catholic inspirations. For Eastlake, these revivals impossibly try to recreate the "simplicity" of older social conditions, a simplicity that can no longer exist in European painting.

This anti-Catholic bias notwithstanding, Eastlake was one of the first critics in Britain to discuss how artistic form instead of a specifically religious inspiration could convey powerful emotions. As I note earlier, this was an approach influenced by Jameson. In "The House of Titian" (1846)—perhaps her clearest formulation of this balance between aesthetics and spirituality—Jameson writes of church art in Lombardy: "A solemn feeling was upon me . . . because the spirit of devotion which had raised them . . . being in itself a truth, that truth died not—could not die—but seemed to me still inhabiting there, still hovering round, still sanctifying and vivifying the forms it had created" (15). Jameson carefully notes that her sense of presence in viewing these works does not result from "a yearn-ing after those forms of faith which have gone into the past" (15); the his-torical truth of religious feeling is the point here, not Catholicism itself. Thus, for Jameson, modern revivals of Catholic art are destined to fail: "I felt how vain must be the attempt to reanimate the spirit of catholicism merely by returning to the forms. . . . Factitious, second-hand exhibitions of modern religious art fall . . . so cold on the imagination" (15–16). Jame-son implies here a criticism of such popular nineteenth-century groups as the German Nazarenes, emulators of early-Italian art. Moreover, in *Sacred and Legendary Art,* Jameson asserts that Protestantism is a certain improve-ment over ancient Catholicism, a "polytheistic form of Christianity" with "strange excesses of superstition" (7). Avoiding such superstitions is cer-tainly one reason why Jameson objects to modern Catholic revivals. In her progressive view of history, respecting the past is useful for improving the future. But she objects to nostalgia for its own sake—particularly when it looks back to beliefs that are now known to be false. As a Protestant, she suggests that she and her like-minded readers are in an ideal position to reject ancient Catholicism.

Religion may have been a motivating factor in Jameson's practice, but it is also clear that formal discussions were as fundamental to her self-con-ception as a professional art critic as they were to Eastlake. In discussing the Campo Santo at Pisa in her essay on "Giotto" (collected in *Sacred and Legendary Art*), she argues that it "is clear that, to understand the religious significance of these decorations . . . the subject must be considered in the order I have followed" (41). Despite mentioning religion, Jameson's pre-

dominant focus in this essay is on artistic form. In "Giotto," Jameson foregrounds the techniques that modern art historians view as central to the development of sculptural figures in High Renaissance works: "For the stiff, wooden limbs, and motionless figures, of the Byzantine school, he substituted life, movement, and the *look*, at least, of flexibility. . . . His style of coloring and execution was, like all the rest, an innovation in received methods" (25). Giotto's "feeling for grace and harmony in the airs of his heads and the arrangement of his groups was exquisite; and the longer he practised his art, the more free and flowing became his lines" (25). For Jameson, formal approaches to art enabled her to avoid religious controversy and to establish objective standards of taste.

Judith Johnston and J. B. Bullen have shown that Jameson differentiated herself from her influential predecessor Alexis François Rio, whose book *De la poésie chrétienne* (1836) canonized works of Catholic art for their ability to express religious feeling (Bullen 275; Johnston 160). Rio's Catholicism bothered British Protestants, but his focus on spirituality was extremely popular. Jameson hoped that her aesthetic emphasis would capture the spirituality of Catholic artworks while avoiding their specifically religious connotations. While Johnston, Bullen, and Michaela Giebelhausen have recognized Jameson's role in this movement, they do not trace Eastlake's use of formal criticism as a response to religious concerns. As I have already suggested, Eastlake differed from Jameson in advancing an even more strident anti-Catholic agenda rather than seeking to avoid religious controversy. Most important, Eastlake hoped to downplay the emotional effect of Catholic art by extending Jameson's focus on formal techniques.

CONCLUSION

Writing in a June 1874 letter to William Boxall, the retired second director of the National Gallery, Elizabeth Eastlake complains about purchases recently made by the new director, Frederick Burton: "I fear he has bought much that is second rate & much that is irrepairably injured, & for enormous prices. That Venus & Amorini by S: Botticelli seems to me to be monstrous in price. . . . I do not envy him, but doubtless his *set* will approve, & he must learn experience" (*Letters* 392). Eastlake here claims her professional knowledge and skills in several important ways. She is attentive to the issue of restoration, which was a pervasive problem in Victorian museum culture and in art critical discourse. She judges the value that the National Gallery has gained based on the price and quality of the artwork. Although East-

lake was one of the few mid-Victorian commentators to promote Botticelli, she questions the purchase of the *Venus & Amorini* for £1,627 from the Alexander Barker estate. Tellingly, Eastlake does not critique Botticelli's *Venus and Mars,* which the National Gallery purchased from the same collection for £1,050. Recent connoisseurship, assisted by twenty-first-century technology, has supported Eastlake's concerns; though the *Venus and Amorini* (now simply retitled *An Allegory*) is a fifteenth-century Italian painting, it is not by Botticelli, as the *Venus and Mars* almost certainly is. Demonstrating her twenty-first-century relevance, Eastlake's letter to Boxall was featured in a major summer 2010 exhibition at the National Gallery in London ("Fakes, Mistakes, and Forgeries"), which devoted an entire room to these two fifteenth-century Italian paintings.

Most significantly, Eastlake suggests in her letter that Burton has not yet developed the professional skills necessary to direct the National Gallery, abilities she sought to prove in her own career. Indeed, Eastlake hoped after the death of Sir Charles that she would be named the second director of the National Gallery. Writing to her cousin Hannah Brightwen in 1875, Eastlake remarked, "I feel that *I* shd have been his best successor in the direction of the Nat: Gallery" (qtd. in Sheldon, *Letters* 13). But, as Eastlake herself recognized, this was hardly a possibility in the mid-1860s in England, when women occupied no such positions of bureaucratic authority. To a certain extent, Eastlake's career is thus representative of the relative lack of recognition afforded to mid-Victorian women scholars—recognition that might have taken the form of official roles or simply a greater acknowledgement of independent scholarly achievements. But Eastlake's work also demonstrates the production of knowledge current in twenty-first-century debates among specialists as well as in popular exhibitions about the history of art.

CHAPTER 4

᠅

"I have often wished in vain for another's judgment"

MODELING IDEAL AESTHETIC COMMENTARY IN
ANNE BRONTË'S *THE TENANT OF WILDFELL HALL*

In her 1850 "Biographical Notice of Ellis and Acton Bell," Charlotte Brontë explains why she and her sisters adopted pseudonyms: "We had a vague impression that authoresses are liable to be looked on with prejudice; we had noticed how critics sometimes use for their chastisement the weapon of personality, and for their reward, a flattery, which is not true praise" (52–53). Bias against women authors was widely recognized in the Victorian period, but Charlotte cites a more specific problem: the dearth of fair criticism for women. Charlotte complains that women's writing is judged based on the writer's identity rather than on the merits of the work itself and that women writers tend to receive empty praise that betrays the critic's disdain. Charlotte's strategic use of a pseudonym eventually gained her productive criticism if not immediate publication; writing as Currer Bell, she submitted *The Professor* (not published until 1857) to Smith, Elder, and Co. and received in 1847 a useful letter in return:

It declined . . . to publish that tale, for business reasons, but it discussed its merits and demerits so courteously, so considerately, in a spirit so rational, with a discrimination so enlightened, that this very refusal cheered the

76

author better than a vulgarly-expressed acceptance would have done. ("Bio-
graphical Notice" 53–54)

Against the "prejudice" and "flattery" that women artists often experi-
enced, Charlotte defines in the "Biographical Notice" several features of
ideal criticism, especially the requirements that it be reasonable, educated,
and "courteously" phrased.

Unlike Charlotte, Anne Brontë wrote very little about her artistic prac-
tice outside of her preface to the second edition of *The Tenant of Wildfell
Hall* (1848). Therein, Anne complains that even writing under her pseud-
onym of Acton Bell failed to gain *Tenant* the sort of rational criticism that
Charlotte received concerning *The Professor.* Instead, *Tenant* received either
praise "greater than it deserved" or "asperity . . . more bitter than just"
("Preface" 3). Anne hoped that critics would objectively read *Tenant* as a
truthful representation distinctly different from the works of Currer or
Ellis Bell ("Preface" 5). However, many contemporary reviewers lumped
the works of the three authors together.[1] Once Charlotte revealed the iden-
tity of the sisters in her 1850 "Biographical Notice," critics assumed that
Tenant was simply modeled on *Jane Eyre* or *Wuthering Heights,* a notion that
was often repeated in the twentieth century. Other nineteenth- and twen-
tieth-century critics further questioned Anne's status as a realistic artist by
claiming that her inclusion of Helen Huntingdon's long diary in the middle
of *Tenant* was an unthinking mistake. Charlotte herself undercut Anne's
claim to realistic art by claiming that her subject was—against Charlotte's
explicit advice—too closely based on the Brontës' family life ("Biographical
Notice" 55).

More recently, Margaret Mary Berg, Antonia Losano, and others have
demonstrated that Anne was an artist consciously different from her sisters,
especially in her representation of an independent woman painter, Helen
Huntingdon, who develops toward a more realistic style.[2] However, despite
this recent attention to Helen's painting and, more generally, to resurrect-
ing Anne as the intellectual and artistic equal of Charlotte and Emily, aes-
thetic commentary in Anne's novels remains underexamined. *The Tenant
of Wildfell Hall* as well as *Agnes Grey* reveals that Anne shared with Char-
lotte a vision of ideal external criticism as both educated and rational, criti-
cism that is best exemplified by *Tenant*'s Gilbert Markham. But Anne also
suggests, primarily through Helen's writings in her diary, that the artist is
sometimes best served by her own commentary. Against the Victorian ste-
reotype that equated serious criticism with an external male voice, Helen

objectively assesses both her own artworks and those of others. Through Helen's selective use of aesthetic commentary, Anne Brontë provides an implicit answer to complaints that she either failed to heed any artistic advice or that she did not understand her own aesthetic choices in *Tenant*.

As has been well-documented, the Brontës were very knowledgeable about the visual arts, a fact that informed key scenes in their novels. In *The Art of the Brontës*, Christine Alexander and Jane Sellars detail how Anne, Charlotte, and Emily gained this knowledge—primarily from romantic drawing manuals; from their art instructor, John Bradley; and from their artist brother Branwell. Alexander notes that Charlotte and her sisters were not simply passive receivers of art; they "were often critical [in their juvenilia] of the forced association between text and picture, occasioned by the poetry or prose being commissioned to accompany an already completed engraving" (15). In other words, the Brontë sisters early on demonstrated attentive and unconventional aesthetic interpretations that they later hoped to find among readers of their novels. Charlotte, for example, followed "the art reviews she had read in the pages of *Blackwoods*" in critiquing such engravings for their uses of perspective and the picturesque (Alexander 15). Sellars writes of Anne, "We have no documentation of the writer's personal views on art but we can attempt to interpret them by reading her novels and by scrutinizing the small number of her drawings still in existence" (134). As I will shortly illustrate in more detail, Anne's novels demonstrate her view of ideal aesthetic commentary as informed by both an extraordinary knowledge of artistic technique and a willingness to question conventional symbolic interpretations.

In contrast to Anne, we know much about Charlotte's aesthetic views, especially on nineteenth-century art criticism as well as on her sisters' novels. Charlotte read and enjoyed William Hazlitt's essays (Wise 3: 88, 174). Like her biographer Elizabeth Gaskell, Charlotte was very familiar with John Ruskin's more famous works, including *The Seven Lamps of Architecture* and *Modern Painters*. Writing to W. S. Williams (the reader at Smith, Elder, and Co.) in July of 1848, Charlotte expressed her enthusiasm about Ruskin's *Modern Painters,* Volume 1 (Wise 2: 240). Given Charlotte's excitement about reading Ruskin, and her willingness to communicate her views of him with acquaintances outside the family, it seems likely that she would have shared *Modern Painters* with her sisters as well. Helen Huntingdon's evolution to more realistic art further suggests that Anne was familiar with the Ruskin school of criticism.

Moreover, Charlotte had Anne explicitly in mind in her July 1848 letter to Williams, as she immediately follows her comments on Ruskin with her

worries that negative reviews of *Tenant* have "depressed" Anne (Wise 2: 241). There are parallels as well between her views of Ruskin and of *Tenant* in this letter. Praising Ruskin's style—"there is both energy and beauty in it"—she opines that *Tenant,* by contrast, "had faults of execution, faults of art" (Wise 2: 240–41). Though Charlotte states in a letter to Williams dated August 14, 1848 that all three sisters are still working on their "art," she clearly viewed *Tenant* as a novel inferior to Anne's earlier *Agnes Grey* (Wise 2: 241, 243). Charlotte's 1850 "Biographical Notice" confirmed her discontent with *Tenant*'s subject as "an entire mistake. . . . She hated her work, but would pursue it" (55). Though Charlotte complains elsewhere in her "Biographical Notice" that critics assess women's art based on the personality of the writer, she seems to make this same mistake here, conflating the novel with the dourness that she saw in her sister. Charlotte suggests that *Tenant* is, in effect, devoid of novelistic art; the book is a mere sermon or documentary designed to warn readers about the evils of debauchery. Perhaps most damaging to Anne's artistic reputation, Charlotte describes her sister's writing as drudgery, not as an artistic process. For Berg, though Charlotte's "passage stresses Anne Brontë's willful determination to use art as a vehicle of moral instruction, the impression that it ultimately conveys is that of a writer at the mercy of a compelling force [personal experience] which she cannot resist and which prevents her from choosing a saner alternative by submitting to the authority of her sister's 'reasonings'" (10). Charlotte places herself in the "Biographical Notice" as the sort of rational reader that she found at Smith, Elder, and Co. after submitting *The Professor* and complains that Anne failed to heed her warnings, thereby sacrificing her artistic practice.[3]

Though Anne did not write directly about nineteenth-century aesthetics aside from her preface to *Tenant,* her novels contradict Charlotte by showing that she did understand the difference between the repetition of mere personal experience and the process of discovery that creates successful art. In *Agnes Grey,* Anne provides a model of unbiased artistic critique that can lead to such artworks. This aesthetic commentary seeks to ignore monetary value, gossip about artworks, and even family ties to the artist. Anne contrasts the ideal aesthetic commentator with Rosalie Ashby, who evaluates paintings based merely on these superficial considerations. Inviting Agnes to Ashby Park, her new home after marrying Lord Ashby, Rosalie remarks that Agnes will see there "two fine Italian paintings of great value . . . I forget the artist . . . doubtless you will be able to discover prodigious beauties in them, which you must point out to me, as I only admire by hearsay" (174, chap. 21). Rosalie's assessment is clearly not based on the

careful interpretive work that Anne expected readers to bring to her novels. For Rosalie, the paintings are simply another possession, like her poodle and even her own child (173–74, chap. 21). In many respects, Rosalie appears as the typical nineteenth-century character who betrays her superficiality though her inability to appreciate art. Yet Rosalie is also distinctive in recognizing her interpretive shortcomings and in pointing to Agnes as a better model. Though we have few examples in the novel of Agnes commenting on art, her ability, in Rosalie's words, "to discover" something new by actually looking "in" artworks suggests features of this interpretive model. This process of discovery is equally important in *Tenant* and contradicts Charlotte's claim that Anne viewed artistic production as mere drudgery. As we will see, superficial characters in *Tenant* lack even the ability to discern their betters in aesthetic perception, suggesting a pointed social critique of the Regency rakes in that novel and of the Victorian tendency to discuss art merely because it was fashionable to do so.

Like Helen Huntingdon in *Tenant,* Agnes Grey's sister Mary successfully paints for money. Also like Helen, Mary does so out of necessity—ostensibly so that her ailing father can "spend a few weeks at a watering place" (*Agnes Grey* 7, chap. 1). Mary's mother encourages the plan: "Mary, you are a beautiful drawer. What do you say to doing a few more pictures, in your best style, and getting them framed, with the water-colour drawings you have already done, and trying to dispose of them to some liberal picture-dealer, who has the sense to discern their merits?" (7–8; chap. 1). Mrs. Grey's comments are notable for several reasons. First, the picture dealer must be "liberal," that is, willing to accept paintings for sale from a woman artist. Mrs. Grey does not propose hiding Mary's identity as Helen does in *Tenant;* she hopes that Mary's paintings will be judged by "their merits" and not by the artist's sex. Moreover, Mary would have been identified as a woman artist not only by her name but also by her feminine medium of watercolors (Losano, "Professionalization" 25n). Helen's decisions to hide her identity and to paint in the masculine medium of oils surely made *Tenant* more threatening to Victorian readers than *Agnes Grey.* Unlike Helen, Mary does not actually support herself or her family, as the Greys ultimately do not need the money (Mary's father encourages her to keep the money). By contrast, Helen supports herself through her painting in *Tenant,* suggesting Anne Brontë's own growing assurance as a novelist and her desire to subvert stereotypes about women's independence.

Mrs. Grey's comments about Mary's art are most significant because of their critical acuity. Mrs. Grey does not judge Mary's art based on the fact that Mary is her own daughter but on their merits as aesthetic objects. In

this sense, Mrs. Grey functions as the sort of ideal critic and reader that both Charlotte and Anne Brontë sought. Mrs. Grey demonstrates her objective appraisal of her daughters' art by contrasting her praise of Mary with her more qualified comments to Agnes: "You draw pretty well too; if you choose some simple piece for your subject, I dare say you will be able to produce something we shall all be proud to exhibit" (8, chap. 1). The implications here seem fairly straightforward: Agnes is good enough to hang something up (if perhaps only in their own home) but not talented enough to earn money. Though we never find out if Agnes might have sold her paintings if she had followed a different career path (Mrs. Grey's comments solidify Agnes's plan to become a governess), we do know that Mrs. Grey was right about Mary, who later "had good success [in selling] her drawings" (48, chap. 5). Mary's more successful drawing career is not solely due to her talent but also to hard work, which contrasts with Agnes's much more distracted practice. Agnes remarks, "Mary got her drawing materials, and steadily set to work. I got mine too; but while I drew, I thought of other things" (9, chap. 1). As we will see, Mary's commitment to hard work allies her with the similarly successful Helen Huntingdon in *Tenant,* which suggests the value that Anne Brontë attached to this virtue in aesthetic production.[4]

Both Mary in *Agnes Grey* and Helen in *Tenant* lack access to the sort of external, public aesthetic commentary that Charlotte Brontë valued in her artistic career, and so they must seek more private sources. For Mary, it is her mother who determines the merit and marketability of her work. For Helen, artistic insights are first developed through personal reflections in her diary. Elizabeth Langland usefully asserts that Helen's diary mitigates the "soft nonsense," or unrealistic niceties, that Anne Brontë hoped to avoid in writing *Tenant* (Brontë, "Preface" 3). Unlike the constant gossip that Helen experiences upon moving to Wildfell Hall—gossip that is "without identifiable authority" and "mindless"—writing in the novel "suggests both thought and authority" (Langland, *Anne Brontë* 122). Helen develops her aesthetic "authority" through her written reflections on her art. Writing allows Helen to judge her artworks objectively based on form, technique, and artistic conception. Moreover, Helen's writing prompts her (and readers) to consider the symbolic significance of her paintings, which is less important to her career but central to her growing awareness of herself and others. Helen's decision to establish independence by leaving her husband and painting for a living was the most outwardly shocking aspect of *Tenant* for contemporary readers. Yet it is Helen's critical mind, as expressed through her commentary on art, that helps her improve her painting and

therefore her earning potential. Helen paints for a living only during a brief section of her life after she manages her escape from Arthur Huntingdon and before his death allows her to reassume the station of a lady. However, Helen writes about her paintings throughout her long diary, both before and during the period in which she paints for a living.

While circumstances force Helen to sell her paintings, she early on expresses professional motivations in her diary by hoping to reach a broader audience. Scholars have commonly identified two phases in Helen's painting career: amateur and professional (Losano, "Anne Brontë's Aesthetics" 53), but this division is blurred when we examine Helen's early writings on her art. Helen begins her diary by imagining that her art may one day do more than simply distracting her: "If my productions cannot now be seen by any one but myself and those who do not care about them, they, possibly, may be hereafter. But then, there is one face I am always trying to paint or to sketch, and always without success; and that vexes me" (123, chap. 16). Arthur Huntingdon, the owner of the face she is trying to draw, is one possible audience for her art. But Helen is aware that this infatuation impedes access to an even larger, more astute audience. Her many portraits of Arthur are personal, not public, works, as her later mortified reaction to Arthur's discovery of them indicates. Even in writing about these portraits of Arthur, Helen assesses them critically, noting that her efforts are "always without success" (123, chap. 16). To be sure, Helen's infatuation with her subject may be part of the reason for her self-critique, but she is equally exacting in assessing other artworks at this point in her career.

Helen's writing on an early landscape painting that she intended to be her "master-piece" (150, chap. 18) demonstrates a critical knowledge of formal artistic terms:

> The scene represented was an open glade in a wood. A group of dark Scotch firs was introduced in the middle distance to relieve the prevailing freshness of the rest; but in the foreground were part of the gnarled trunk and of the spreading boughs of a large forest tree, whose foliage was of a brilliant golden green. . . . Upon this bough, that stood out in bold relief against the sombre firs, were seated an amorous pair of turtle doves, whose soft sad coloured plumage afforded a contrast of another nature. (150, chap. 18)

Helen's command of such formal concepts as "middle distance," "foreground," and "bold relief" shows that she is a serious artist prior to selling her paintings. While early-Victorian commentators often described

paintings in terms of narrative significance, Helen presages later, professional critics in focusing on form as well as on the story told by the painting. These formal terms suggest that Helen's painting before her marriage is not merely a woman's accomplishment, and thus it may be too simple to assume that she becomes a professional only when she makes money. Moreover, Helen's command of painterly technique indicates that Anne Brontë was more knowledgeable about novelistic form than those who have critiqued *Tenant* have commonly believed. In a famous remark that influenced twentieth-century views of the novel, the Irish novelist and critic George Moore (1852–1933) wrote that "almost any man of letters" would have advised Anne to let Helen tell her story directly rather than interrupting the story with Gilbert's reading of Helen's diary (253).[5] But Anne seems in *Tenant* conscious of both formal features and overall aesthetic effect. Helen considers her landscape in total as "somewhat presumptuous in the design" (150, chap. 18). Helen suggests through this comment that she understands the distinction between art and life. For Losano, "A 'presumptuous design' hints at the intervention of the artist into the realities of nature, the presence of conscious aesthetic form rather than systematic copying from nature" ("Anne Brontë's Aesthetics" 56). In emphasizing aesthetic design over mimesis, Anne Brontë here seems well aware of how to avoid the problem that Charlotte and other critics supposedly identified in her novels—that is, that they were too much like Anne's own life.

Through her heroine, Anne seems equally conscious that art should communicate certain ideas through an original composition. Helen writes in her diary, "I had endeavoured to convey the idea of a sunny morning. I had ventured to give more of the bright verdure of spring or early summer to the grass and foliage, than is commonly attempted in painting" (150, chap. 18). Even at this supposedly preprofessional stage in her career, Helen's verbs indicate awareness of her own artistic inadequacies in reaching for the uncommon. This gap between ideals and execution—a recurring problem in Victorian aesthetics—is similarly represented in *Jane Eyre*. Jane remarks of the paintings that Rochester examines, "My hand would not second my fancy; and in each case it had wrought but a pale portrait of the thing I had conceived" (157, chap. 13)—an opinion seconded by Rochester: "You have secured the shadow of your thought; but no more, probably" (158, chap. 13). Losano notes that Jane's ekphrasis "emphasizes the process of painting rather than the product" (*Woman Painter* 116). By contrast, Helen's written commentary aims at—and eventually helps achieve—a more finished product, which suggests a difference in aesthetic philosophy between Anne's novels and those of Charlotte. Instead of emphasizing

the process of artistic creation, Anne hoped that her novel would represent successful likenesses of real, if sometimes undesirable, characters ("Preface" 3).

Helen's writings about her landscape thus demonstrate her early awareness of artistic ideas and formal execution. But her commentary also shows the importance of symbolic and narrative interpretations, which often underscore Helen's emotional connections to her paintings. A central part of Anne's aesthetic philosophy, one wrongly critiqued by Charlotte as unconsciously expressed, was that art should be informed by lived experience and feeling. Naomi Jacobs remarks that Helen's diary in general allows her to express "all the rage and frustration she must suppress when with other people. She mentions several times that the writing 'calms' her" (213). While Jacobs has Helen's married life specifically in mind, her observation about Helen's ability both to steady herself and to express feelings through her writing is equally applicable during her courtship with Huntingdon. These feelings are prominently expressed through symbolic descriptions of her landscape painting. Most obviously, the "amorous pair of turtle doves" in the painting suggests a connection to Helen's infatuation with Arthur Huntingdon (150, chap. 18).

But Helen's adjectives also imply a warning, which Helen may only realize subconsciously at this point in her life; the turtle doves' "soft *sad* coloured plumage" indicates the perils that await young couples in love (150, chap. 18; emphasis mine). The turtle doves are "too deeply absorbed in each other" to notice the young girl kneeling before them. This absorption in each other and ignorance of their surroundings suggests narrative significance; the birds are unaware of anything that might threaten their future happiness. The young girl does not provide a better model of attention; her "pleased" and "earnest" gazing show that she does not understand the troubles that await the turtle doves; she will likely make the same mistakes in her own love life (150, chap. 18). As Brontë notes in her preface, the novel as a whole is a warning to young women taken with dashing young men, with symbolic and narrative descriptions of artworks serving to reinforce this message in powerful ways. Brontë suggests that Helen should have read her painting for its negative symbolic connotations as well as for the possibility that the story begun by the painting could end badly.

In contrast to the novel's ideal mode of interpretation—that is, closely examining form, symbolism, and narrative—Arthur Huntingdon "attentively regard[s] [Helen's landscape] for a few seconds" (Helen wryly remarks) while trying to court her (150, chap. 18). Huntingdon's cursory attention to Helen's painting indicates a pervasive problem in Victorian aes-

thetics, particularly as more and more artworks were available to the public eye. In a lecture delivered at the 1857 Manchester Art Treasures Exhibition, which I discuss more fully in the next chapter, Ruskin argues, "The amount of pleasure that you can receive from any great work, depends wholly on the quantity of attention and energy of mind you can bring to bear upon it" (*Works* 16: 57–58). Similarly, in her preface to the second edition of *Tenant*, Anne Brontë writes that early critics of the novel have read the novel "with a prejudiced mind [or have been] content to judge it by a hasty glance" (3). Huntingdon demonstrates the kind of superficial appraisal about which Ruskin and Brontë worried, a method of looking unlikely to unravel even the simplest artworks. But Huntingdon is not simply marked as a superficial character because of his inability to appreciate art; more specifically, he fails to use the interpretive tools advocated by the novel. Instead of considering Helen's technique, formal features, and symbols, Huntingdon remarks on the landscape in clichéd terms:

> Very pretty, i'faith! and a very fitting study for a young lady.—Spring just opening into summer—morning just approaching noon—girlhood just ripening into womanhood—and hope just verging on fruition. She's a sweet creature! but why didn't you make her black hair [that is, like Helen's]? . . . I should fall in love with her, if I hadn't the artist before me. (150, chap. 18)

Helen's technical as well as symbolic description of her painting demonstrate the limits of reading the painting on a merely iconographic level, "searching for particular symbolic motifs and assigning significance to various visual elements in her picture" (Losano, "Anne Brontë's Aesthetics" 51). Moreover, Helen's decision about the figure's hair—"I thought light hair would suit her better" (151, chap. 18)—suggests just one of the ways in which Huntingdon's biographical reading is amiss. Huntingdon's association of the painting's subject with Helen demonstrates a particular challenge that women artists and art critics faced in commentary on their work: not only did they struggle with the general lack of attention that Ruskin describes, but they also had to deal with the sexual interest of male viewers, including that from Ruskin himself. Responding in 1886 to a letter in which the artist and art critic Emilia Dilke acknowledged her intellectual debt to him, Ruskin highlights her sexuality over her status as the foremost authority on French art history in Britain: "I am entirely delighted but more astonished than ever I was in my life—by your pretty letter and profession of discipleship. . . . I thought you at Kensington the sauciest of

girls" (qtd. in Israel 87). Helen escapes this kind of attention only upon first moving to Wildfell Hall.

In an earlier chapter titled "Further Warnings," Brontë contrasts Arthur Huntingdon's self-interested appraisal of art with Helen's thoughtful and solicited commentary on the works of others. Because he is not romantically interested in Milicent Hargrave, Huntingdon "carelessly takes up" her drawings and casts each one aside without comment (136, chap. 17). Instead of forcibly taking another's paintings—as Huntingdon does so often—Helen provides advice only when asked. She comments on Milicent's paintings "with my critical observations and advice, at her particular desire" (136, chap. 17). Helen's "critical" comments and "advice" oppose the mere flattery that women artists commonly experienced in the mid-Victorian period. Although we do not know exactly what Helen says to Milicent, we can guess that she provides expertise about the paintings' form and ideas, as she does in remarks on her own paintings. Thus, Brontë may have imagined Helen as the sort of figure who could supply some of the rational and courteous criticism on women's work that she found lacking. But Brontë represents both the value and limitations of such collaborations: while Helen remarks on Milicent's drawings when asked, she never requests Milicent's opinions, nor are her drawings ever described in the text, perhaps indicating that Milicent is not the same caliber of artist.[6]

A more significant problem is that Helen's ability to provide critical commentary to Milicent is limited by her own infatuation: "My attention wandered from [Milicent's] drawings to the merry group," which included Huntingdon (136, chap. 17). Brontë here demonstrates that characters cannot be neatly divided between those who appreciate art and those who do not; though Helen provides a better model of attention than does Huntingdon, she too is distracted by her own love interest. Moreover, she initially fails to correctly interpret Huntingdon's superficial social performances, suggesting her own lack of perceptive acuity. Notably, Helen's diary helps her begin to "see" Huntingdon more clearly; she writes, "I do not think the whole would appear anything very particular, if written here, without the adventitious aids of look, and tone, and gesture, and that ineffable but indefinite charm, which cast a halo over all he did and said, and which would have made it a delight to look in his face, and hear the music of his voice, if he had been talking positive nonsense" (136, chap. 17). Surely, Huntingdon *is* speaking nonsense, and thus embodies the "soft nonsense"— the mere charming flow of words—that Anne Brontë eschews in her preface (3). Huntingdon appears in Helen's description as a sort of villainous melodramatic actor with his overstated gestures and his thoughtless words,

a performance that requires little interpretation on the reader's part. But while Helen partially acknowledges Huntingdon's superficiality, she is on the whole taken with him.

Like her ekphrastic comments on her landscape painting, Helen's later writings on Huntingdon's portrait help her more accurately diagnose his flaws. After experiencing life with the increasingly degenerate Huntingdon and then escaping from him, Helen writes of his portrait, "Now, I see no beauty in it—nothing pleasing in any part of its expression; and yet it is far handsomer and far more agreeable—far less repulsive I should rather say—than he is now; for these six years have wrought almost as great a change upon himself as on my feelings regarding him" (377, chap. 44). Unlike what occurs in *The Picture of Dorian Gray,* the portrait itself has not changed. Rather, Huntingdon's physical decline finally causes him to look like what he is—an ugly and vulgar man—a fact that Helen should have read much earlier in his portrait. Similarly to such later Victorian art commentators as Walter Pater and Oscar Wilde, Helen acknowledges the subjective role of the viewer in assessing art and nature. But, through her comments on her landscape and on Huntingdon's portrait, she also implies that some interpretations better account for the real life that these artworks represent. Most prominently, art should be interpreted without the sort of romantic "charm" that clouded Helen's initial appraisal of both Arthur Huntingdon's social performances and her own portrait of him. As Brontë notes about "vicious characters" in her preface to *Tenant,* "It is better to depict them as they really are than as they would wish to appear" (4). Anne here responds to criticism of the first edition of *Tenant* that she went too far in portraying the depravity of Arthur Huntingdon and his friends, saying that they are depicted realistically even if readers might hope that such characters do not exist. Brontë suggests that readers have the duty to acknowledge realistic representations when they are rendered as such.

In noting *Tenant*'s basis in real characters, Anne seems to reinforce Charlotte's critique that *Tenant*'s subject is merely based on Anne's own family life ("Biographical Notice" 55). But Anne's preface also speaks of the thankless and difficult labor inherent in her realistic artistic process: "I wished to tell the truth. . . . But as the priceless treasure too frequently hides at the bottom of a well, it needs some courage to dive for it, especially as he that does so will be likely to incur more scorn and obloquy for the mud and water into which he has ventured to plunge, than thanks for the jewel he procures" (3). Realistic art, claims Anne, takes more work than simply copying real life or repeating more comfortable stories. As Alexandra Wettlaufer notes, Anne's realistic artistic vision worked against Charlotte's

attempts to romanticize the Brontë sisters: "*The Tenant of Wildfell Hall* and its hero, Helen Huntingdon, participated instead in the ongoing construction of a new image of the female artist in the mid-century as neither accidental nor apologetic, but instead as a woman whose identity is deliberately chosen and defiantly located in an unromanticized world of contemporary reality" (225). Similar to Anne's productive process, Helen describes how she must labor to improve her skills as she moves toward producing more realistic art as a means of financial support:

> The palette and the easel, my darling playmates once, must be my sober toil-fellows now. But was I sufficiently skilful as an artist to obtain my livelihood in a strange land, without friends and without recommendation? No; I must labour hard to improve my talent and to produce something worth while as a specimen of my powers, something to speak favourably for me, whether as an actual painter or a teacher. (337, chap. 39)[7]

The sort of work that Helen has in mind here is clearly different from her earlier approach to art. But her consciousness and knowledge of its deficiencies are not new. As I have argued, it is this growing self-knowledge, expressed through writing, that enables Helen to paint for money rather than becoming what was more socially acceptable for a Victorian woman: "a teacher" (337, chap. 29).

If Helen's early interpretations and paintings are made less successful by her infatuation with Arthur Huntingdon, her efforts to improve her painting through hard work are impeded by unsolicited comments and advances from Walter Hargrave. Helen sets up her easel in the library, which she believes will be private. Hargrave, however, interrupts Helen's solitary painting with his superficial comments on art. Helen writes sarcastically, "Being a man of taste, he had something to say on this subject as well as another, and having modestly commented on it, without much encouragement from me, he proceeded to expatiate on the art in general" (338, chap. 29). Like Arthur Huntingdon and his lack of attention, Hargrave demonstrates a particular problem in Victorian aesthetics: a tendency for cultured individuals to talk about art merely because it was fashionable to do so. Also like Huntingdon, Hargrave's primary interest in Helen is sexual; he cares little about her art. Yet Brontë's primary point here is not about how to judge individual characters based on their appreciation of art but about how a woman's art should be produced and interpreted. Helen's writings and her sarcastic tone reveal Anne Brontë's understanding and critique of the cultural as well as personal challenges that faced women

artists. In response to these challenges, Brontë suggests that a woman's art is usually best produced and interpreted in solitude, without the distracting attentions of male viewers. Notably, Helen is best served at this point in her artistic career by her own diaristic writings, not by comments from any male viewers.

Helen's move to Wildfell Hall helps her to avoid, for a time, the bothersome attentions of male suitors, and she there demonstrates her developing cleverness as an artist. Helen takes obvious satisfaction in painting for a living; her studio, she writes,

> has assumed quite a professional, business-like appearance already. I am working hard to repay my brother for all his expenses on my account; not that there is the slightest necessity for anything of the kind, but it please me to do so: I shall have so much more pleasure in my labour, my earnings, my frugal fare, and household economy, when I know that I am paying my way honestly. (376–77, chap. 44)

Like Mary in *Agnes Grey,* Helen does not need to work for a living, as her brother would gladly support her. But Helen—in supporting herself fully—subverts Victorian gender norms to a greater extent than does Mary and influences another woman to at least contemplate independence. Weary of her mother's entreaties to marry, Esther Hargrave tells Helen, "I threaten mamma sometimes, that I'll run away, and disgrace the family by earning my own livelihood, if she torments me any more; and then that frightens her a little. But I *will* do it, in good earnest, if they don't mind" (419, chap. 48). Helen counsels patience, but it is she who has abandoned a self-described "career" as a wife. As a painter, Helen gains a certain degree of power and freedom of choice. Her removal of Huntingdon's portrait from its frame, a frame she will reuse for another saleable painting, symbolizes this greater control over her own affairs (377, chap. 44). Further, Helen deliberately conceals her identity: she signs her paintings with false initials and changes the names of places depicted in her paintings (43, chap. 5)—an indication of Anne Brontë's knowledge of the period's fascination with attribution, which was famously connected with her own authorship. Equally important as her growing professional control, Helen's move to Wildfell Hall facilitates her more astute interpretations of paintings in her diary. It is only after escaping Arthur Huntingdon's house that Helen is able to read his portrait as an indication of his depravity.

As it turns out, however, Helen becomes too isolated at Wildfell Hall. She can no longer comment on the art of others, and she finds that she

needs an outsider's perspective on her own paintings. Against critics who have argued that Anne Brontë erred in her narrative structure, Juliet McMaster posits the importance of both Helen's diary *and* Gilbert's narration: "As Helen's diary records the destruction of opposites [Helen and Arthur Huntingdon], the story of Gilbert Markham serves to restore our faith in the possibility of a relationship between a man and a woman that is one of equals who are capable of mutual accommodation and beneficial modification" (363). Such "accommodation" and "modification" are significantly expressed through Gilbert and Helen's conversations on aesthetics. Early in his narration, Gilbert indicates his perceptiveness in deciphering Huntingdon's character in one of Helen's portraits: "There was a certain individuality in the features and expression that stamped it, at once, a successful likeness. The bright, blue eyes regarded the spectator with a kind of lurking drollery—you almost expected to see them wink; the lips—a little too voluptuously full—seemed ready to break into a smile" (45, chap. 5). Gilbert here positions himself as an ideal reader of *Tenant* by recognizing this portrait as a realistic representation or "successful likeness." By contrast, early readers of *Tenant* failed to recognize that "characters [like Huntingdon] do exist" ("Preface" 4). Most important, Gilbert can read the portrait for Huntingdon's flawed character. Huntingdon's features are more than simply mimetic for Gilbert; the eyes and lips rightly suggest for him negative symbolic qualities in the way that they seem to wink and smile mockingly. In referring to his reader in the second person, Gilbert asks readers of the novel to imagine how the portrait would mock its viewer if it could move. We are thus encouraged to interpret the portrait the way Gilbert does, realizing that Huntingdon is "prouder of his beauty than his intellect" (45, chap. 5). Through Gilbert's interpretation, we are meant to understand that Huntingdon represents the certain threat to women that Anne Brontë implies he is in positing the existence of "vicious characters" ("Preface" 4).

To be sure, the autobiographical form of the novel (in the guise of his letter to Halford) allows Gilbert to "shape his past to portray himself in the most advantageous light" (Westcott 214), that is, to make himself look perceptive. But Gilbert's trick is ultimately Brontë's; by constructing her novel so that Gilbert can portray himself as an interpretive model, Brontë again demonstrates her consciousness of her own formal choices. Gilbert himself reinforces this attentiveness to form by writing about Helen's growth as an artist in specific, formal terms; the Huntingdon portrait is "not badly executed; but, if done by the same hand as the others, it was evidently some years before; for there was far more careful minuteness of detail, and less of that freshness of colouring and freedom of handling, that delighted and

surprised me in them" (44, chap. 5). Gilbert positions himself as a percep-
tive connoisseur in recognizing similarities among Helen's paintings while
also noting specific improvements in her later works: "freshness of colour-
ing and freedom of handling" (ibid.). Helen has moved beyond mere col-
oring and execution to a freer style that can express the larger concepts
lacking in her earlier landscape. Like Helen in her comments on this land-
scape, Gilbert understands that good art is not simply the result of mime-
sis or "careful minuteness of detail." Rather, we should look for ideas that
"delight" or "surprise," even if they are imperfectly rendered. These verbs,
which describe Anne's conception of the effect of successful art on a per-
ceptive viewer, provide an implicit answer to Charlotte's claim in her 1850
"Biographical Notice" that Anne's writing drudgingly copied actual life.

Helen's markedly different reactions to Gilbert confirm his status as
someone who can help her further improve her paintings. Gilbert nar-
rates that when asked "about some doubtful matter in her drawing[,] [m]
y opinion, happily, met her approbation, and the improvement I suggested
was adopted without hesitation" (64, chap. 7). To our knowledge, this is the
first time in her life that Helen has sought or accepted another's sugges-
tion on her art. Helen makes clear the importance of Gilbert's perspective:
"I have often wished in vain for another's judgment to appeal to when I
could scarcely trust the direction of my own eye and head, they having been
so long occupied with the contemplation of a single object, as to become
almost incapable of forming a proper idea respecting it" (64, chap. 7). Hel-
en's contrast between mere fixation on the object depicted and the ideas
expressed by the artwork demonstrate Anne Brontë's desire to go beyond
the mere facts of her own family life in writing *Tenant*. Gilbert responds
to Helen's worry about fixation: "That . . . is only one of the many evils
to which a solitary life exposes us" (64, chap. 7). Helen agrees with Gil-
bert's remark, indicating that, though she values painting in solitude, she
could learn to value such conversations with an equal in both intellect and
perception.

Near the end of the novel, Gilbert appears to question his own percep-
tiveness by noting (in his letter to Halford) that he initially failed to under-
stand the symbolic significance of the rose that Helen presents to him.
Upon picking the "half-blown Christmas rose" and removing the snow
from it, Helen remarks, "The rose is not so fragrant as a summer flower,
but it has stood through hardships none of *them* could bear. . . . Look, Gil-
bert, it is still fresh and blooming as a flower can be, with the cold snow
even now on its petals.—Will you have it?" (465, chap. 53). Because Gilbert
does not immediately understand the rose's significance, readers are asked

to form their own interpretations, keeping in mind the previous significance of such symbols. The symbolism here seems straightforward: the rose represents Helen, who has been made stronger, though no less attractive, by her trials. In offering the rose to Gilbert she is offering herself as well; like the rose, she has unfrozen herself. Though he eventually holds out his hand and accepts Helen's gift, Gilbert hesitates to grasp the rose—in both literal and symbolic terms. However, Gilbert's hesitation in fact marks him as a more careful perceiver than Arthur Huntingdon, who too quickly (and wrongly) assumes symbolic understanding of Helen's paintings.

Moreover, Gilbert points out that the interpretive blockages in this scene are not his alone, as Helen misinterprets his actions: "Misconstruing this hesitation into indifference—or reluctance even—to accept her gift, Helen suddenly snatched it from my hand, threw it out on to the snow, shut down the window with an emphasis, and withdrew to the fire" (465–66, chap. 53). Gilbert again fails to understand the symbolism behind Helen's gestures, asking, "Helen! what means this?" (466, chap. 53). Helen complains, "You did not understand my gift," to which Gilbert responds, "You misunderstood me, cruelly" (466, chap. 53). Brontë emphasizes the importance of mutual understanding in this scene. In doing so, she suggests her duty to make her art clear as well as the necessity for readers to interpret the novel for both its lifelike and symbolic qualities. Helen reveals the meaning of the rose only after allowing Gilbert (and readers) time to decipher on their own: "The rose I gave you was an emblem of my heart" (466, chap. 53). Gilbert still does not grasp Helen's full meaning, as he needs to ask if he may have her "hand" in marriage. Gilbert remarks in his letter to Halford, "Stupid blockhead that I was!—I trembled to clasp her in my arms, but dared not believe in so much joy" (467, chap. 53). Despite the initial confusion, Gilbert's point is that he has learned to interpret Helen's actions, complementing his ability to read her art for symbolic meaning.

This increased symbolic acuity, coupled with Gilbert's astuteness in formal matters, positions him as an ideal reader—not only of Helen's history, but also of the novel as a whole. The same can be said of Helen, who develops both her own symbolic interpretations and her aesthetic techniques. Given the interpretive models that *Tenant* itself provides, we should take Anne Brontë seriously as a significant contributor to the nineteenth-century discourse about aesthetics, including the differences between real life and its more figurative rendering in art. Read in this way, Anne Brontë can be seen as not just the equivalent of her sisters, but also as making her own distinct contribution to nineteenth-century realism.

CHAPTER 5

A New Kind of Elitism?

ART CRITICISM AND MID-VICTORIAN EXHIBITIONS

\mathcal{H}elen Huntingdon's initial skepticism about accepting guidance from others and eventual acceptance of only Gilbert's advice reflect a familiar Victorian tension between reliance on authority figures and a commitment to one's own critical faculties. Not surprisingly, Victorian artists were not the only figures to confront this problem. This chapter considers how this tension between authority and more subjective interpretations affected viewers as they confronted a bewildering array of artworks. While dependence on the descriptions provided by art critics was inevitable in 1848 when engravings were not cheap, the opening of public galleries and the proliferation of illustrated periodicals made personal encounters with art increasingly possible. After the establishment of the National Gallery in 1824, public galleries and exhibitions steadily grew throughout the nineteenth century. Amassing artworks in these public venues was viewed as an issue of national importance—large collections in the National Gallery and elsewhere, it was thought, would show the rest of Europe that Britain was finally serious about the arts. Moreover, many art critics and government figures believed that these exhibitions would, with proper organization and written guidance, help elevate public taste by teaching a growing audience which artworks to appreciate. While artworks in

eighteenth-century venues were usually hung randomly, with no written assistance, most Victorian public exhibitions attempted to arrange chronologically or by school and sometimes included wall placards and catalogues to educate a general audience.

The reality of these Victorian public venues, however, was much less tidy than the ideal imagined by advocates for public art education. The desire to amass large permanent collections and gigantic temporary exhibitions often clashed with the goal of proper arrangement. The available space in the National Gallery—even in the institution's current location in Trafalgar Square—proved too small to organize a growing collection properly. Temporary exhibitions, such as the Manchester Art Treasures Exhibition of 1857 or the Great Exhibition of 1851, tended to overwhelm visitors with the sheer number of artworks on display, despite organizers' attempts to categorize works. As in pre-Victorian galleries, paintings often covered walls from floor to ceiling, with some hung so high that they were impossible to view. There was simply not enough space to hang all the artworks "on the line," or at the eye level of viewers. Crowds at these exhibitions further prevented the close inspection of artworks and provided a competing demand on the attention of viewers. As Kate Flint asserts, looking at pictures was often a secondary activity in art galleries: "Depictions of art shows, whether in paintings or periodical publications, ultimately serve to reinforce the point that spectators are participating in social rituals" (*Victorians* 176). Moreover, written information could not always be counted on to direct the attention of viewers. Some exhibitions provided no written guidance, while others bombarded visitors with wall placards, catalogues, and the often contradictory comments of contemporary art critics, which were increasingly available in periodicals and guidebooks. In short, Victorian art venues frequently encouraged that "distraction" which Jonathan Crary has seen characterizing nineteenth-century viewing practices.

Victorian art critics recognized this problem and employed various strategies to mitigate the problems posed by too many artworks, sources of guidance, and other visitors. Most prominently, their commentaries sought to limit the number of artworks on which a viewer would need to focus. They did so in two major ways: (1) by making the correct attributions of artworks a key concern and (2) by encouraging viewers to select for themselves excellent works toward which to direct their attention. The first approach was developed by such influential art historians as Anna Jameson and A. H. Layard. The second, most famously advocated by Ruskin, asked viewers to unravel the difficult truths in just a few of the best paintings. Despite these well-developed schemes for managing attention in public gal-

leries, however, critics throughout the nineteenth century reveal a nostalgia for the sorts of private spaces that dominated the British art world before the Victorian period. Though advocating art collections more accessible to the public, these critics suggest that venues mimicking private, even elitist, spaces provide the best opportunity for viewing artworks, a desire that would be repeated by such later Aesthetic critics as Oscar Wilde.

IMAGINING THE IDEAL GALLERY

The National Gallery's original home, at 100 Pall Mall, was tiny. Opened in 1824, the gallery was located in a few rooms of John Julius Angerstein's home after his collection was purchased by Parliament. Paintings were hung on almost every available inch of wall space. The gallery averaged fifty visitors an hour and held up to two hundred people (Taylor 37). After two new collections were added to Angerstein's, the gallery moved to 105 Pall Mall in 1834. Although the space was larger, Anthony Trollope complained that it was "a dingy, dull, narrow house, ill-adapted for the exhibition of the treasures it held" (qtd. in Taylor 37). Trollope's wish—that the building better accommodate a national collection—was echoed throughout the period.

The new National Gallery building in Trafalgar Square, opened on April 9, 1838, suffered from some of the same problems that bedeviled its temporary Pall Mall locations. It was already clear in the late 1830s that Trafalgar Square would lack the space for a comprehensive arrangement— largely because the Royal Academy occupied half the building. Critics and other visitors found the Trafalgar Square location deficient in proper lighting, without room for larger paintings, and crowded with people. A May 1850 commission headed by the painter Sir Charles Eastlake, then keeper of the National Gallery, reported that more than three thousand people visited the building per day in 1848 and 1849. As a result of increased visitors to London for the Great Exhibition, that number was almost twice as high in 1851 (Taylor 59, 70). According to most official accounts, the crowds at the Great Exhibition and National Gallery in 1851 were orderly, which "confirmed an earlier reforming belief that exhibitions managed by the state were 'good' for the population and that the experience of all the arts would lead to better national superiority in design and manufacturing skill" (Taylor 70). However, while the Great Exhibition was generally considered a national success, the National Gallery was seen as too limited in its appeal to educate manufacturers and the public.

An 1840 drawing by Richard Doyle, "In the National Gallery," illustrates some of the imagined challenges to and one possible solution for the gallery's educative mission (fig. 3). Doyle shows the barriers to close examination of the artworks but also provides one example of effective spectatorship: upper-class male stands at an appropriate distance from a popular portrait of a girl and focuses his attention on it. Doyle's Trafalgar Square gallery is crowded with visitors and paintings. A rail protects the portrait; however, one man (who appears to have stereotypical working-class facial characteristics) touches the frame while another stands right in front of it, partially obstructing the artwork from viewers within the gallery. Moreover, these figures block the portrait even from viewers of Doyle's sketch, suggesting the immediacy of lapses in gallery etiquette for his audience. The two women in the drawing stand behind the male viewers and are thus unable to see the portrait. One of the women directs her gaze entirely at her catalogue, as does another male who is closer to the painting. Some of the other visitors, including one of the women, are gauging the attentive gentleman's reaction to the artwork. Doyle implies that visitors to galleries should learn from this gentleman's disposition toward the painting. Doyle's ambivalence about written information as possibly too absorbing (judging from the woman and man who are buried in their catalogues) is greater than most art critics, but he similarly hopes for an ordered attention based on that modeled by an upper-class viewer.

As early as 1847, a Select Committee on Works of Art was formed to study plans to expand the National Gallery's exhibition space to accommodate more art and visitors. Proposals for entirely rebuilding the gallery were considered until 1879. And although the original building, albeit redesigned and with multiple additions, remains in Trafalgar Square to this day, and although none of the schemes for rebuilding the National Gallery was ever adopted, these plans demonstrate Victorian ideals of exhibition spaces. Through their writings on the subject in the popular press, art critics advocated their own designs and those of others and delineated the deficiencies of the Trafalgar Square building. In proposing to solve problems of inadequate artworks and room, art critics hoped to elevate and display British taste. While both aims (education and amassing artworks) served nationalist tendencies, they also tended to clash with each other. For most critics, teaching the public required limiting the number of artworks so that they could be easily seen and digested. But some writers believed that a large collection would demonstrate British cultural prowess. At certain times in the National Gallery's history, proper arrangement and hanging were at odds with the desire to amass artworks in elaborate exhibition spaces.

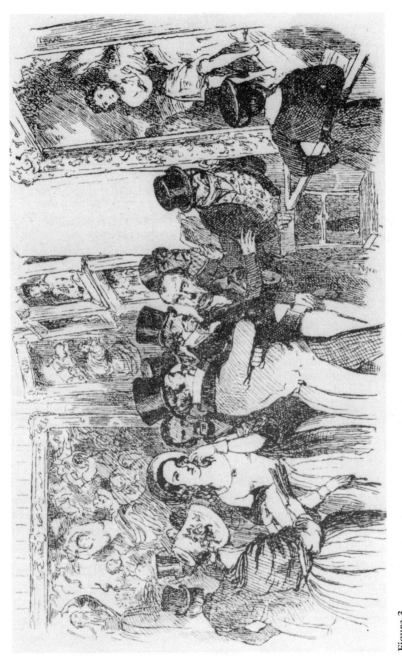

Figure 3

Doyle, Richard. "In the National Gallery." 1840. From *A Journal Kept by R. Doyle in 1840*. London: Smith, Elder, anc Co., 1885: The National Gallery, London.

Ruskin, who wrote much on the organization and function of gal-
leries and museums, hoped to focus viewers on a few, logically arranged
artworks: "In all museums intended for popular teaching, there are two
great evils to be avoided. The first is, superabundance; the second, disor-
der. . . . Any order will do, if it is fixed and intelligible" (*Works* 26: 203).
While, as Jonah Siegel notes in *Desire and Excess,* Ruskin does not provide
advice about specific arrangements, he is adamant about the need for an
unchanging order. In "A Museum or Picture Gallery: Its Functions and Its
Formation," Ruskin asserts:

> The first function of a Museum . . . is to give example of perfect order and
> perfect elegance . . . to the disorderly and rude populace. Everything in its
> *own* place, everything looking its best because it is there, nothing crowded,
> nothing unnecessary, nothing puzzling. Therefore, after a room has been
> once arranged, there must be no change in it. (*Works* 34: 247)

While Ruskin ostensibly considers the epistemological benefits of "order"
in a museum, the term here is primarily a political one. Written in 1880,
when Ruskin was himself becoming less sanguine about the general pub-
lic's ability to appreciate art, these remarks nevertheless express the pre-
vailing belief that organization was crucial for educating "the disorderly
and rude populace" (*Works* 34: 247). Like other critics, Ruskin believed that
most viewers had short memories and attention spans; permanent order
would help them find and study specific works. More importantly, such
regimentation would provide them with an example of how to conduct
themselves both within and outside of the museum space, an emphasis on
moral instruction that we see surrounding temporary exhibitions—such as
The Great Exhibition of 1851 or the Manchester Art Treasures Exhibition
of 1857—as well as permanent ones. However, because of their sheer size
and uncertain organization, temporary exhibitions particularly worried
Ruskin and other critics who hoped to provide spectators with examples of
orderly attention.

Writing to his father in 1852, a year after the death of J. M. W. Turner,
Ruskin described an ideal gallery to house the artist's works:

> I would build it in the form of a labyrinth [. . . so] that in a small space I
> might have the gallery as long as I chose—lighted from above—opening
> into larger rooms like beads upon a chain, in which the larger pictures
> should be seen at their right distance, but *all on the line,* never one picture
> above another. [. . .] Thus the mass of diffused interest would be so great

that there would never be a crowd anywhere: no people jostling each other to see two pictures hung close together. Room for everybody to see everything. (qtd. in Siegel, *Desire* 222)

Paradoxically, Ruskin hopes to fix attention—to allow spectators to contemplate individual pieces of art—by spreading interest throughout his museum. The size of Ruskin's gallery would obviate the necessity for hanging paintings floor-to-ceiling. Viewers would not have to compete with or even talk to each other and could thus focus on individual artworks. Ruskin imagines the ideal spectator as solitary but not free from being directed by the design of the building itself. While visitors to this labyrinthine space would conceivably have some choice as to how they walked through the museum, Ruskin clearly wants viewers to see artworks in a certain way— for example, "all on the line" and the larger pictures "at their right distance." As in Ruskin's vision of an exemplary gallery, "diffused" interest and direction would often create tensions in Victorian art commentary. Critics tried to provide some direction while realizing that viewers could not be completely controlled.

In an 1852 letter to the editor of the *Times* (London), Ruskin proposes his ideal Turner gallery as a suitable way to rebuild the entire National Gallery. His plan would improve the current layout by allowing viewers to see all the works of one artist in a room and then to proceed to a contemporary artist in the next room. Ruskin believes that the "fatigue" of visitors in the current gallery arrangement "is indeed partly caused by the straining effort to see what is out of sight, but not less by the continual change of temper and of tone of thought, demanded in passing from the work of one master to that of another" (*Works* 12: 413). Ruskin and other like-minded critics were working against the British tendency toward random "organization" in galleries and museums—a state of affairs that can be compared to the descriptions of shop contents in Charles Dickens's *The Old Curiosity Shop* (1840–41) or in *Our Mutual Friend* (1864–65). Concentrating on one artist at a time would help instruct those without formal knowledge of the arts: "Few minds are strong enough first to abstract and then to generalize paintings hung at random. Few minds are so dull as not at once to perceive the points of difference, were the works of each painter set by themselves" (412). Organizing paintings in this way would provide the kind of order that Ruskin advocates in "A Museum or Picture Gallery." In addition, it would allow visitors to compare an ancient master with a contemporary British painter. For Ruskin, many of these British painters were worthy of the comparison (Turner, above all); the arrangement would thus show

the public the potential of British art. Both artists and consumers would be instructed and inclined to improve the arts after seeing paintings properly grouped.

Despite his interests in limitation and proper arrangement, Ruskin remained enamored of extensive continental European collections. In his letter on the National Gallery to the *Times,* Ruskin remarks, "In the last arrangement of the Louvre, under the Republic, all the noble pictures in the gallery were brought into one room, with a Napoleon-like resolution to produce effect by concentration of force; and, indeed, I would not part willingly with the memory of that saloon" (*Works* 12: 411). Ruskin suggests his desire to manage attention, to convince the public of good taste, by more powerful means of acquisition then available to Britain. Nor was Ruskin the only commentator to hope that the National Gallery would serve nationalistic ends. Sir Henry Cole wanted the building itself to serve as a testament to British taste. He notes, for example, that the central staircase in a redesign plan he approves would be "of nobler proportions than that at the Louvre" ("National Gallery Difficulty Solved" 351). The galleries themselves would be arranged in an awe-provoking manner: "Openings would lead each way into an uninterrupted series of rooms [and] . . . an effective vista the entire length of the building . . . would be obtained, which might be decorated with columns and arches, as in similar openings in the galleries of the Vatican" (351). Further, the plan's entrance hall roof of "light glass and iron" (351) seems influenced by the Crystal Palace, a building associated with British artistic ingenuity. Thus, for Cole and Ruskin, public art education is advanced by both proper arrangement and awe-inspiring buildings and collections. Ultimately, however, challenging continental claims to cultural dominance were for the most influential art critics more important than the best schemes for improving the taste of individual viewers.

In his comments on picture galleries, Ruskin betrays a similar elitism. Testifying before the National Gallery Site Commission in April of 1857, Ruskin proposes two galleries: one accessible to the public with second-rate pictures and one at some remove from the city center with the best pictures. This second gallery would, in theory, limit visitors to those truly interested in art. Ruskin remarks, "Pictures not of great value, but of sufficient value to interest the public, and of merit enough to form the basis of early education . . . should be collected in the popular Gallery, but . . . all the precious things should be removed and put into the great Gallery, where they would be safest" (*Works* 13: 547). Though Ruskin states that placing artworks outside of London will protect them from pollution, he seems worried about

the "the precious things" being injured by the public as well. As in his comments at Manchester, preservation and class elitism are intertwined. Thus, he desires a public gallery that mimics a private art venue, an uncrowded space removed from the city center. Ruskin expressed this elitist wish again in his 1880 "A Museum or Picture Gallery: Its Functions and Formations," where he opined that the ideal exhibition room would "be a lordly chamber like Prince Houssain's" (*Works* 34: 260). Taken out of the context of his other writings, Ruskin seems here merely to be making a convenient comparison. But his pervasive desire for an aristocratic space becomes clear in the body of his art criticism.

While Ruskin's blend of elitist and democratic aesthetics has been well documented, Anna Jameson is usually regarded as a straightforward popularizer of the arts. To be sure, as she began to specialize in art writing in the 1840s, Jameson reached a broad audience through her handbooks to London's public and private galleries and her articles in periodicals. Both general visitors to galleries and experts found her writings useful. Jameson's *A Handbook to the Public Galleries of Art in and Near London,* published by John Murray in 1842, would have been very accessible to general readers. She notes in her preface that her aims are three: (1) that the book be compact enough to carry into a gallery, (2) "that the matter should be printed and arranged as not to fatigue the eye while the reader was moving or standing in varying lights," and (3) that the information be arranged to follow exactly how pictures are hung in the galleries (vi–vii). Similarly, her introduction defines such terms as "history painting" and "sacred vs. profane" so that nonexperts can follow her thoughts. By attempting to elevate public taste, Jameson was following the major trend of 1840s art writing, and reviewers praised her *Handbook* for this emphasis (J. Johnston 156). Indeed, in her section on the National Gallery, Jameson hopes that the collection will grow quickly so that art can be more accessible and arranged to educate the public: "The number of pictures should be at least doubled before any such arrangement could be either improving or satisfactory, though undoubtedly the purposes for which the *National* Gallery has been instituted demand that it should be taken into consideration as soon as possible" (12–13). Significantly, Jameson advocates the acquisition of important paintings by women—"a Lady Carlisle, a Lady Wharton, or a Lady Rich" (12)—as well as those by men, an emphasis rarely found in contemporary art criticism by men or women.

Jameson was also less worried than many of her contemporaries that the public would loiter in art galleries and possibly injure the art: "The fears once entertained that the indiscriminate admission of the public would be

attended with danger to the pictures, or would prove otherwise inexpedient, have fortunately long since vanished; no complaint has ever been made" (16). These concerns about the public certainly persisted in the mid-Victorian period, despite Jameson's democratic claims. Moreover, Jameson betrays an enthusiasm for the private space even as she hopes that art galleries will become more accessible to the public. In her *Handbook to the Public Galleries,* Jameson lauds the sort of venue that Ruskin imagined for his great gallery outside of the city. While criticizing the Dulwich Gallery's second-rate pictures, she approves of its location away from London: "Over the city we have left broods a perpetual canopy of smoke and fog, and care heavier and darker than either" (442). Jameson's vision is more democratic than Ruskin's—her Dulwich Gallery affords a space where "the charmed attention of the most fastidious amateur," an attention further elevated by her guidebook, will find intellectual solace. There is no split here between serious connoisseurs and dilettantes as in Ruskin's criticism. Still, Jameson values public venues that restrict the size of crowds with some sort of admission system. Defending the requirement at Sir John Soane's Museum that visitors ask for admission, Jameson remarks, "Some security against mischief so easily done . . . seems indispensable in this great metropolis, whose inhabitants are not particularly conspicuous among civilised nations for their high reverence for art" (550). Her earlier comments on the safety of artworks in the National Gallery notwithstanding, Jameson seems here concerned with the conduct of those in the lower classes, thus reflecting the early-Victorian emphasis on teaching a greater respect for the arts. But she is not particularly cognizant of the very real barrier that the need to request admission might mean for working-class visitors: "The mere obligation of asking admission, which is never refused, is surely no great hardship" (550). As was the case with much Victorian art criticism, Jameson's comments assume readers with at least some financial and social means.

Indeed, both Jameson and Ruskin believed that ownership fostered art appreciation. In one of his public lectures at the Manchester Art Treasures Exhibition, Ruskin claims that owners have the opportunity to study their works in detail, "much more being always discovered in any work of art by a person who has it perpetually near him than by one who only sees it from time to time" (*Works* 16: 81). Jameson's similar admiration for private ownership comes as something of a surprise in her popular *Handbook to the Public Galleries.* Jameson values upper-class collectors, not the middle-class purchasers advocated by Ruskin, as the most likely to appreciate art fully. Charles I is for Jameson a representative model because he "did not merely consider his pictures as a part of his royal state, or as objects of personal

ostentation, but really loved them, and fully, and with the discrimination of an accomplished connoisseur, [and] appreciated their intrinsic beauty and value" (191). Jameson's emphasis on "intrinsic beauty" suggests a Kantian notion of art appreciation rather than one that requires teaching. For Jameson, it seems that the upper-class art owner has a different kind of respect for art than viewers in the lower classes.

Her 1844 *Companion to the Most Celebrated Private Galleries of Art in London* makes clear, thirteen years before Ruskin's comments at Manchester, that private owners will observe what gallery visitors cannot: "All who possess fine pictures, and really love them, are familiar with minute beauties" (xix). Jameson assails the buying of pictures merely because it is fashionable (a consistent theme in Ruskin's criticism as well), but she believes that such acquisitiveness will eventually elevate the owner's taste. In a rare moment of faulty logic in her body of work, Jameson asserts that the "wish to possess is followed by delight in the possession. What we delight in, we love; and love becomes in time a discriminating and refined appreciation" (xxvii). Jameson has so much respect for private collections that she advocates maintaining them rather than amassing too many artworks in a national collection. She believes that private homes are usually the best places for preserving pictures—unlike public collections with their "loiterers and loungers, the vulgar starers, the gaping idlers" who are likely to touch the pictures (xxxiv–xxxv). As in her comments on admission requirements in public galleries, Jameson argues that asking for entrance to private galleries poses no great barrier to the public. While Jameson never proposes the Ruskinian two-gallery system, her conception of one truly accessible national collection and scattered public and private venues seems to work in a similar, discriminatory fashion. In a vision that presages Wilde's view of the ideal art gallery, the general public gets the crowded space, while the upper classes enjoy more leisurely venues.

MANAGING ATTENTION AT A TEMPORARY VENUE
The Manchester Art Treasures Exhibition of 1857

The Manchester Art Treasures Exhibition of 1857 featured no permanent building like the National Gallery—or even a moveable one like the Great Exhibition's Crystal Palace—that might provide a lasting, physical indication of British taste. The exhibition was, however, seen as a model for how to fix some of the problems associated with the National Gallery and with British patronage of the arts in general. "We trust," wrote the *Dublin*

University Magazine, that the exhibition "may lead the nation to see the necessity of establishing a national gallery of paintings worthy of the country. It is neither becoming [to] the wealth or greatness of the English people that they should be content with that thing in Trafalgar Square, as contemptible in its architecture, as it is miserable in its collection of works of art" (620). In many respects, the show lived up to expectations. The exhibition, the first comprehensive display of the fine arts in Britain, was "stunningly successful in making available to the new world of art lovers a vast quantity of work that had hitherto been unavailable" (Siegel, *Desire and Excess* 182). For the first time, the public could see the private collections of Queen Victoria, Prince Albert (who provided much of the impetus for the exhibition), and other important connoisseurs (Steegman 234). Most visitors had never seen and had little knowledge of the early-Italian artworks on display. Critics believed that the exhibition, with its broad collection and attempts at an organized physical space, provided a good example of how to form a national collection. But many commentators complained that the exhibition lacked sufficient written information, organization, and genuine artworks to educate a mass art audience. These concerns—voiced two decades after they were first raised at the beginning of the Victorian period—demonstrate both the pervasive preoccupation with guiding viewers and the slow implementation of the means for doing so.

Notably, the *Dublin University Magazine* and other periodicals contended that the written information provided at Manchester was not sufficient for guiding the public. Viewers could choose among a variety of publications, including official and unofficial guidebooks and many articles in the popular press. But, similarly to the high volume of commentary that surrounded the 1851 Great Exhibition, these Manchester articles must have confused, as well as assisted, viewers. Manchester guides often contained contradictory information. For example, some guidebooks questioned the provenance of many artworks, while others made no mention of these problems.

In addition to stark differences among various sources, single guides contained disparities in the kinds of information provided. For instance, some sections of the *Official Catalogue* feature extremely detailed commentary. "Paintings by Ancient Masters" includes a comprehensive history of art that defines important terms and artistic periods and points the viewer to specific paintings. The terms provided indicate that the author of this section, George Scharf (the first secretary and keeper of the Gallery of National Portraits), intended his commentary to help the general viewer. For example, Scharf defines "diptych" (a term that would have been famil-

iar to most upper-class viewers) in highly accessible language: "an altar-piece, generally small, made in two leaves so as to close face to face, like the cover of a book" (11). Scharf also refers to popular guides such as Anna Jameson's *Handbook to the Public Galleries* and *Handbook to the Private Galleries* and G. F. Waagen's *Treasures of Art in Great Britain*. By contrast, other sections of the catalogue, such as "Paintings by Modern Masters," merely list the artworks by number, title, and contributor. The organizers were not art critics but artists, connoisseurs, and antiquarians; their differing levels of guidance suggest a less uniformly enthusiastic vision of public education than that held by most art critics.

This unevenness is further indicated by the use of wall placards at the show. While the exhibition's Museum of Ornamental Art section included labels, the Paintings by Ancient Masters division did not. The *Manchester Guardian* complained that a "few labels upon the [Ancient Masters] pictures, marking both date and the school to which they belong, would have done great service to the uninitiated, and to those who do not so readily turn to their catalogues" (*Handbook to the Paintings by Ancient Masters* 84). This commentator suggests that wall labels were omitted because they would have undermined the sale of the catalogue. In any event, many working-class visitors probably chose not to buy the one-shilling catalogue and would have benefited from the more widespread use of labels. The decision to do without labels in some sections reveals that the old notion that art should be appreciated without written mediation was still a prominent, though waning, ideal.

Not only does the catalogue demonstrate the problem of disparate information as well as venal consideration, but it also illustrates the overwhelming scope of the exhibition. The Manchester venue was divided into ten sections: Paintings by Ancient Masters, Paintings by Modern Masters, British Portrait Gallery, Collection of Historical Miniatures, Museum of Ornamental Art, Sculpture, Water-Colour Drawings, Original Drawings and Sketches by the Old Masters, Engravings, and Photographs. While the exhibition was praised for its comprehensiveness, the organizers' attempts to cover such a range of media, time periods, and locales challenged attendees to digest an overwhelming array of art. In this respect, the accumulative impulse of organizers was not in the best interests of public education. Further, the catalogue demonstrates the uncertain arrangement of the artworks within these divisions. In particular, critics complained in Manchester periodicals that the works of each artist were not grouped together. It is in fact difficult for a modern reader of the catalogue to find where a particular work of art by a specific artist was located in the exhibition.

To combat these informational and organizational problems, critics claimed that their guidebooks would help the general viewer discern the most important artworks. In the introduction to *A Walk Through the Art-Treasures Exhibition: A Companion to the Official Catalogue* (1857), G. F. Waagen, the major organizer of the exhibition and then a professor of art history at Berlin University, remarks,

> The following pages are destined not for the small number of connoisseurs, but for the larger proportion of lovers of art who seek both pleasure and instruction within the walls of this Exhibition. My object is, in few words, to point out and to define the characteristics of such objects of art as deserve the attentive observation of all visitors. In so large a collection there is necessarily much of inferior interest, and many erroneous titles occur, by which the visitor may be misled. Moreover, he will gain time by not being obliged to select for himself from this accumulation of objects what is most worth seeing. ("Frontispiece")

Waagen takes a paternalistic stance in seeking to protect viewers from false attributions and from either seeing too much or too little. But he also implies that his comments are not exhaustive because he has focused on the earlier sections: "I therefore confine my remarks to those [artworks] which have most attracted my observation" ("Frontispiece"). Waagen suggests that viewers could value other paintings than those that have interested him. The paradox in Waagen's remarks—between a commentary that expresses mere personal interest and one that serves as a comprehensive guide for "all" viewers—demonstrates a larger problem in Victorian art criticism. Because many venues displayed a large number of art objects, critics were often limited in what they themselves could examine and discuss. Neatly encapsulating this challenge, the art critic of the 1883 *Saturday Review* asked rhetorically, "Does anyone imagine that the art critic likes having eight hours, at the utmost, in which to inspect and form his opinions about eighteen hundred works of art?" (qtd. in Flint, *Victorians* 191). Despite writing a comprehensive guide to British art—*Treasures of Art in Great Britain* (1854), which provided much of the inspiration for the exhibition—and despite his own role as a primary organizer, Waagen indicates his inability to manage completely what visitors will see.

Waagen's comments on specific artworks and sections of the exhibition clearly express this ambivalence about directing viewers. His *Treasures of Art in Great Britain* notwithstanding, Waagen refuses to write about individual English paintings "because these objects of art are better known to

the English public than to me; and . . . no foreigner can understand the merits of the English schools so well as the English themselves" (42). Waagen elsewhere cites other art critics as better authorities than himself. For example, he notes that J. B. Waring's descriptions of the ornamental art in the official catalogue are sufficient: "It would be quite superfluous and presumptuous on my part to enter into any details" (74). But Waagen then recommends an exact order in which a visitor should read the catalogue and see the sculptures: "It is advisable to begin with the many fine antique sculptures in bronze and terracotta . . .; next, to read the observations on sculpture in ivory, p. 152; and then to go on in the following order to look at this quite first rate collection of sculptures in this material" (74). Waagen's remarks on specific works are representative of those made by other critics at Manchester: they provide direction while noting the insufficiency of their expertise. Critics thus envision viewers as seeking some guidance, but not allowing themselves to be managed fully by any one source—even an official catalogue or its companion handbook.

Because of the uneven written information available at the exhibition, *The Dublin University Magazine* advocated a specific form of public instruction: "To exhibit all the objects that shall be displayed to the eye of the visitor without giving him any information further than catalogues can afford . . . will be somewhat like turning a man without books into a garden to learn botany. . . . The great efficient agent of instruction to be adopted is, in our judgment, the lecture" (620). Invited by the exhibition organizers, Ruskin delivered two lectures at Manchester entitled "The Discovery and Application of Art" and "The Accumulation and Distribution of Art."[1] As in his later "Traffic" (1864), Ruskin attacks the values of his hosts, arguing in these lectures that the accumulation of artworks is inimical to art education. Ruskin avoids specific commentary about the artworks, providing general principles instead. Most prominently, the individual, not the art critic, is responsible for interpreting artworks.

In order to prompt this work on the part of the viewer, Ruskin advocates focusing on the difficulties presented by a single great work of art. The mass of artworks at Manchester is, by contrast, too accessible for viewers: "Art ought not to be made cheap, beyond a certain point; for the amount of pleasure that you can receive from any great work, depends wholly on the quantity of attention and energy of mind you can bring to bear upon it. Now, that attention and energy depend more on the freshness of the thing than you would all suppose" (*Works* 16: 57–58). Ruskin argues that concentration on a few artworks will prevent them from becoming merely ordinary sights because "fragments of broken admirations will not,

when they are put together, make up one whole admiration; two and two, in this case, do not make four, nor anything like four. Your good picture, or book, or work of art of any kind, is always in some degree fenced and closed about with difficulty" (58). For Ruskin, the "difficulty" that encircles a good work of art can only be penetrated with careful, laborious attention: "Hence, it is wisely appointed for us that few of the things we desire can be had without considerable labour, at considerable intervals of time" (58).[2] At stake in the interpretive work that Ruskin proposes is a democratization of the arts without lowering standards of taste as a result. Unlike many contemporary commentators, Ruskin does not believe that the mere diffusion of artworks is an effective means of teaching viewers. Instead, such accessibility encourages the public to treat the arts as any other viewable commodity. By contrast, hard interpretive work demonstrates the value of the arts.

Although Ruskin seems democratic in advocating interpretive labor, he could be quite elitist, as his emphasis on orderly attention suggests. His comments at Manchester also betray an upper-class English elitism in his comments on preserving artworks: "Take pride in preserving great art, instead of producing mean art; pride in the possession of precious and enduring things, a little way off, instead of slight and perishing things near at hand" (*Works* 16: 70). By "a little way off," Ruskin means Italy and other places in Europe; he hopes Englishmen will take up residence on the Continent in order to do what war-prone foreigners cannot do: preserve their own art. He argues, "Every stake that you could hold in the stability of the Continent, and every effort that you could make to give example of English habits and principles on the Continent . . . would have tenfold reaction on the prosperity of England" (70–71). Ruskin's emphasis on preservation restricts by national origin and class: only wealthy English landowners have the means and "habits" to care properly for European art.

In addition to Ruskin's worry about preservation, the Manchester exhibition highlighted a different set of problems concerning the provenance of artworks. As most of the exhibited artworks were from private collections, they had not previously been subjected to scrutiny by a wide array of experts. Because the show put so many artworks together, viewers could now compare works that were supposedly by a particular artist. In their comments at Manchester, critics were especially concerned with matters of attribution. The increased preoccupation in postromantic aesthetics with originality, along with the heightened demand for guidance about a growing number of available paintings, placed special pressures on critics to identify correctly the works of known painters. Properly attributing works was viewed as a way to instruct viewers and strengthen national art venues.

Sir Austen Henry Layard, a friend of Ruskin's and an influential art critic for the *Quarterly Review,* describes the exhibition's attributive problems: "Of the long line of great painters who adorned the Florentine and Sienese schools during the fourteenth century . . . we have no worthy example; of most of them none at all, although their names are liberally bestowed by the catalogue" (173). Layard's comment is representative of a mid-nineteenth-century trend that "reversed the once common practice of ascribing as many works as possible to artists of note. New methods of analysis along with the increasing value placed on scarcity made it more interesting and important not to swell the pages of the catalogues, but to *reduce* the number of works ascribed to a celebrated author of the past" (Siegel, "Leonardo" 169). Ironically, as Leonee Ormond has demonstrated, and as I discuss in more detail in chapter 6, artworks were frequently reattributed incorrectly.

According to Layard and some other critics at Manchester, not all these questionable paintings are misattributed: some are outright forgeries. Layard asserts that some works are hung at a distance to make exposure difficult. Steegman notes that Layard's claims were well-founded: "There was an immense demand for pictures of certain Schools, and the demand was met by an assiduous and steady supply. *Expertise* was exceedingly rare, and the great majority of collectors at home and on their travels trusted to their own judgement" (243). Art critics at Manchester tried to fill this gap in expertise by advising the public which artworks were genuine. For example, Layard attributes "the gem of the whole Exhibition . . . the unfinished picture representing the Holy family with four angels" (175) to Michelangelo. Yet he admits that "there is no evidence of its being his work, except those qualities which mark it as worthy of his genius" (175). As Siegel notes in "Leonardo," identifying such subjective "qualities" was more important to some art critics (such as Walter Pater) than scientific evidence that a certain artist had actually painted an artwork. By contrast, art historians such as Anna Jameson and Elizabeth Eastlake sought to determine attributions with as much factual information as possible. Layard demonstrates a third, hybrid approach—a desire both to identify works of genius through traditional connoisseurship and, in other cases, to fix attributions scientifically.

As my conclusion to chapter 3 indicates, these preoccupations with authenticity and proper attribution have remained pervasive into the twenty-first century. While we now take for granted that art writers will carefully research the provenance of artworks, this approach was not yet standard in the mid-Victorian period. In the older, practicing-artist model of the art commentator in the Sir Joshua Reynolds mold, there was little time to conduct exhaustive historical inquiry. By contrast, the increasing

specialization of late-industrial culture allowed such writers as Jameson and Eastlake both the time and the audience to research the history of art. In addition, this same culture, in its seemingly endless ability to manufacture, created new worries about the authenticity of art. We thus see a new conception of the art specialist as a figure who could protect the public from "false" art. While such an aim was certainly in line with teaching a broader public to appreciate the best art, it also betrayed a new kind of elitism in privileging the art critic's knowledge. As we will see in chapter 6, George Eliot and Charlotte Brontë were less concerned with such facts than they were with exploiting the possibilities of artworks with more indeterminate titles and authors.

CHAPTER 6

֍

Interpreting Cleopatra

AESTHETIC GUIDANCE IN
CHARLOTTE BRONTË'S *VILLETTE* AND
GEORGE ELIOT'S *MIDDLEMARCH*

"*H*itherto I have only had instinct to guide me in judging art," wrote Charlotte Brontë after reading John Ruskin's *Modern Painters*, Volume 1, in 1848; "I feel more as if I had been walking blindfold—this book seems to give me eyes. I *do* wish I had pictures within reach by which to test the new sense. . . . However eloquent and convincing the language in which another's opinion is placed before you, you still wish to judge for yourself" (Wise 2: 240). Here, Ruskin has provided Brontë with a method of seeing, but her eyes will remain her own. In *Villette* (1853), Lucy Snowe expresses a similar relationship to art—one we will see as distinctly Protestant: "I liked to visit picture-galleries, and I dearly liked to be left there alone" (248, chap. 19). Lucy, however, is never left entirely to her own devices in a Villette art gallery crowded with viewers and artworks. Other visitors try to manage her gaze, and written information about the artworks structures her interpretations. Despite the fact that this art gallery scene is set in France, Lucy's encounter with and response to such competing demands for her attention reflect the profound changes to British Victorian art institutions and viewing practices that I describe in chapter 5.

The Victorian women novelists whom I study in this essay, Charlotte Brontë and George Eliot, themselves grappled with this same problem of

encountering artworks in crowded public spaces. These novelists evidently read contemporary art critics, including Ruskin and Jameson, and used their lessons—especially the admiration for private spaces—in key moments of spectatorship. While the heroines of *Villette* and *Middlemarch* are eventually able to study artworks in public, their most meaningful encounters are private ones. In particular, private viewings allow Lucy and Dorothea Brooke the freedom to apply their own interpretations of artworks to what are at the time unhappy romantic lives. Both characters are able to see through art objects that the men they thought would bring fulfillment to them are unlikely to do so, thus echoing Helen Huntingdon's growing perceptive ability in *The Tenant of Wildfell Hall*. Brontë and Eliot posit through these scenes a feminist aesthetic as these women learn to become active interpreters rather than merely the objects of male gazes. Moreover, in leaving these representations uncertain, these authors suggest that readers too should treat artworks as opportunities for interpretive work, especially in the symbolic realm. Capitalizing on two other key contemporary art critical concerns, Brontë and Eliot demonstrate the importance of attribution and authenticity—strikingly, while each depicting artworks named "Cleopatra." But they also show that the attributions of artworks are much less stable than contemporary art critics recognized. By playfully manipulating these instabilities, the novelists imply links to the changing lives of their heroines and to their own pseudonymous statuses as artists. Eliot properly identifies the *Sleeping Ariadne* statue, but notes that the characters in *Middlemarch* know it as *Cleopatra*. Brontë purposely misnames her novel's *Cleopatra*, a painting based on a work with a different name and subject matter. But the "false" name of both artworks—*Cleopatra*—has as much significance for the novels as their real identities.

Writing at cross-purposes to some art critics' emphasis on elevating national taste, Brontë and Eliot represent the particular problems faced by women in art venues. Placing Lucy Snowe and Dorothea Brooke in foreign art galleries provides a less threatening example of interpretive freedom by avoiding more direct references to contemporary debates about British art. But the parallels to and implications for British spectatorship are clear. Similarly to contemporary art critics, Brontë and Eliot describe galleries crowded with artworks, information, and visitors. Lucy Snowe and Dorothea Brooke also encounter men who are concerned with where these women are looking or who treat them as aesthetic objects. Demonstrating their intellectual independence, Lucy and Dorothea manage to choose among these competing demands on their attention, forming their own interpretations of artworks and providing models for readers of the novels.

Upon her early-morning arrival at the Villette art gallery, it seems that Lucy will have the solitude that she desires. But, after examining the *Cleopatra,* Lucy notes that "the room, almost vacant when I entered, began to fill" (250, chap. 19). Lucy claims not to have noticed the crowding of the gallery—she says, "as, indeed, it did not matter to me"—and begins to inspect other artworks. But she cannot ignore the other visitors in the gallery for long: the Catholic schoolteacher Monsieur Paul Emanuel escorts her away from the *Cleopatra* and toward didactic religious paintings. Lucy decides that these paintings' subjects are far less interesting and remarks sarcastically to herself, "It was impossible to keep one's attention long confined to these masterpieces, and so, by degrees, I veered round, and surveyed the gallery" (253). Lucy studies the other spectators in the gallery, including M. Paul, who looks at the *Cleopatra* while intermittently glancing at Lucy to ensure that she is not observing it. Lucy later tells him that she has viewed the forbidden painting all along: "I have looked at her a great many times while Monsieur has been talking: I can see her quite well from this corner" (255). Jill Matus claims that Lucy's "gaze does not usually unsettle those around her or allow her to appropriate control and power" ("Looking" 345–46), but Lucy's admission must surprise M. Paul. Of course, M. Paul is not a professional art critic; however, he does represent a controlling figure in Victorian art criticism: the tour guide. Yet M. Paul demonstrates that even if art critics could accompany their readers (as many pretended to do in their writings), they could not completely manage which artworks viewers chose to inspect.

M. Paul also expresses the fear that, without a chaperone, Lucy will be observed by male viewers. Middle-class women became the largest single group of gallery visitors during the Victorian period, a fact that heightened the anxiety that they would be exposed to the male view. But Brontë's scene suggests that the underlying concern may have been women's new freedom to spectate. Just as Lucy looks at whatever art she pleases, she regards the other gallery visitors, often without being observed. She remarks, for example, that Dr. John "was looking for me, but had not yet explored the corner where the schoolmaster [M. Paul] had just put me. I remained quiet; yet another minute I would watch" (257). As Alison Byerly notes, "She remains in the shadows while he [Dr. John] takes the spotlight. He is unwittingly thrust into the typically female position: on stage" (102). While art critics worried about the distracting influence of crowds in galleries, Brontë presents Lucy's notice of others as liberating.

Lucy's independence is qualified by certain features of the Villette art gallery. She rejects M. Paul's attempts to direct her gaze, but is guided by

the disposition of the *Cleopatra*. Protecting certain pieces of art became relatively commonplace in the 1850s as larger crowds flocked to galleries, a practice that often enhanced the artwork's popularity. Ruskin hoped that particular gallery arrangements would direct viewers toward the most instructive and worthy artworks, even as he disliked the adulation of popular paintings. Though Lucy derides the *Cleopatra* as "of pretentious size, set up in the best light, having a cordon of protection stretched before it, and a cushioned bench duly set in front for the accommodation of worshiping connoisseurs" (249–50), she and others linger before this artwork. While Lucy seeks to differentiate herself from those she sarcastically calls "worshiping connoisseurs," she accepts some forms of guidance.

Most prominently, Lucy's catalogue structures her interpretation of the *Cleopatra*. After reading the name of the painting, Lucy contemplates the sexualized and slothful nature of this *Cleopatra*: "She had no business to lounge away the noon on a sofa. She ought likewise to have worn decent garments; a gown covering her properly, which was not the case" (250). Like Lucy, most Victorian readers would have been familiar with contemporary accounts of the Orient and imagined an exotic Cleopatra. But Brontë nevertheless had a choice as to how she described a painting entitled *Cleopatra*. Writes Matus, "When Brontë labels the subject of her painting she is not thinking of Cleopatra as the intelligent, powerful, and ruthless Queen of Egypt, but Cleopatra as a dark, indolent gipsy-queen" ("Looking" 355). Lucy describes the Cleopatra as "huge" and "dark-complexioned" (250), which suggests the qualities that Matus notes as well as a kind of racialized sexuality that would have resonated with Victorian stereotypes about Oriental women.

That Brontë consciously decided to emphasize the subject's sexuality becomes clearer in examining her source painting. As Gustave Charlier first noticed, Brontë based her *Cleopatra* on an actual painting that she had seen at the Brussels Salon in 1842, *Une Almé*, by Edouard De Biefve. De Biefve's painting—not of Cleopatra, but of a fully clothed dancing girl—seems restrained to modern viewers. But Brontë's depiction of the *Cleopatra* is consistent with contemporary reviews of *Une Almé*. "We should have preferred as title for this work: *A Slave of the Harem*," remarked one writer (qtd. in Charlier 389). Brontë thus draws on both popular assumptions about the Cleopatra myth and reviews of *Une Almé* to provide a model of femininity that Lucy necessarily rejects. Lucy refuses the image of woman as a sexualized, useless being, and indicates that she will avoid this role in her own life. However, her passive waiting for M. Paul at the end of the novel seems to subvert somewhat this liberated sentiment.[1]

Lucy's prescriptive derision of the *Cleopatra* clashes with her own wish to be left alone while viewing art. She leaves little room for the reader to interpret the painting differently, and Lucy's own opinion is much structured by its disposition and by the catalogue. Further, her general views of art are heavily influenced by Ruskin, especially in her interpretations of natural elements: "These [pictures] are not a whit like nature. Nature's daylight never had that colour; never was made so turbid, either by storm or cloud, as it is laid out there, under a sky of indigo: and that indigo is not ether; and those dark weeds plastered upon it are not trees" (249). But Brontë does indicate ways in which readers can bring their own understanding to the novel's paintings. First, a small minority of Brontë's readers could have seen the *Cleopatra*'s differently titled source painting. More importantly, by incorporating Ruskinian art critical theories, Brontë allows for various interpretations of the Villette gallery artworks. Because Ruskin did not equate truth to nature with mere mimesis, the viewer has much leeway, as Lucy demonstrates, to determine this truth. Ruskin wanted viewers to work creatively in deciphering artworks, not to follow authority blindly. In *Villette,* Lucy observes that Dr. John expresses the kind of insight into art that Ruskin advocated: "I always liked dearly to hear what he had to say about either pictures or books; because, without pretending to be a connoisseur, he always spoke his thought, and that was sure to be fresh: very often it was also just and pithy" (257). Dr. John is not didactic; Lucy suggests that he is willing to have a reciprocal conversation about art. His insights contain the "freshness" that Ruskin equated with active interpretation on the part of a viewer.

However, Dr. John lacks genuine enthusiasm, which Ruskin and Brontë believed was crucial to understanding art. Lucy later complains that Dr. John "*could* feel, and feel vividly in his way, but his heart had no chord for enthusiasm" (324, chap. 23). For most Victorians, enthusiasm was an ideal state, not just for art reception, but for the appreciation of noble emotions. Dr. John's shallow feeling for art indicates a lack of concern for others. By contrast, Lucy's passion for a few artworks suggests an enthusiasm that marks her larger sympathy: "These exceptions I loved: they grew dear as friends" (249, chap. 19). Such passion could stereotype a viewer, and particularly a female one, as having a frivolous appreciation for art. Yet the works that Lucy endorses possess certain admirable criteria: "An expression in this portrait proved clear insight into character; a face in that historical painting, by its vivid filial likeness, startlingly reminded you that genius gave it birth" (249). The combination of such standards with affective responses to art, missing in many standard gallery guides, was a

distinctive trait of such diverse Victorian art critics as Anna Jameson, Elizabeth Eastlake, and Walter Pater.

Among the paintings that Lucy sees, the boyhood portrait of Dr. John demonstrates with particular force how ekphrastic descriptions can challenge readers to decipher meaning.[2] The adult Lucy closely studies the portrait's details and suggests that *Villette*'s readers do the same. The work is alive—"fresh, life-like, speaking and animated" (213, chap. 16)—an important criterion for realistic art. But this reality, the "clear insight into character" that it provides, is open. Lucy's description contains a number of qualifications: Dr. John's "eyes looked *as if* when somewhat older, they would flash a lightning response to love: *I cannot tell* whether they kept in store the steady-beaming shine of faith" (213, emphases mine). The personality traits Lucy attributes to Dr. John are contradictory: he has "a gay smile," yet "whatever sentiment met him in form too facile, his lips menaced, beautifully but surely, caprice and light esteem" (213). Lucy also allows for readerly interpretation by indicating that this is her own, biased account of the portrait; she muses, "How it was that what charmed so much, could at the same time so keenly pain?" (214). When Lucy later recalls the portrait during her argument with Dr. John over Ginevra Fanshawe, the insight the artwork provides her is again uncertain. Dr. John's expression, "a subtle ray" out of the corner of his eye reminiscent of the portrait, makes her think him "more clear-sighted" about Ginevra than he indicates. But she wonders if this is merely a "chance look" that has "half led" her "dubiously to conjecture" that the portrait reflects reality (243, chap. 18). By leaving open many possibilities, Brontë prompts readers to work toward their own conclusions.

In *Middlemarch,* George Eliot demonstrates a similar regard for individual interpretations and enthusiastic appreciations of art. Dorothea Brooke complains that most of the artworks on her Roman honeymoon fail to capture the kind of natural truth that Brontë and Ruskin associate with moral enthusiasm: "The painting and sculpture may be wonderful, but the feeling is often low and brutal, and sometimes even ridiculous. Here and there I see what takes me at once as noble—something that I might compare with the Alban Mountains or the sunset from the Pincian Hill" (153, chap. 22). Dorothea does not describe any of these noble artworks, but Eliot mentions one in her journals. In 1870, George Henry Lewes and Eliot stayed in Dresden for six weeks, visiting that city's famous art gallery three times a week. The masterpiece of the Dresden gallery was Raphael's

Sistine Madonna (fig. 4), a painting as famous in the Victorian period as Leonardo da Vinci's *Mona Lisa* is today. Raphael's *Madonna* occupied its own room in Dresden, "with a special setting resembling an altarpiece in a chapel" (L. Ormond 45). Upon first seeing the *Madonna* "on a crowded Sunday," Eliot "was so struck that she found herself overcome with emotion and had to leave the room" (L. Ormond 45). While Charlotte Brontë's Lucy Snowe ridicules the disposition of the Villette *Cleopatra,* and Ruskin often attacked popular artworks, Eliot found the *Madonna* deeply moving despite its fame. Indeed, as Leonee Ormond demonstrates, Eliot was frequently influenced by the identities and reputations of paintings. However, Eliot's sources of information—guidebooks and artwork labels—were often incorrect. Many of the paintings that Eliot admired were later proved to be copies or the productions of lesser artists (although not the *Sistine Madonna*).

Ormond remarks that Eliot's "mistakes"—the misattributions that she repeats in accounts of her travels to Europe—"can tell us something about her approach to the whole question of artistic creation" (33). However, Ormond does not elaborate on the insight provided into Eliot's artistic method. I would argue that Eliot plays with the identities of artworks both to guide readers and to allow interpretive space, a dynamic seen across the period's discourse on the teaching of taste. Eliot demonstrates that she herself can be a savvy consumer of modern art information as well as a victim of its mistakes. Most prominently, artworks are not primarily important because of the names of the artworks themselves (as some Victorian art critics argued) but rather as sites of passionate engagement that counter the valuing of women as mere aesthetic objects.

Eliot's much-studied Vatican Hall of Statues scene (chap. 19) seems to avoid the excesses of information, visitors, and artworks that I have described as endemic to the Victorian art-viewing experience. In the crowded Villette gallery, Lucy considers the *Cleopatra,* the still lifes hung underneath, and the four didactic works to which M. Paul leads her. The only artwork described in Eliot's scene is the *Ariadne* statue. Yet Eliot places her reader in the Vatican, a venue well-known to mid-Victorian readers as one replete with art objects. "The Vatican," wrote William Hazlitt earlier in the century, "is rich in pictures, statuary, tapestry, gardens, and in views from it; but its immense size is divided into too many long and narrow compartments" (qtd. in Siegel, *Desire and Excess* 176). Hazlitt focuses—as did many Victorian critics—on the confusion attendant on the gallery's physical space. But Eliot emphasizes and exploits a different problem: the dramatic increase in information available to modern viewers of art.

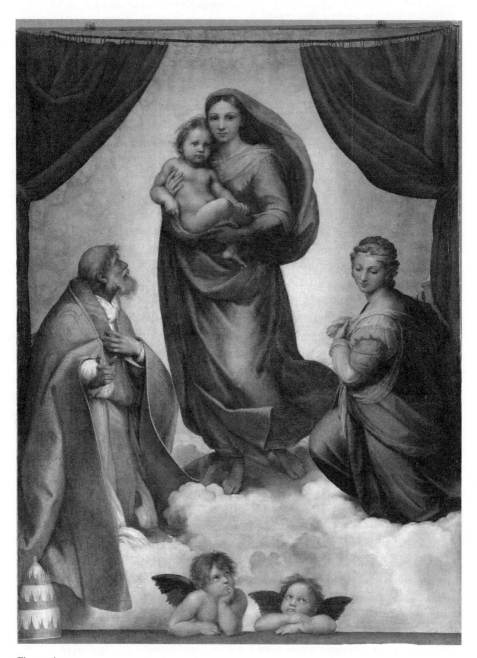

Figure 4

Raphael (Raffaello Sanzio) (1483–1520). *The Sistine Madonna*. 1512/13. Oil on canvas. 269.5 × 301 cm. Inv. Gal. Nr. 93. Photo: Elke Estel/Hans-Peter Klut. Gemaeldegalerie Alte Meister, Staatliche Kunstsammlungen, Dresden, Germany. Photo Credit: bpk, Berlin/Gemaeldegalerie Alte Meister/Elke Estel/Hans-Peter Klut/Art Resource, NY.

By setting her novel in the early nineteenth century, Eliot can show contemporary readers (that is, of the 1870s) how much more they know about art than do her characters. Chapter 19 opens with telling commentary on viewers and critics of the early 1800s: "Travellers did not often carry full information on Christian art either in their heads or their pockets; and even the most brilliant English critic of the day [Hazlitt] mistook the flower-flushed tomb of the ascended Virgin for an ornamental vase due to the painter's fancy" (130). In his *Notes of a Journey through France and Italy* (1826), Hazlitt identified the flowers in Raphael's *The Coronation of the Virgin* as decorative rather than as symbolic of the Virgin's resurrection (Witemyer 85)—a claim corrected by Anna Jameson in *Legends of the Madonna* (1852). Eliot knew Jameson's work well, and thus demonstrates her own knowledge of contemporary Victorian art criticism in chiding Hazlitt (Wiesenfarth 371).

Such corrections are not merely pedantic. Adolf Naumann, Will Ladislaw, and Dorothea see in the Vatican Hall of Statues "the reclining Ariadne, then [that is, in the 1830s] called the Cleopatra" (131). While these characters would have called the statue "Cleopatra," readers of *Middlemarch* in the 1870s would have known this statue by its proper title: *Ariadne* (fig. 5). As Abigail Rischin demonstrates, identifying the statue's correct name and its mythological connotations allowed contemporary readers to guess at what might happen between Dorothea and Will: just as Ariadne was abandoned by Theseus and later saved by Dionysus, Dorothea is neglected by her husband and might be rescued by Will (1127). Like Brontë's artwork, Eliot's "Cleopatra" (the "false" name of the statue) introduces an erotic element into the story, in this case by suggesting that Will and Dorothea might become lovers. Will's reaction to seeing Dorothea juxtaposed with the *Ariadne* intimates this: "He felt as if something had happened to him with regard to her" (133). Earlier in the chapter, Naumann and Will see Dorothea as a living statue—"a breathing blooming girl, whose form, not shamed by the Ariadne, was clad in Quakerish grey drapery"—and Naumann further aestheticizes her by hoping to create her portrait (131). As my analyses of *North and South* and *The Tenant of Wildfell Hall* demonstrate, women Victorian novelists were particularly concerned that the new emphasis on seeing could be used to objectify women. Their implicit aesthetic commentaries seek to undermine such objectification.

Eliot works against these fixed images by emphasizing the changes in both Dorothea and her relationship with Will. She hopes that her association of Dorothea with a doubly named artwork will both hint at romantic possibilities and encourage active interpretation by *Middlemarch* readers. In

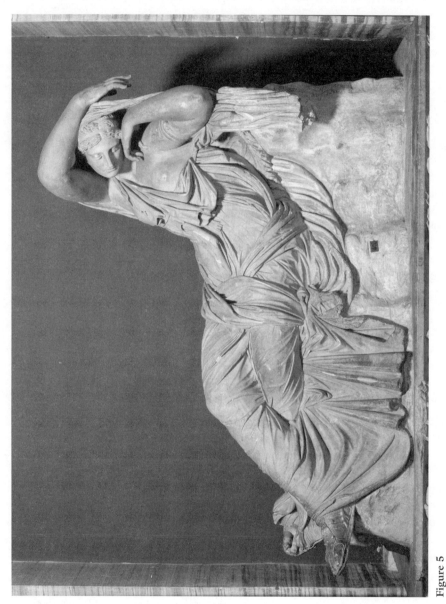

Figure 5
Sleeping Ariadne. 240 B.C.E. Hellenistic sculpture. Museo Pio Clementino, Vatican Museums, Vatican State. Photo Credit: Scala/Art Resource, NY.

a letter to her publisher, John Blackwood, Eliot remarked, "Any observation of life and character must be limited, and the imagination must fill in and give life to the picture" (qtd. in Byerly 123). Eliot's preference for creative interpretation over surface appearances is stated in the first few pages of the novel, when she warns her reader not to confuse inner character with physical looks: "Poor Dorothea! compared with her, the *innocent-looking* Celia was knowing and worldly-wise; so much subtler is a human mind than the outside tissues which make a sort of blazonry or clock-face for it" (3, chap. 1, emphasis mine). For Eliot, the real is not reducible to visible facts. By contrast, many Victorian critics began to view more factual commentary—for example, that concerning form or precise attribution—as a mark of their professionalism. As I will argue in chapter 7, a good number of the period's art critics worked against this approach by emphasizing the unknowable and the possibility for affective connections with artworks.

While seemingly agreeing with this more subjective aesthetic, Eliot complicates the possibilities for feeling and interpretation by representing the challenges presented by venues crammed with art objects. Dorothea is somewhat able to focus on the *Ariadne* in the Vatican Hall of Statues, but finds her viewing experiences in most Roman galleries deeply disheartening:

> There are comparatively few paintings that I can really enjoy. At first when I enter a room where the walls are covered with frescoes, or with rare pictures, I feel a kind of awe. . . . But when I begin to examine the pictures one by one, the life goes out of them, or else is something violent and strange to me. It must be my own dullness. I am seeing so much all at once, and not understanding the half of it. . . . It is painful to be told that anything is very fine and not able to feel that it is fine—something like being blind, while people talk of the sky. (143, chap. 21)

During her travels to Europe, Eliot similarly complained about seeing too much: "So many pictures have faded from my memory[,] even of those which I had time to distinguish" (qtd. in L. Ormond 42). Contemporary art critics would undoubtedly suggest guidance, but Edward Casaubon's connoisseurship and Will's technical advice do not encourage emotional responses. Lacking moral enthusiasm, Casaubon fails to appreciate the "strangely impressive objects around them. . . . What was fresh to her mind was worn out in his; and such capacity of thought and feeling as had ever been stimulated in him by the general life of mankind had long shrunk to a sort of dried preparation, a lifeless embalmment of knowledge" (136–

37, chap. 20). Rather surprisingly, Will's comments are similarly devoid of human feeling. At one point, he assures Dorothea that "there is a great deal in the feeling for art which must be acquired. . . . Art is an old language with a great many artificial affected styles, and sometimes the chief pleasure one gets out of knowing them is the mere sense of knowing" (143, chap. 21). But upon seeing an example of such an "artificial affected style," a painting by Naumann, Dorothea objects to this kind of deciphering: "What a difficult kind of shorthand! . . . It would require all your knowledge to be able to read it" (148, chap. 22) and remarks, "I think I would rather *feel* that painting is beautiful than have to read it as an enigma" (149, emphasis mine). Dorothea's emphasis on feeling mirrors a prominent theme in the most influential Victorian art commentary from the beginning to the end of the period.

Eliot's title for book 2, "Old and Young," intimates the differences between art appreciation based on overfamiliarity and that stemming from enthusiastic inexperience. The title, however, does not quite match up with the ages of Eliot's characters. Both Casaubon and the younger Will seem too knowing about art. Dorothea provides a better model by learning to appreciate art based on feeling. Earlier in the novel, responding to Will's sketch, Dorothea indicates that she might not be susceptible to art: "You know, uncle, I never see the beauty of those pictures which you say are so much praised. They are a language I do not understand. I suppose there is some relation between pictures and nature which I am too ignorant to feel" (53, chap. 9). Dorothea's uncle, Mr. Brooke, is unlikely to teach her; his claim that some paintings are valuable lacks personal conviction. Like Will and Casaubon, he discusses art in a pedantic, worn-out way, telling Dorothea, "You had a bad style of teaching . . . else this is just the thing for girls—sketching fine art and so on. But you took to drawing plans; you don't understand *morbidezza,* and that kind of thing" (53). Remarks Bert Hornback in his explanatory notes for *Middlemarch,* "*Morbidezza* was a term popular with eighteenth-century art critics to describe that style of painting characterized by extreme delicacy and softness" (53n). Similar to her response to Will's sketch, Dorothea believes that the artworks at the Grange, "these severe classical nudities and smirking Renaissance-Correggiosities[,] were painfully inexplicable, staring into the midst of her Puritanic conceptions: she had never been taught how she could bring them into any sort of relevance with her life" (49). At stake for Dorothea as well as for Lucy is developing feelings for artworks that do not offend their Protestantism.

Like Brontë, Eliot hints that private settings may provide an even bet-
ter opportunity for women viewers to interpret and form personal con-
nections with art, thereby questioning the contemporary value placed on
mass accumulation in public galleries. Upon returning from Rome, Doro-
thea sees most of the furnishings in Lowick Manor's blue-green boudoir
as lifeless. One object "gathered new breath and meaning: it was the min-
iature of Mr. Casaubon's aunt Julia, who had made the unfortunate mar-
riage—of Will's grandmother. Dorothea could fancy that it was alive now"
(190, chap. 28). But the reality present in the miniature, a sense gained from
Dorothea's disappointment in her own marriage, is by no means straight-
forward. The miniature depicts "the delicate woman's face which yet had a
headstrong look, a peculiarity difficult to interpret. Was it only her friends
who thought her marriage unfortunate? or did she herself find it out to be
a mistake, and taste the salt bitterness of her tears in the merciful silence
of night?" (190, chap. 28). The "difficulty" here for readers is not the art-
work itself, but the narrator's description, which leaves open Aunt Julia's
own thoughts on her marriage and the applicability of her experience to
Dorothea's.

Eliot suggests the power of such private aesthetics in the public realm
and thus echoes my discussion of household taste in chapter 2. In particu-
lar, the complexity associated with Aunt Julia's miniature challenges ste-
reotypical ways of envisioning women in other parts of *Middlemarch*. In
chapter 19, Naumann asks Will, "You are not angry with me for think-
ing Mrs. Second-Cousin the most perfect young Madonna I ever saw?"
(132). Naumann's comment fails to account for the intricacy indicated by
Eliot's connection of Dorothea with the *Cleopatra/Ariadne*. Eliot may have
admired the *Sistine Madonna,* but her heroine is not reducible to a "perfect
young Madonna." Naumann and Will's quarrel over how to describe Dor-
othea further reveals the deficiency of labels. Understandably, Will rejects
Naumann's reference to Dorothea as his "great-aunt." Dorothea is techni-
cally Will's "second cousin" in-law, but he tells Naumann to call her instead
"Mrs. Casaubon"—a public name disliked by both Will and Dorothea.

Both Eliot and Brontë believed that there was much advantage to
obfuscating their own public identities. Eliot famously wrote to William
Blackwood in 1857, "Whatever may be the success of my stories, I shall be
resolute in preserving my incognito, having observed that a nom de plume
secures all the advantages without the disagreeables of reputation" (qtd. in
Hirsch 2). Similarly, Charlotte Brontë, in her 1850 "Biographical Notice of
Ellis and Acton Bell," explained the Brontë sisters' decision to use pseud-

onyms: "Averse to public publicity [. . .] we veiled our names under those of Currer, Ellis, and Acton Bell" (qtd. in Levine, "Harmless Pleasures" 275). But under these false names, Eliot and Brontë hoped that they would be recognized—not merely identified—through their works. As Caroline Levine notes, Brontë's use of the verb "veil" demonstrates the contradictory impulses of concealment and revelation. Displaying similar wishes, Eliot wrote Barbara Leigh Smith Bodichon, the well-known landscape painter and feminist activist, "You are the first friend who has given any symptom of knowing me—the first heart that has recognized me in a book [*Adam Bede*] which has come from my heart of hearts" (qtd. in Hirsh 5). Joseph Liggins's false claim to be the author of *Adam Bede* prevented some of her other friends from knowing her, and Eliot was eventually forced to disclose her identity after the subsequent scandal. By contrast, Brontë viewed her pseudonym as a game: "It is time the obscurity was done away. [. . .] The little mystery which formerly yielded some harmless pleasure, has lost its interest" (qtd. in Levine, "Harmless Pleasure" 275). Brontë's valuing of mystery in matters of attribution presages later Victorian art commentary—most prominently, Walter Pater's *Renaissance*.

Thus, while the complex identities of the authors, characters, and artworks of *Villette* and *Middlemarch* certainly owe much to Victorian problems of gender and authorship, they are also rooted in the nineteenth-century culture of art, a culture deeply influenced by the 1835–36 select committee. In particular, the committee's twin emphases on verbal direction and expertise in specific fields of the arts found expression in a movement, largely populated by female critics, toward precise scholarship on art. Eliot's use of Jameson to correct Hazlitt not only serves to introduce a scene of contested artworks, but also places Eliot in a field of women writers who questioned the assumptions that great art was produced only by the most famous artists and that only men could comment on these works. In *Impressions of Theophrastus Such* (1879), Eliot wrote:

> It is a commonplace that words, writings, measures, and performances in general, have qualities assigned them not by a direct judgement on the performances themselves, but by a presumption of what they are likely to be, considering who is the performer. [. . .] But that our prior confidence or want of confidence in given names is made up of judgements just as hollow as the consequent praise or blame they are taken to warrant, is less commonly perceived, though there is a conspicuous indication of it in the surprise or disappointment often manifested in the disclosure of an authorship about which everybody has been making wrong guesses. (qtd. in Hirsch 7)

As if to remind readers of the disjunctions between artist and artwork and private and public lives, both Eliot and Brontë continued to use their pseudonyms for *Villette* and *Middlemarch,* novels that themselves manipulate the identities of artworks in ways that would have scandalized many Victorian art critics. The typical mid-Victorian art commentator authoritatively named artworks; Eliot and Brontë exploit the indeterminacy in the modern art world by creatively modifying these attributive concerns in order to complicate images of women.

CHAPTER 7

⚜

Sensational Sentiments

IMPRESSIONISM AND THE PROTECTION OF DIFFICULTY

IN LATE-VICTORIAN ART CRITICISM

uring the famous 1878 trial in which James McNeil Whistler sued John Ruskin for his description of *Nocturne in Black and Gold: The Falling Rocket* as "ask[ing] two hundred guineas for flinging a pot of paint in the public's face" (*Works* 29: 160), Ruskin's defense attorney Sir John Holker attempted to legitimate Ruskin's claim by discrediting Whistler as a serious painter. Holker's tactic would have been one familiar to a Victorian audience, as he suggested that Whistler's paintings were particularly attractive to women and therefore not deserving of either serious critical attention or monetary reward. In an imaginary tour of the Grosvenor for the jury, Holker described Whistler's works as "surrounded by groups of artistic ladies—. . . . and I daresay we would hear those ladies admiring the pictures and commenting upon them" (qtd. in Merrill 165–66).[1] Holker's description is of course a fiction, yet it is also a powerful one that belittled not only Whistler's paintings but women's critical judgment as well. Equating women's judgment with frivolity was a stereotype that was repeated throughout the Victorian period.[2] Indeed, the women critics on whom I focus in this chapter, Emilia Dilke and Vernon Lee, were both aware of the stereotype that Holker repeats and able to formulate their own specific criteria for evaluating impressionist art and art criticism.

Dilke's response to the stereotype of women's frivolity was to demonstrate her greater commitment to the art fact, especially when compared with male critics such as Walter Pater. I discuss Dilke at some length in this chapter because she both continues the art historical work begun by Jameson and Eastlake and because she provides an approach to impressionist art that differs substantially from more canonical critics. Vernon Lee, though closer to Pater's approach to art, differed from him by eschewing human emotion in painting. As a result, her influential definition of literary impressionism focused on the genre's opportunities for escapism. In fact, she is cited by the *Oxford English Dictionary* as the first writer to use "impressionism" in the literary sense. My point is not to claim that Dilke and Lee were completely different from their more famous male counterparts but that their awareness of gender stereotypes influenced their critical practices. Indeed, despite differences among the critics who are the central figures in this chapter—Dilke, Lee, Pater, Ruskin, and Oscar Wilde—all four register surprisingly similar concerns about impressionist art and art criticism. Following Ruskin's wish to preserve the difficulty inherent in the best artworks (discussed in chapter 5), all four worry about impressionist works that are too easy to grasp. But these later critics do so in a more elitist way, arguing against artworks that represent lower-class subjects with whom viewers might too easily identify. In other words, they argue against subjects that do not require explanation from an art critic. Instead of directly stating this class bias, their concerns are often masked by an aesthetic complaint about theatricality, or a direct pandering to the audience.

In studying these concerns about too-accessible art, I examine two kinds of aesthetic objects—Renaissance art histories and impressionist paintings—works that at first glance might seem incongruous. The Renaissance, and particularly the high Italian Renaissance, was viewed by many Victorians as the apogee of artistic creation, one to which British art could aspire. Impressionist painting, by contrast, was new, supposedly not based on any venerable artistic traditions, and associated with revolutionary France. But the same problem—the extent to which artworks should engage the sensations of individual viewers—impinged on discussions of both Renaissance and modern art. As Linda Dowling and other scholars have recently demonstrated, the Renaissance was often used by Victorian writers—including Dilke, Pater, and Lee—as a celebration of individualism (77–78). Lee characteristically remarks that her essays in *Renaissance Studies and Fancies* (1896) are "the outcome of direct personal impressions of certain works of art and literature" (vii). By their uncharacteristic treatments of the period,

these writers further subvert the stereotype of the Renaissance as canonical. Dilke discusses France, not Italy, and Pater examines such lesser-known figures as Pico of Mirandola and Luca della Robbia. While some scholars have claimed that Pater's approach to Western literature and art was conservative, his study of the Renaissance was "congruent down to the level of minute details, with the interests of the painters associated with art for art's sake and Aestheticism" (Prettejohn, "Walter Pater" 47). Yet Pater, similarly to the other writers I examine, hopes to limit a too-easy understanding of the artwork, primarily through historical distance. Despite the political connotations of the Renaissance, history was a safer, more distanced subject than the contemporary life treated by many modern painters. For all of the critics discussed here, impressions are useful for putting distance between the viewer and artwork, but they become dangerous when they allow viewers to identify with artistic subjects, particularly when these subjects question contemporary notions of class and gender.

IMPRESSIONISTIC HISTORIES OF THE RENAISSANCE

In his 1873 *Studies in the History of the Renaissance,* Pater famously describes Leonardo da Vinci's completion of an angel in the corner of his master's painting: "The pupil had surpassed the master; and Verrocchio turned away as one stunned, and as if his sweet earlier work must thereafter be distasteful to him, from the bright animated angel of Leonardo's hand. The angel may still be seen in Florence, a space of sunlight in the cold, laboured old picture" (80). Reviewing Pater's 1873 text for the *Westminster Review,* Dilke wrote, "This story has long been exploded as having no foundation, nor even verisimilitude, and the angel, which may still be seen at Florence, shows not a trace of special beauty nor even a sign that it has been touched by a different hand to that which painted the rest of the picture" (640).[3] Dilke omits Pater's admission that "the legend is true only in sentiment" (80), which seems to suggest that she fails to grasp his notion of history as based in ideas rather than facts. However, Dilke shared with Pater a belief that objective facts alone could not adequately represent history and its artworks. For both Dilke and Pater, histories of the Renaissance involved a necessary filtering through the consciousness of the art critic. That is, both writers believed that Matthew Arnold's project to "see the object as in itself it really is" (616) was impossible. The only way to approximate reality was, in Pater's words, "to know one's *impression* as it really is" (*Renaissance* xix).

Part of Dilke's motivation in criticizing Pater was to differentiate his method from her own supposedly more factual art histories. Dilke was conscious of the common notion that women's judgment lacked substance. Her approach was not without costs, as she has been criticized by both contemporaries and modern scholars as too devoted to facts. A Victorian reviewer representatively remarked on Dilke's "undue parade of the virtues of research . . . or . . . the actual belief that some burrowing among forgotten archives is an achievement so valuable that it makes literature unnecessary and original thought of nothing worth" (qtd. in Israel 258). Modern scholars have read Dilke's critique of Pater as similarly neglecting his contributions to literary technique.[4] But in her 1873 "Contemporary Literature: Art" that critiques Pater's *Renaissance,* Dilke demonstrates that she understands literary imagination as well as historical facts. Dr. Alfred Woltmann's *Architectural History of Berlin,* for example, lets "us know something of the character of each succeeding architect as a man"; in so doing, it "ceases to be a purely technical account . . . and becomes a living history of human effort, and its imperfect outcome" (639). Woltmann recreates the lives of artists without divorcing them from factual knowledge about the period: "It must not however be supposed that Dr. Woltmann has treated his subject from *a purely literary point of view,* he has not neglected to give the reader an ample measure of technical criticism and information" (639, emphasis mine). In her complaint about criticism that takes this "purely literary point of view" (639), Dilke presages Whistler's famous "Ten O'Clock" lecture, in which he lampoons critics who interpret art "absolutely from a literary point of view" (87). But while Whistler lumps all writers together as mere storytellers, Dilke defines ideal criticism as that which contains both the literary and the historical fact. For Dilke, some art histories are simply too literary—that is, merely based on the critic's imagination. For example, Theodor Simons's book on ancient Rome is a "highly dramatic account" of "the most sensational character" (641). Not only is this bad history, as Dilke's references to drama and sensationalism suggest, but Simons's account is also motivated by a desire to please readers for profit rather than to instruct. Following other mid-Victorian writers on the arts, Dilke establishes a hierarchy for art criticism similar to that found in literature, with the sensational and theatrical clearly at the bottom.

While Pater's *Renaissance* avoids such a low classification, it strays in Dilke's view away from the material facts of the period: "Mr Pater writes of the Renaissance as if it were a kind of sentimental revolution having no relation to the conditions of the actual world. Thus we . . . feel as if we were wandering in a world of unsubstantial dreams. We do not feel that the

writer has that intimate possession of his subject which alone can convey the impression of reality" (640). Rather than in Pater's subject matter, the threat for Dilke resides in Pater's emphasis on "sentiment" (640), or a kind of feeling too accessible for his readers. Although Dilke hoped to democratize the arts in Britain, she here indicates the undesirable possibility of "revolution" (640) if individual sense impressions are taken too far. Despite disagreeing with Pater's overall treatment of the Renaissance, Dilke approves of his ability to identify key ideas about the period: "Mr Pater possesses to a remarkable degree an unusual power of recognising and finely discriminating delicate differences of sentiment. . . . In this respect these studies of the sentiment of the Renaissance have a real critical value" (640). In contrast to her fear of Pater's "sentimental revolution" (640), Dilke here praises his more refined use of "sentiment" as "an emotional thought expressed in literature or art" (*OED,* s.v. "sentiment"). The *Oxford English Dictionary* notes that this intellectual use of "sentiment" was developed by authors such as Samuel Johnson and Samuel Taylor Coleridge—and was thus also familiar to a fairly broad audience (s.v. "sentiment"). This sort of sentiment could also appeal to lower tastes as well as higher ones; Samuel Johnson writes in *The Rambler* in 1750, "'Either the sentiments must sink to the level of the speakers, or the speakers must be raised by the height of the sentiments'" (qtd. in *OED,* s.v. "sentiment"). Throughout the Victorian period, artists and art critics including Dilke worried about the lower form of artistic sentiment—that is, that writers and artists were lowering their thoughts to appeal to the masses. In his 1885 "Ten O'Clock" lecture, Whistler asserts that the masses have become incapable of appreciating good art because "sentiment is mistaken for poetry" (81) in the popular imagination. Like many other Victorian writers, Whistler opposes the highest form of artistic expression, or "poetry," with the lower, too-accessible form of sentiment.

This concern with lower forms of sentiment was expressed much earlier in the period, especially in regard to social realist painting. As Judith Stoddart demonstrates, reviewers from the 1840s on began to differentiate between two different kinds of sentimental painting: an intellectual art that made no demands on viewers and a more popular, "essentially nonaesthetic" type that asked readers to sympathize with the subject (210). Richard Redgrave's *The Sempstress* (1844), which encourages viewers to empathize with the feelings of a lower-class woman, was considered a primary example of "nonaesthetic" art. William Thackeray complained in 1844 that Redgrave's painting was demonstrably in bad taste because of its public admiration. Moreover, notes Stoddart, reviewers criticized Redgrave's painting by associating it specifically with women's taste. Thus,

Thackeray writes that Redgrave's depiction of "small sentiment" took the "manliness" out of Thomas Hood's poem "The Song of the Shirt." The *Athenaeum* of 1844 wrote that the work was "too sentimental" and "cherished by the namby-pamby taste of fine ladies" (qtd. in Stoddart 204). In her own art criticism and in her writings on other critics, Dilke seems both aware of this critical heritage and eager to dissociate herself from the more popular and supposedly female type of sentiment.

As a result of this awareness, Dilke's histories are a careful balance between interesting readers in artworks and limiting their engagement with the period under discussion. In her own writings on the French Renaissance, Dilke makes clear that she agrees with Pater's celebration of the individualism and innovation associated with the period. In Volume 1 of her first book, *The Renaissance of Art in France* (1879), she characterizes the ideology of the period as "the new gospel of self-development, in the world of art" (70–71). Dilke begins her second volume of the book by noting, "When the imprisoned instincts of fifteen centuries burst their bonds, the moment of revolt left its traces everywhere; in art and literature, as in life; and the necessary transition from old forms to new, which gradually took place in Italy, was in France peculiarly sudden and complete" (*Renaissance of Art* 2). Safely separated in time from nineteenth-century revolutions, Renaissance innovations earn Dilke's approval.

However, in *The Renaissance of Art in France,* Dilke carefully limits access to the period. For Dilke, the art of the French Renaissance

> is in a most special way the expression of the desires not of a nation but of a class, the result of individual needs, individual taste, individual caprice at a period when the life of the few had become exceedingly rich and complex. It cannot, therefore, appeal to a wide public, and requires perhaps more than the art of any other time a knowledge of the conditions under which it was produced in order to arrive at an appreciation of its excellence. (1: 1)

On the one hand, Dilke suggests the need for a more democratic form of artistic culture than the very limited one found in the French Renaissance.[5] At the same time, she seems to revel in the limited appeal of the period. As an art historian interested in the material conditions in which art was produced (similar to her predecessor Elizabeth Eastlake), Dilke highlights the need for her own expertise in explaining the culture of the French Renaissance. Yet she also expresses a more democratic enthusiasm for her subject: "There is something verging on the fantastic," she writes of the architect Jean Bullant's Château de Ecouen, "in this lavish use of pillar and pilaster.

The exuberant profusion of creeping ornament which overflows the bordering lines of every frieze . . . also heightens the impression of caprice" (84); the effect that Bullant achieved "is the apparent impress of a single purpose and a single mind" (86). Though ostensibly writing a factual art history, Dilke here and elsewhere demonstrates a Paterian interest in the impression an artwork might convey to an individual viewer.

In addition to her acceptance of impressionistic criticism, Dilke highlights the sensual aspects of the French artworks she discusses. As one example of the Renaissance's enthusiasm for art, Dilke notes "the delight in the nude which instantly manifested itself" (18). This interest, Dilke admits, has "its coarser side" (19)—an aspect she illustrates with a story about a cardinal who "smuggled" a pornographic painting into his chamber, claiming it was a Madonna. Dilke admits that the *Légende du Cardinal de Guise* may not be true (as it was written by one of the cardinal's enemies), yet she shares it nevertheless in order to engage her readers. Dilke balances such sensuality with the kind of dry, pedantic language that characterizes much twenty-first-century art criticism. She writes of one building, "The whole length is crowned by heavy machicolated battlements, so that the aspect of the exterior is severe, but the façade which looks upon the court is not wanting in elegance" (44). The distinct lack of an observing eye in such passages, in contrast to her description of Bullant's Château, seems a response to what she characterized as Pater and Ruskin's tendency to emphasize personal impressions of artworks. In dramatically juxtaposing such dry observations with sensual exuberance, Dilke demonstrates the twin aims of much impressionistic criticism: inviting readers to form their own impressions of artworks while also distancing them from works of art.

Pater and Dilke achieve these goals by both preserving historical incompleteness and interesting readers in historical mysteries. Pater's "Luca della Robbia" opens with this general remark on Italian Renaissance sculptors: "One longs to penetrate into the lives of the men who have given expression to so much power and sweetness. But it is part of the reserve, the austere dignity and simplicity of their existence, that their histories are for the most part lost, or told but briefly" (49). This historical vision is necessarily and preferably incomplete, like the best art itself. In "Luca," for example, Pater argues that the power of Michelangelo's sculpture inheres in an "incompleteness, which suggests rather than realises actual form"—an incompleteness that "was in reality perfect finish" (53). Although Pater here discusses a Renaissance artwork, his emphasis on suggestive form aptly characterizes impressionist painting and seems to signal his approval of that modern style as based in a venerable tradition.

In deciding to write about well-known artists as well as more obscure ones, Pater aims to show that modern art history cannot fully illuminate even the most famous figures; impressionistic accounts are more important than what he calls "mere antiquarianism" (78). Unlike the incomplete accounts of Luca della Robbia and his workmen, much is known about Leonardo's life from both Vasari and nineteenth-century scholars. But Pater has little respect for modern efforts to challenge Vasari's dates, stories, and attributions:

> For others remain . . . the separation by technical criticism of what in his reputed works is really his, from what is only half his, or the work of his pupils. But a lover of strange souls may still analyse for himself the impression made on him by these works, and try to reach through it a definition of the chief elements in Leonardo's genius. The *legend,* as corrected and enlarged by his [Vasari's] critics, may now and then intervene to support the results of this analysis. (78)

Individual impressions of the artwork should remain primary, but Pater is not advocating a merely subjective appreciation of art. Rather, he wants viewers to analyze their impressions in the context of scholarship by Vasari and modern art historians. Vasari's legends, suggests Pater, are particularly valuable in accessing Leonardo's genius because they contain "the air of truth" (83) rather than simple facts. This sense of the truth protects the "mystery which at no point quite lifts from Leonardo's life" (84). For Pater, such legends protect the sense of incompleteness that must surround events separated from us by time.

Dilke likewise celebrates historical mysteries. During one section of her *Renaissance,* she considers the early sixteenth-century construction of palaces and châteaux in Paris. "Paris," she writes, "should be well within the range of modern curiosity. We expect to get easily at definite knowledge concerning its work and those to whom it was done" (67). But after three pages considering various dates and sources to establish the architect of buildings at Fontainebleau, Dilke remarks, "we are forced to acknowledge that often the utmost efforts of search will not even yield a name" (67). Dilke's skepticism underscores the difficulty of her project and the necessity of the expert to approach historical reality.

Further, Dilke approves of others' art criticism that preserves the mystery or incompleteness of the world's best artworks. Thus, Dilke celebrates Pater's *Imaginary Portraits* (1878): "Now the very incompleteness of these portraits . . . adds to the reality of their characterization as pictures of his

[Pater's] own mind, and increases the interest with which we read in them moods of the inmost soul of one amongst ourselves" (qtd. in Seiler 166). As a work that seemingly makes no claims to be an objective account, *Imaginary Portraits* is for Dilke less threatening than Pater's art-historical *Renaissance.* Yet Dilke also lauds the more purely impressionistic (and thus less historical) aspects of Pater's *Renaissance:* "He can detect with singular subtlety the shades of tremulous variation which have been embodied in throbbing pulsations of colour, in doubtful turns of line, in veiled words" (640). Her 1870 review of Ruskin's *Lectures on Art* uses strikingly similar terms: "His analysis of subtle qualities of colour, of line, his criticism and description of any work which he has made a subject of study, cannot be surpassed for justness and delicacy" (305–6). Their subtlety notwithstanding, Dilke realizes that the central goal of both Ruskin's and Pater's criticism is communicating with readers. Pater's impressions are "matched . . . for us in words" (640) and "we at once share" (305–6) those of Ruskin. Despite their immediately shareable qualities, the impressions of both critics require what Dilke views as a desirable necessity for deciphering on the part of the reader.

INCOMPLETENESS IN IMPRESSIONIST PAINTING

Despite the limited audience for French impressionist painting in Britain before the turn of the century, Pater, Dilke, and Lee all seek to restrict popular access to these works by defending their inherent difficulty. French impressionism was threatening to British critics for several reasons. For one thing, the movement lacked for many commentators the connections with tradition that earlier painters supposedly respected. Though High Renaissance artists were celebrated as individual innovators, they were also praised for respecting prior artistic movements. Not only was impressionism viewed as a complete break with the past, but the association of the movement with France also exacerbated fears about its revolutionary connotations. The *Times* (London) critic of 1874 representatively wrote of French impressionism, "One seems to see in such work evidence of as wild a spirit of anarchy at work in French painting as in French politics" (qtd. in Flint, *Impressionists* 14). In her introduction to *Impressionists in England: The Critical Reception,* Kate Flint writes, "Throughout the nineteenth century, to parallel artistic with political revolution signified a pronounced condemnation of sudden change, of any upheaval which threatened established

order" (14). French impressionism was seen as a passing fad, not a lasting or important development in painting (Flint 5).

The extent of this anxiety about impressionist painting is somewhat surprising because it was never as accessible or as broadly popular as many earlier genres. French impressionists were particularly slow to gain a foothold in Britain; the first exhibition of such works in 1870 was not a success (Flint, *Impressionists* 3). The Royal Academy Selection Committee rejected works by Monet and Pissarro in 1871; such paintings were usually exhibited at small private galleries. Ruskin's ignorance of French impressionism at the time of the *Whistler v. Ruskin* trial in 1878 was typical of that displayed by other British critics. In the 1880s, even well-informed viewers knew little about French impressionism—a catalogue for an 1883 show in London thus sought explicitly to introduce the painters "to the English connoisseur"; the *Artist* opined that the same exhibition, "important as it is, is hardly one to attract the mass" (qtd. in Flint, *Impressionists* 6). This perception of elitism lasted through the end of the century. The *Saturday Review* of 1901 remarked that impressionism "to most people, [is] a mere phrase, utterly unintelligible, and consequently suggestive of high culture" (qtd. in Flint, *Impressionists* 14). There would thus seem little danger that the style would become too popular among Victorian audiences.

Nevertheless, the critics under discussion here praise art and art criticism that limits popular access to these works. In his 1893 review of George Moore's *Modern Painting,* Pater notes that "we in England still know so little" about modern French painting. But even as he hopes for more widespread knowledge about these modern works, he praises Moore for recognizing that great art contains secrets: "beyond all that can be had of teachers—there is something there, something in every veritable work of art, of the incommunicable, of what is unique, and this is perhaps, the one thing really of value in art" (3). For Pater, even nonspecialists can appreciate this quality, but for those who "really know. . . . preference in art will be nothing less than conviction" (3). Moore, a critic with such conviction, conveys his enthusiasm for French painting through a style characterized by verbal "impressionism, to use that word, in the absence of any fitter one" (3). Pater's review is thus less concerned with the art that Moore discusses than with the author's style, which for Pater successfully preserves the aura of the art object by its preservation of the unknowable.

More concerned with actual modern artworks than Pater, Lee similarly finds that the best impressionist paintings can only be understood by those with a certain temperament. In "Imagination in Modern Art" (1897), Lee

compares modern and "old religious painters," noting that the latter are more universally comprehended because they depict "scenes familiar to all men" (521). However, Lee prefers the more elitist complexity of modern painting, which requires the intervention of a specialist. Unlike older paintings, the work of an impressionist painter "is still very personal, very sporadic; and only those can understand it who have been initiated, so to speak, by the grace of their own constitution" (521). Lee's Paterian need for a special disposition seems contradictory because in *Renaissance Studies and Fancies,* she emphasizes the role of individual perception. However, in "Imagination in Modern Art," she clarifies this emphasis on subjectivity, arguing that some individuals are more able than others at unraveling complex artworks. Thus, even with the move toward allowing viewers to interpret art subjectively at the end of the century, critics still limit the democratization of taste.

Like Lee and Pater, Dilke finds that the best art is understood by the few rather than the many. But Dilke differs from those critics in her disapproval of most impressionist painting. One notable exception is Dilke's fondness for some of Whistler's paintings, despite his frequent association with the impressionists.[6] In her 1872 review of the "Summer Exhibition of the Society of French Artists," Dilke associates Whistler's *Arrangement in Grey and Black No. 1,* also called *Portrait of the Artist's Mother* (1871; fig. 6) with "intellectual power," which he achieves through suggestiveness and incompleteness (185). Whistler "voluntarily ren[ounces] any attempt to rouse pleasurable sensations by line, or form, or colour" in this portrait (Dilke, "Summer Exhibition" 185). Dilke's preference for intellect over mere sensation is similar to her differentiation between high and low sentiment.

However, Dilke's advocacy of intellectual sentiment is complicated by her own religious beliefs. As I discuss in chapter 3, earlier art critics' views on art were often influenced by a fear of Catholic inspirations. Even as writers turned more firmly away from religion and toward aestheticism, the concerns of contemporary religious debates influenced their commentaries. Dilke's review of Whistler's mother begins with aesthetics but then quickly turns to approval of the painter's Protestant vision: "At first sight in its voluntary renunciation of any attempt to rouse pleasurable sensations by line, or form, or colour, it brings up a vision of the typical Huguenot interior—protestantism in a Catholic country" ("Royal Academy" 185). Dilke's *The Renaissance of Art in France* explains her regard for the Huguenots and thus reinforces her favorable assessment of Whistler's Protestantism. For Dilke, the Huguenots held the potential in Renaissance France to reinvigorate the moral spirit of the country but were unfortunately suppressed by

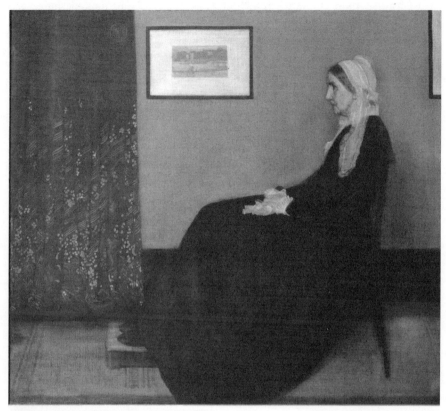

Figure 6
Whistler, James Abbott McNeill (1834–1903). *Arrangement in Grey and Black No. 1,* or *Portrait of the Artist's Mother* (Anna Mathilda McNeill, 1804–81). 1871. Oil on canvas. 144.3 × 162.5 cm. Museé d'Orsay, Paris, France. Photo Credit: Erich Lessing/Art Resource, NY.

the Catholics: "The most distinguished men in France, even in the world of arts and letters, stood not in the ranks of the cause which triumphed, but on the side of that which fell. . . . the collapse of the Renaissance and the victorious wars of the Catholic party sprang from some common cause" (*Renaissance* 29). This "common cause" that quelled the artistic advances of the Renaissance and allowed the Catholics to win was moral indifference. Thus, in comparing Whistler's effect to French Huguenot interiors, Dilke suggests that his painting contains a higher moral value than other paintings at the 1872 Royal Academy exhibition because of his Protestant intellectualism.

Dilke finds that most impressionist painters sacrifice both intellectual and moral power in appealing to the sensations of viewers. Dilke asks rhetorically, "What is likely to be the effect on taste of the production in art of work which corresponds in style to the style of the sensation writers in literature?" ("Summer Exhibition" 204). Dilke means two different things by her use of the word "sensation." First, she complains about paintings which appeal to the senses through a facile technique, a "well-calculated rough and ready handling, [which] forcibly accentuate[s] for us only our most obvious physical impressions" (204). Dilke here captures the lower connotation of "impression" as an "effect produced on the senses . . . in its purely receptive aspect" (*OED*, s.v. "impression"). As this definition indicates, impressionist art and literature, while providing a desirably suggestive picture of reality, could also encourage viewers to respond based on sense alone. Second, Dilke suggests that "vulgar" subjects (that is, lower-class people or social-climbing members of the middle class) are meant to shock viewers rather than appealing to their intellects:

> One cannot but fear that this terrible effectiveness, so easy to understand, or, say rather, so impossible to misunderstand, which puts so forcibly to the eye the commonest, the most vulgar, the most salient facts, has from its very intelligibility a much to be dreaded seduction, and that it will to a great extent destroy any relish which may exist in the public for work of a more subtle quality. ("Summer Exhibition" 204)

Dilke here seems to be writing about pornography, not a high art form. That is, she believes that the easy seductiveness of impressionism will prevent readers from unraveling more complex works. Although we commonly think of impressionist painting as similar to Dilke's conception of Pater's *Imaginary Portraits*—as conveying fragmentary moods rather than objective reality—Dilke believed that the style was often too easily understood. For Dilke, not all impressions are incomplete enough; the best ones make readers do significant interpretive work. Her frequent return to visual pleasure in her own *The Renaissance of Art in France* and her sometimes favorable comments on Pater and Ruskin notwithstanding, Dilke is unwilling to accept this level of sensualism in a modern visual art form. Moreover, Dilke makes clear the political ramifications of this seductiveness. Although willing to accept a limited form of individualism associated with the French Renaissance, Dilke finds more recent impressionist innovation a sign of larger social instability: "Modern society is developing the individual at the expense of the family, and in every field of human labour

this is making itself felt" ("Summer Exhibition" 205). Dilke here rejects the late-Victorian emphasis on individual sense impressions in favor of a more organic view of society.

Many contemporary critics shared Dilke's concern about the supposed "vulgarity" ("Summer Exhibition" 204) of impressionist paintings, deploring the representation of "low" subjects—including both the working classes and those of the middle class who seemed to have forgotten their station in life. The "Lady Correspondent" for the 1881 *Artist* faulted the impressionists' "admiration for the ugly and the vulgar. . . . Can art descend lower? . . . This is 'Realism' so called; this is in art what M. Zola is in literature" (qtd. in Flint, *Impressionists* 42–43). Like Dilke, this reviewer suggests that some impressionist art approaches the degeneracy of supposedly vulgar realism. Defenders of French impressionism in Britain, notes Flint, tried to deflect these concerns by arguing that the style was in fact based in tradition and that the technique should be appreciated apart from the subject.

But reviewers remained fixated on the subjects of impressionist paintings. Much of Dilke's worry about the vulgarity and understandability of these paintings centered on what she viewed as their common subjects. "The head and expression have an ordinary character," she writes of Bouvier's *Spring,* "they are those of the model unmodified, and the straightforward empty gaze disturbs the complete harmony of the impression" ("Summer Exhibition" 205). For Dilke, the figure lacks the absorptiveness—the unawareness of the spectator—that Michael Fried demonstrates was so important to nineteenth-century reviewers. In "The Exhibition of the Royal Academy of Arts" (1872), Dilke similarly worries about the subjects of paintings, and particularly those that engage the viewer. Dilke's belittling of Millais's *Hearts are Trumps* may be partially due to the subject: three card-playing, well-dressed women, one of whom looks directly at the viewer (fig. 7). Again demonstrating her awareness of the stereotype denigrating women's judgment, Dilke seeks to dissociate herself from depictions of frivolous dress and activity.[7]

Lower-class subjects also earn Dilke's direct censure. Considering the "careless servant" of Fred Walker's *Harbour of Refuge,* Dilke asks, "Why has Mr. Walker suffered us to look straight into those eyeless sockets?" (185). Though unable to look at the viewer, the servant is the focal point of the painting. In contrast to *Harbour of Refuge,* Dilke praises works that present higher subjects in subtle ways. Accordingly, James Tissot's *Les Adieux,* a painting of an upper-class couple sorrowfully parting with a handshake, is "as polished and high-bred as a poem of the best society

Figure 7
Millais, Sir John Everett (1829–96). *Hearts are Trumps*. 1872. Oil on canvas. 165.7 × 219.7 cm. Tate Gallery, London, Great Britain. Photo Credit: Tate, London/Art Resource, NY.

should be" (185). Dilke's comparison of the painting with poetry indicates that these engaged, upper-class subjects are suitable for the best art.

Wilde shared with Dilke a dislike of impressionist paintings depicting lower-class subjects, and particularly those rendered in a theatrical way. Reviewing the Grosvenor's opening for the *Dublin University Magazine* while suspended from Oxford in 1877, Wilde shudders at Millais's "picture of a seamstress, pale and vacant-looking, with eyes red from tears and long watchings in the night, hemming a shirt. It is meant to illustrate Hood's familiar poem" (8). Though the woman is absorbed in her own suffering and not appealing directly to the viewer, she nevertheless seems to be making an emotional appeal. For Wilde, Millais has violated the stricture of maintaining distance between audience and picture that informed reviews of sentimental art in the 1840s. Even worse, notes Wilde, is that the painting hangs above another Millais representing the three daughters of the Duke of Westminster: "As we look on it, a terrible contrast strikes us between this miserable pauper-seamstress and the three beautiful daughters of the richest duke in the world, which breaks through any artistic reveries by its awful vividness" (8). As in other reviews of modern paintings, the technique—Millais's realism—is less important than what is depicted. Thus, Wilde contrasts Tissot's "over-dressed, common-looking people" with another artist's "beautiful grouping of noble-looking men, its exquisite Venetian glass aglow with light and wine" (21). Wilde is attracted by both the class of men and the interior decorations contained in this painting, a view that elides with his favorable conception of the Grosvenor as a well-appointed space for leisurely, upper-class contemplation of art.

Wilde's assessments of Whistler's paintings at the 1877 Grosvenor are similarly informed by the class of the subjects depicted. Wilde remarks that the artist's Nocturnes "are certainly worth looking at for about as long as one looks at a real rocket, that is, for somewhat less than a quarter of a minute," because their titles and color "smudges" convey little recognizable information (18). Like Ruskin, Wilde was bothered by the indistinctness of these paintings. But Wilde seems most attentive to class issues, as he explicitly notes the setting of *Nocturne in Black and Gold: The Falling Rocket* as the Cremorne Gardens, a well-known pleasure park frequented by prostitutes and other undesirables. Ruskin shared Wilde's concern about this kind of vulgarity. Though he did not write directly about Whistler's subjects, Ruskin objected to lower-class elements in other paintings. Directly after attacking Whistler in *Fors Clavigera,* Ruskin remarks that Tissot's paintings at the 1877 Grosvenor "are, unhappily, mere coloured photographs of vulgar society" (161). Scholars often uncertainly attribute

Ruskin's attack on Whistler to a variety of causes, including his declining faith in the masses and to his ill health, but it seems equally likely that he was incorporating this late-Victorian fear of lower-class subjects. During the *Whistler vs. Ruskin* trial, Ruskin's attorney Sir John Holker attempted to capitalize on *Nocturne in Black and Gold*'s subject by joking, "I do not know what the ladies would say to that, because it has a subject they would not understand—I hope they have never been to Cremorne—but men will know more about it" (qtd. in Merrill 167).[8] As in his derogatory comments about Whistler's paintings in general, Holker here references women's supposed naïveté about low subjects in paintings, something that Dilke implicitly contradicts in her explicit rejection of the vulgar.

Like most of his British contemporaries in the 1870s, Wilde favors clearly drawn paintings that convey appropriate feeling for a high subject. Thus, Wilde approves of Whistler's *Arrangement in Grey and Black, No. 2: Portrait of Thomas Carlyle* (1872–73) because of the painting's treatment of a dignified subject: "The general sympathetic treatment, show Mr. Whistler to be an artist of very great power when he likes" (19). For Wilde, this painting is sympathetic without being sensational. By contrast, Wilde complains about paintings at the Grosvenor that appeal to lower tastes through theatrical and indistinct effects. For example, Whistler's Henry Irving "is so ridiculously like the original that one cannot help almost laughing when one sees it" (18). The painting, like its subject, exhibits the theatricality that nineteenth-century reviewers associated with lower-class entertainment—and thus flawed artistic conceptions. The indistinctness of the painting exacerbates Wilde's fears about its low subject: "Out of black smudgy clouds comes looming the gaunt figure" (18). Wilde worries that viewers will not recognize the portrait of Irving for the lower-class subject that it is.

Similarly, Lee complains about paintings that merely repeat empty, conventional signs. She derides, for example, a number of paintings from the fourteenth and fifteenth centuries that take the Annunciation of the Virgin as their subject: "In one by Cosimo Rossetti she [the Virgin] lifts both hands with shocked astonishment as the angel scuddles in; in the lovely one, . . . now given to Verocchio, she raises one hand with a vacant smile, as if she were exclaiming, 'Dear me! there's that angel again'" (*Renaissance Studies* 86). The gestures to which Lee objects are similar to the ones used in popular Victorian melodramas: they carry obvious meaning but are not emotionally realistic. Lee thus denigrates art that is too accessible to the general viewer. As an example of a higher artistic mode, Lee cites the Annunciation of Botticelli, which suggests much with few signs. Botticelli's angel "lift[s] a hand which seems to beg patience, till the speech

which is throbbing in his heart can pass his lips" (88). The emotion here is not overtly stated; it needs to be interpreted. Likewise, in an Annunciation by Signorelli, "There is no religious sentiment, still less any human: the Madonna bows gravely as one who is never astonished" (88)—in short what we might expect from a scene of this magnitude. The scene does not depend on easy religious identifications, nor is it meant to provide the more sensational qualities of shock or "astonishment."

As Lee's approval of Signorelli's Madonna as appropriately dignified makes clear, Catholic artworks could be successful if interpreted aesthetically rather than religiously. In this sense, Lee's approach was close to that taken earlier in the century by Jameson and Eastlake. But, notwithstanding her religiously motivated desire to focus on aesthetics, Lee exhibits an odd disregard for human emotions within paintings. Lee's description of Signorelli's Madonna makes sense on a religious level: the Madonna is a figure more sacred than human at this point in the story. Further, Lee believes that too much human emotion would ruin the gravity of the situation and place the emphasis on viewers of the painting. Yet in removing all human emotion and sentiment, Lee's interpretation seems to separate the viewer entirely from the painting.

In contrast to Lee, Pater highlights human emotion in his essays on individual artists in the *Renaissance*. Pater's conclusion, writes George Levine, "strangely and almost inhumanly equates deeply different kinds of sensations, 'strange colours, . . . curious odours . . . the face of one's friend,' for example. The 'hard, gem-like flame' with which Pater wants us to burn is precisely *not the engaged, sentimental,* entirely human feeling with which one would think we normally engage the world" (25–26, emphasis mine). But, in his focus on the conclusion, Levine neglects the human feelings that Pater incorporates into his chapters. "First of all," Pater notes of a drawing he assumes is by Leonardo (now attributed to one of Leonardo's students),

> there is much pathos in the reappearance, in the fuller curves of the face of the child, of the sharper, more chastened lines of the worn and older face, which leaves no doubt that the heads are those of a little child and its mother. A feeling for maternity is indeed always characteristic of Leonardo; and this feeling is further indicated here by the half-humorous pathos of the diminutive, rounded shoulders of the child. (90)

Pater's focus on "pathos" and "feeling" is clearly different from Lee's approach to subjects within paintings. However, Pater qualifies such feeling by focusing on the forms—the lines and curves—of the figures as well

as on their "pathetic" qualities. As scholars such as Flint and Prettejohn have demonstrated, Pater's attention to form is typical of professional Victorian criticism. Yet, as I have also argued throughout this book, formal analysis does not necessarily preclude serious consideration of emotional content. Writing toward the end of the century, Lee extends her earlier denial of much human emotion by advocating art that is purely decorative. In "Imagination in Modern Art" (1897), Lee complains that most viewers still find human emotion most compelling. She hopes that spectators will instead appreciate the natural patterns embodied for her in Whistler's *Harmony in Blue and Gold: The Peacock Room*: "Once painters have learned the necessary craft, and beholders have felt the emotion attaching to things not human, as much as they already feel the emotion of human things; shall we not see walls and ceilings covered with patterns like these . . .?" (515). Lee here rejects what earlier reviews termed "nonaesthetic art" (Stoddart 210), or art that asks viewers to identify with suffering human subjects, in favor of interior decoration.

In his 1877 review of the Grosvenor Gallery (fig. 8), Wilde presages Lee's value of decorative art. Wilde suggests that the interior of the Grosvenor provides an upper-class, well-decorated context for the art:

> There are only three rooms, so there is no fear of our getting that terrible weariness of mind and eye which comes on after the "Forced Marches" through ordinary picture galleries. . . . there are luxurious velvet couches, . . . and, in fine, everything in decoration that is lovely to look on, and in harmony with the surrounding works of art. (6)

Wilde's 1890 *The Picture of Dorian Gray* supports this initial impression of the gallery. Advising the artist Basil Hallward about where to send his portrait of Dorian Gray, Lord Henry Wotton remarks, "You must certainly send it next year to the Grosvenor. The Academy is too large and too vulgar" (140–41). Though Wilde's views on art certainly developed between his 1877 review of the Grosvenor and his 1890 novel, his earlier review seems to ally him with the elitist views of Lord Henry Wotton. By contrast, Ruskin worries that the interior decorations in the Grosvenor highlight commercialism over artistic merit. In *Fors Clavigera,* Ruskin singles out the upholstery as "very grievously injurious to the best pictures it [the Grosvenor] contains, while its glitter as unjustly veils the vulgarity of the worst" (*Works* 29: 158). Ruskin indicates that viewers, focused on the Grosvenor's furniture, would fail to observe that many of the paintings are depictions of low subjects. While Wilde too was bothered by some of these lower-

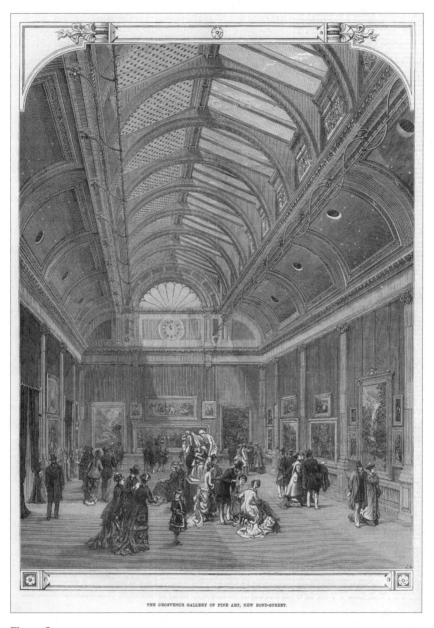

THE GROSVENOR GALLERY OF FINE ART, NEW BOND-STREET.

Figure 8
Visitors socialize and view contemporary paintings in the main gallery. Grosvenor Gallery of Fine Art, London, 1877. *The Illustrated London News.* 5 May 1877. 420. © *Illustrated London News Ltd*/Mary Evans.

class subjects, he views the upper-class decorations in the Grosvenor as even more satisfying than much of the art.

On his return to the Grosvenor in 1879, Wilde does not entirely abandon considerations of subjects. Rather, he suggests that they have become more ideal, less like the horrible real life that he was forced to confront in the 1877 paintings of Millais. Thus, Edward Burne-Jones's *Annunciation* depicts "a passionless, pale woman, with that mysterious sorrow whose meaning she was so soon to learn mirrored in her wan face" (24). The painting hints at a story about this well-known figure but lacks the theatricality that Wilde found so irritating in his 1877 review of Whistler's Henry Irving. Overall, his 1879 review demonstrates an increased willingness to discuss art apart from its subject and a consequent appreciation of what he calls "modern" art. Unlike the "commonplace" Royal Academy, writes Wilde, "it is at the Grosvenor Gallery that we are enabled to see the highest development of the modern artistic spirit" (24). Even in light of this comment, Wilde's about-face on Whistler's work is remarkable:

> Mr. Whistler, whose wonderful and eccentric genius is better appreciated in France than in England, sends a very wonderful picture entitled *The Golden Girl . . .*; nor have the philippics of the *Fors Clavigera* deterred him from exhibiting some more of his 'arrangements in colour,' one of which, called a *Harmony in Green and Gold,* I would especially mention as an extremely good example of what ships lying at anchor on a summer evening are from the 'Impressionist point of view.' (27)

Wilde indicates that this impressionist view is a very indistinct one—a quality he now values for its decorative qualities. There seems nothing at all objectionable in the painting. However, in his approval of *Harmony in Yellow and Gold: The Gold Girl—Connie Gilchrist* (1876–77), Wilde demonstrates a newfound ability to appreciate even lower-class subjects, as Gilchrist was an artist's model and stage performer. How could Wilde approve of this image while being so critical, only two years earlier, of Whistler's Henry Irving portrait? For one thing, Gilchrist was a relatively new commodity at the time of Wilde's 1879 review, having made her stage debut only two years earlier, and thus she fits his conception of a "modern artistic spirit" (24). In addition, while *The Gold Girl* is a successful likeness of Gilchrist, the painting is also decorative—something that Wilde suggests is missing in the "smudgy" Irving portrait. Wilde emphasizes the color harmony of *The Gold Girl;* it is, he says, a "life-size study in amber, yellow and browns" (27).

Further, Wilde's approval of *The Gold Girl* suggests a source for Sybil Vane in *The Picture of Dorian Gray*. Dorian Gray first describes Sybil Vane to Lord Henry Wotton as possessing "'a little flowerlike face, a small Greek head with plaited coils of dark brown hair, eyes that were violet wells of passion, lips that were like the petals of the rose'" (50). Here, Dorian supports Lord Henry's contention that "women are a decorative sex" (47). While Lee and Dilke reject this equation of women with decoration, Wilde's *Dorian Gray* and art critical writings suggest his own approval. The narrator tells us that, upon returning to the theater, Dorian views the theatrical Sybil as marked by an "artificial manner" with an "*absolutely* false" voice, which "was wrong in colour" (80). Unlike Whistler's Connie Gilchrist, Wilde's later Sybil Vane is no longer absorbed in her performance. As a result, Sybil has ceased to be decorative, and she loses the love of Dorian as a result (and, it seems, Wilde as well). In his emphasis on aesthetic decoration, Wilde thus illustrates a partial shift away from the difficulty advocated by Ruskin and Dilke as the primary value of art. Yet, in his rejection of melodrama and mere sensation, Wilde similarly seeks to protect art from a too-easy understanding.

Though impressionism was increasingly accepted after the Victorian period, the movement has yet to shed its association with commercialism and easy consumption. A quick look in closing at a recent review of an American impressionist painter reveals that the same worries about the style's seductively pleasing power have continued into the twenty-first century—even as some impressionist painters are now often ranked with Renaissance geniuses. To be sure, the painter reviewed, Childe Hassam, was no genius. But he was the subject of a 2004 retrospective at the Metropolitan Museum of Art, something that raised the hackles of at least one major art critic. In his review, chief art critic of the *New York Times* Michael Kimmelman warns viewers about the kind of commercialized sentimentalism that also rankled Victorian critics: "Hassam's most characteristic works remain [American] flags: heartfelt, iconic celebrations of civic expansion and nationalism" (3). Echoing Wilde's 1877 review of Whistler's Nocturnes, Kimmelman notes that most of Hassam's paintings are "less fascinating the longer you look. Hassam could do almost anything technically in a variety of media. . . . Anything except what mattered most, which was offer up something beyond glitter and nostalgia" (2). That "something" for Kimmelman as well as for Dilke and other Victorian reviewers of impressionist paintings is an active engagement with viewers' intellects.

Yet Kimmelman seems most annoyed about the decorative and commercial qualities of much impressionism, which "was the perfect style for

a while: quick to accomplish, visually snappy, handsome above the sofa and suited to endless variations on the same themes, satisfying buyers who wanted something just like, but not exactly the same as, what they saw at their friend's home" (2). Kimmelman complains about Hassam's too-easy accessibility, something exacerbated by the painter's use of a supposedly facile style. The paintings both take no effort to understand and are in reach of those buyers who cannot afford a Degas or Monet. Hassam's paintings were simply another decoration in the home for his buyers—a sure sign of their baseness. Kimmelman suggests that the Metropolitan Museum of Art is complicit with the art market that wants to sell his paintings—an insinuation similar to Ruskin's critique of the 1877 Grosvenor. Only art critics, say the writers I examine here, can protect viewers from a style that can fool the majority with its commercialized sentimentalism.

CONCLUSION

❧

"An astonishingly tasteless idea"?

ARTISTIC VALUE AFTER SEPTEMBER 11

*S*peaking before a standing-room-only audience at Indiana University in March 2004 after being selected to rebuild the World Trade Center site, the architect Daniel Libeskind vowed to reconnect architecture with people and to replace what it had supposedly lost in the twentieth century: its "magic" and connection with nature. "Architecture is life" and "human meaning," he remarked. A year earlier, Libeskind was equally enthusiastic about the competition for the site design, which he had not yet won: "From now on, architecture will never be the same. There will never be a building without people talking about what is happening and what it's going to look like. From now on, architecture will be as interesting for people to talk about as the taste of wine" (qtd. in Iovine B5). Libeskind's simile underscores a central problem in discussions of taste from the eighteenth century on: claims for democratization often rest on elitist assumptions. While the plans for the World Trade Center site have engaged a large section of the public, architecture and its commentary remains to many readers as foreign as the subtle differences among wines.

Admittedly, architecture has been a less prominent focus in this book than other art forms like painting. But architecture was also integral to most Victorian discussions of taste. As I demonstrate in the first two chap-

ters, worries about increased access to both household goods and architectural forms were inextricably linked in the commentaries of Pugin, Ruskin, and the architect Charles Eastlake. Further, debates about the National Gallery and other venues (the focus of chapter 5) demonstrate that buildings were considered as important to educating visitors as the artworks themselves. The embodied perspective that Jonathan Crary has seen as defining nineteenth-century viewing practices is frequently represented in relationship to actual buildings in Victorian writings on art. Dilke, for example, places her reader inside Renaissance buildings to illustrate both their formal features and their marks of individual genius, which she clearly links to Victorian notions of freedom. Pugin and Ruskin were thus not the only Victorian critics to consider the social importance of architecture. I conclude with commentary on the World Trade Center site because it illustrates such Victorian tendencies in a way that most recent art criticism does not.

Modern art criticism, whether in the popular press, at exhibitions, or in textbooks, often divorces works from their social contexts, discussing them instead in purely formal terms. The stories, embodied perspectives, and colorful language that characterize many Victorian writings on the subject—even ones that are more formal in focus—are usually absent in recent commentary. For example, *Gardner's Art through the Ages,* a standard modern textbook for undergraduate art history courses, characteristically remarks of James Tissot's *The Ball on Shipboard* (1874) that the painting's "obliqueness of light direction makes for a most complex tonality. . . . the painter is concerned above all with rendering the scene as if it is occurring at an instant in time—spontaneous, unposed, natural. The effect is photographic, as John Ruskin realized" (847). The description provides a definition for realistic impressionism but neglects the interesting and important contemporary debates that surrounded Tissot's paintings, including those about his supposedly unsuitable subjects. Demonstrating his focus on subject as well as form, Ruskin remarks in *Fors Clavigera* (79) that Tissot's paintings "are, unhappily, mere coloured photographs of vulgar society" (*Works* 29: 161). By contrast, the authors of *Gardner's Art* suggest that Ruskin was merely pointing to Tissot's technique, rather than joining a historically specific discussion about form and subject.[1]

In *Ways of Seeing,* John Berger argues that such a preoccupation with form in modern art commentary is a way of ignoring the real emotion in a painting: that created by the relationships among artist, subject, and viewer. Berger illustrates this problem by referring to a twentieth-century study of the seventeenth-century Dutch artist Frans Hals. While the art historian

(whom Berger does not name) denies any relationship between the painter and his subjects, discussing the work in purely formal terms, Berger argues that Hals must have been affected by his status as a pauper in representing the regents who provided him with charity. Berger notes that the paintings "work upon us because we accept the way Hals saw his sitters," that is, as powerful, yet deeply flawed individuals (13). Berger encourages viewers to see this human relationship for themselves. Thus, the viewer's emotional response as well as awareness of historical class dynamics is key to Berger's aesthetics.

In contrast to the formal concerns of much recent art criticism, human emotions have been emphasized in much of the discourse surrounding the commemoration of September 11. Immediately after the terrorist attacks, critics assured readers that the arts could provide solace to grieving individuals and to the country as a whole.[2] These writers suspended their usual impulse to group the various arts into distinct value hierarchies. Traditionally "high" arts such as literature and painting were discussed in similar terms to such forms as pop music; critics commonly assumed that all these genres could both reach individual mourners and provide a common mode for sharing feelings. Writing on pop music in a *New York Times* article dated September 13, 2001, Neil Strauss argued that Elton John's "Candle in the Wind" could provide solace for those affected by tragedy. For Strauss, the song transcends its subjects—Princess Diana, most recently, and Marilyn Monroe, originally—to connect with individual experiences and emotions (E5). Indeed, the song has been immensely popular in both the United States and Britain. Strauss's endorsement of "Candle in the Wind," despite its popularity and emotional appeal, is representative of the tendency to collapse value hierarchies after such national tragedies as September 11 and the death of Princess Diana.

Writing a few days after Strauss's article, the *Times*'s chief art critic Michael Kimmelman argued that the "high" art displayed in museums could, in the words of his title, "be a haven from all the anxiety of devastating events" (D1). "While everything in the world has changed," writes Kimmelman, "museums are about continuity" (D1, D5). "And about excellence, by the way," he remarks in a seemingly unimportant aside; "Now is a good time to remind ourselves why quality matters" (D5). Kimmelman links good taste with social stability by suggesting that the "quality" of art contained in museums helps these venues provide "continuity." In doing so, Kimmelman reestablishes the hierarchy of the arts that was temporarily leveled in the immediate aftermath of September 11. Like Victorian critics, Kimmelman and other recent critics find themselves in a quandary: they

want to engage readers without lowering standards by endorsing overly emotional art.

The debate about how to rebuild the World Trade Center site has presented critics with a similar problem—that is, how to protect architectural taste from the emotions surrounding the September 11 tragedy. A compounding factor is the popularity of the project's most prominent architects, which has threatened to shift the focus away from architectural standards. "With talk of truth and beauty, memory and monument, these architects have been selling themselves like movie stars," writes Julie Iovine in a February 2003 article in the *New York Times.* "Not since Gary Cooper appeared in *The Fountainhead* has the public been so riveted by architecture and architects" (B1). Libeskind in particular gained the kind of attention not usually enjoyed by twenty-first-century artists. Such minutiae as his cowboy boots and black glasses were spotlighted in the Style section of the *New York Times* on two different occasions (Iovine B5). While Libeskind claimed in his March 2004 speech that the project is "not about the ego of the architect" but rather involves collaboration with other builders and the public, he presented his studio's design as a creation of his own individual genius.[3] An image of the "Master Site Plan for the World Trade Center Site" on the Lower Manhattan Development Corporation's website carried Libeskind's signature, not the name of his architectural firm—Studio Daniel Libeskind (the studio's name, of course, also highlights Libeskind's importance).

Art critics have capitalized on this renewed interest in the arts, and particularly on the design selection for the World Trade Center site, by attempting to influence public taste. Similarly to Victorian commentary on key developments in the art world, this recent writing both celebrates the supposed democratization of the arts and seeks to set certain standards of taste. Herbert Muschamp, chief architecture critic for the *New York Times,* wrote in February 2003, "One of the most heartening developments to come out of the debate over the future of ground zero has been the public's greater awareness of what an architectural program is. . . . Throughout the debate, the public has been saying that it wants to control the program" ("Designers' Dreams" B5). To an extent, the process was indeed democratic. The proposed designs were posted on the Lower Manhattan Development Corporation's website, and public comment was both solicited and seemingly considered. The initial six plans were all rejected because of the public outcry about their blandness and commercial focus. The two designs selected as finalists—that from Libeskind's studio and the "Think" plan—were the most popular. However, the ultimate decision to choose Libes-

kind's plan, which has itself been extensively modified over the past several years due to decisions by the developer and other architects, was made by Governor George Pataki.

In their commentaries on the most popular designs for the site, architecture critics have been primarily motivated by a desire to preserve good architectural taste. Critiquing Libeskind's design in February 2003, Muschamp complains about the values contained in the plan but also about its overall lack of taste. For Muschamp, Libeskind's ideas are aggressive and vengeful, especially the 1,776-foot pointed tower, which has remained a prominent feature of the current design. Muschamp asks of Libeskind's conception, "Why . . . should a large piece of Manhattan be permanently dedicated to an artistic representation of enemy assault? It is an astonishingly *tasteless* idea. It has produced a predictably *kitsch* result" ("Balancing Reason and Emotion" 1, emphases mine). Muschamp suggests that what would have been acceptable immediately after September 11 is no longer so: "Boundaries must be placed around grief lest it overwhelm our ability to gain new perceptions" (3). Muschamp hopes to limit emotional appeal with reason rather than accepting a plan that seems calculated to please the public. Libeskind's design "trade[s] on sentimental appeal at the expense of historical awareness" in its "quasi-religious" (2) references to American values in such features as the 1,776-foot tower.[4] Muschamp argues that this sentimental appeal is not limited to Libeskind and his design alone; memorial architecture has become so popular that it is now simply another "branch of industry" (2). Muschamp's complaints about seductive sentimentality and its commercialization in art are strikingly similar to those made by Victorian writers some 150 years earlier.

Despite his dismissal of "quasi-religious" sentiment, Muschamp's review is informed by his own ideology about American values. Thus, he prefers the other finalist, the "Think" design, over Lebeskind's plan because "Think" contains Enlightenment ideals in its "abstract geometric composition" and spaces for cultural learning (1). The abstract form of the building would supposedly prevent the kind of sentimental appeal attached to Libeskind's more obvious symbolic features. In other words, Muschamp hopes to preserve the sort of difficulty valued by Ruskin in prompting the public to think and reason about architecture. As it turns out, however, Muschamp seems as interested in social control as in individual reason or emotion. For Muschamp, the "Think" plan would provide order to the city in a way that a memorial giving voice to anger could not: the "spaces it proposes for memorial observance . . . would be enclosed within the Enlightenment framework that has stabilized this country since

birth" (3). Through its skeleton-like recreation of the Twin Towers, the building would be "a soaring affirmation of American values" (1). Thus, while seemingly about subjective interpretations and remembrance, the "Think" plan in Muschamp's conception is simply ideological and controlling. In arguing instead for impermanent art on such memorial sites, Mark Lewis remarks, "Public art is literally an art creating a public, an art creating society—one that may or may not be commensurate with any real body of people in a real time or place" (12). Thus, no permanent art can meet the actual needs of a diverse group of people.[5] Victorian memorials, notes Richard Stein, have served the kind of ideological and controlling functions that Lewis hopes to avoid in his argument for impermanent art. According to Stein, the Albert Memorial in London has never been primarily a site for grieving over the prince consort. Rather, it is "a power machine, a device for simultaneously representing, exerting, and rearticulating authority" in its classification of both colonized peoples and residents of London (246). The memorial focuses the viewer on British values and imperial might.

As the new collection of buildings finally rises at Ground Zero, assessments center on the question of whether or not the site should serve primarily as propaganda for American values. In a comment that sounds similar to recent commercials celebrating American resiliency after the recession, Robert Ivy, executive vice president and CEO of the National American Institute of Architects, remarks, "Of course, they said it [building the site] couldn't be done. . . . Yet all, . . . failed to take New York grit into full account" (3). Instead of evaluating the aesthetic features of the site, Ivy seems most intent on building it up; Libeskind's 1,776-foot tower, which "will overtop all other buildings in the United States," "seems to be rushing upward" (4). Ivy does mention the memorial function of the site but seems most impressed with the progress of the project and with its developer, Larry Silverstein.

By contrast, Michael Sorkin, architecture critic and professor at the City University of New York, derides what he sees as the major "'theme' of the site": "memory and *profit*" (6, emphasis mine). Like Mark Lewis, Sorkin had advocated that the site be left with no buildings or memorial. In its ultimate goal of profit making, the built site will be at best "uniform" and at worst "overscaled and aggressively bereft of humane meaning" (Sorkin 4). Here, Sorkin complains about the hyperformalism and lack of human emotion that Berger finds missing in much twentieth-century art commentary. Moreover, Sorkin asserts that the site's bland appearance indicates "a steady lowering of architectural expectations" (5). Similar to much Victo-

rian art commentary, Sorkin's anxious review hopes to return us to supposedly better times when tastes were higher.

Despite critics' preoccupations·with national values and the preservation of high taste, the recent debate about the World Trade Center site has illustrated one promising sign in modern art criticism. The critics I consider here view their advice as important not only for aesthetics but also for questioning some of our usual beliefs about responding to tragedies. Thus, Muschamp argued in February 2003 that Libeskind's plan was particularly inappropriate for a nation preparing for war with Iraq: "Unintentionally, the plan embodies the Orwellian condition America's detractors accuse us of embracing: perpetual war for perpetual peace" ("Balancing Reason and Emotion" 2). More recently, Sorkin has complained about the "monster infrastructure of surveillance and 'security'" at the site, including the "bombproof bunker" at the base of One World Trade Center (4). These critics' misgivings about the embodiment of war in architecture are reminiscent of Ruskin's critique of nations that are too focused on arms races to prioritize quality art. Imagining a conversation in his lecture "Traffic" with a gentleman who seeks his advice on home decoration, Ruskin writes:

> I think such and such a [wall]paper might be desirable—perhaps a little fresco here and there on the ceiling—a damask curtain or so at the windows. "Ah," says my employer, "damask curtains, indeed! That's all very fine, but you know I can't afford that kind of thing just now! . . . [A]t present I am obliged to spend it nearly all in steel-traps . . . for that fellow on the other side of the wall." (*Works* 18: 438–39)

A humorous situation when occurring between two gentlemen is not so when nations fight and neglect beauty, when the world "paints itself red with its own heart's blood instead of vermilion" (*Works* 18: 439). While many twenty-first-century readers will disagree with such positions and even with the premise that art can serve a socially redemptive function, commentaries such as those by Muschamp and Sorkin may engage the public to an extent not seen since the nineteenth century. We may no longer share the Victorian faith in sages, but Muschamp's portrayal of Libeskind's design as a symbol of war and Ruskin's juxtaposition of blood and vermilion should at the very least provoke thought about beliefs that often go unquestioned.

NOTES

INTRODUCTION

1. Arguing against the emphasis on control through the aesthetic, David Kaiser and other scholars of "liberative" aesthetics have demonstrated that Kant hoped to balance the state and individual freedom—not privilege the former (Kaiser, *Romanticism, Aesthetics, and Nationalism* 26–27).

2. Though not a novelistic example, Elizabeth Eastlake's considerable scholarship and connoisseurship certainly furthered the career of her husband Sir Charles, as I discuss in chapter 3.

CHAPTER 1

1. For recent discussions of the 1835–36 select committee and conceptions of art education, see Mervyn Romans, "An Analysis of the Political Complexion of the 1835/6 Select Committee on Arts and Manufactures" and Malcolm Quinn, "The Political Economic Necessity of the Art School 1835–52." For the most influential book-length studies of Victorian art education, see Quentin Bell's *The Schools of Design* (1963) and Stuart Macdonald's *The History and Philosophy of Art Education* (1970).

2. As Andy Green demonstrates, the idea of limited government involvement does not necessarily violate the principles of the classical political economists. In his *Wealth of Nations,* Adam Smith argues that the government should have a role in "erecting and maintaining those public institutions and those public works, which though they may be in the highest degree advantageous to a great society . . . could never repay the expense to any individual or small number of individuals" (qtd. in Green 253).

3. For parallel anxieties attendant on increased verbal literacy, see Patrick Brantlinger's *The Reading Lesson.*

4. As Green notes, the decentralized model of the schools of design was informed by British ideology that shunned state intervention in technical and scientific education (294). Unlike Continental Europe, Britain industrialized without state direction; as a result, the apprenticeship system was believed sufficient to teach technical skills.

5. See Richard D. Altick, *The English Common Reader,* especially chapter 4, "The Social Background," for difficulties faced by the working class in learning to read (such as few schooling opportunities, lack of leisure time, poor lighting conditions at home, and expense of reading glasses).

6. The literary subjects favored by the Westminster committee proved more accessible to middle-class viewers. But these already popular literary subjects needed little legislative encouragement (Altick, *Paintings from Books* 179).

CHAPTER 2

1. For a good discussion of twentieth- and twenty-first-century criticism of *North and South,* see Susan Johnston's *Women and Domestic Experience in Victorian Political Fiction,* 103–5. Patsy Stoneman's "Afterword: The Critical Debate, 1985–2004" in the second edition of her *Elizabeth Gaskell* provides a comprehensive overview of recent writing on Gaskell. Stoneman's first chapter in the same book considers work on Gaskell before 1985.

2. The flowers are from Margaret's country home in Helstone and thus demonstrate Thornton's understanding of Margaret's love for this nature—a nature neglected by other characters in the novel.

3. See Regenia Gagnier's *The Insatiability of Human Wants,* 38–40, for Gaskell's use of Edmund Burke's categories of the beautiful and the sublime.

4. For a different and interesting reading of the novel, see Elizabeth Langland's *Nobody's Angels,* chapter 5. Langland argues that Clare cleverly manipulates the social codes of dress and taste to put her family, including Molly, into social circulation.

5. I am indebted to an anonymous reader's report on an earlier version of this chapter for this suggestion.

6. The dynamic that Douglas describes was certainly active in Victorian aesthetics. Commentators on public galleries and museums worried that lower-class visitors would dirty works of art and the buildings in which they were housed. Artists often completely omitted or significantly marginalized the lower class and their filth in works of art. Ellen Handy, for instance, has described how photographers edited out working-class garbage and excrement in representations of Victorian cities.

7. Pamela Parker, in "From 'Ladies' Business to 'Real Business,'" reads the distinction between the Hales and the Thorntons in this way, claiming that the Hales' household decorations indicate their upper-class status (2). Parker usefully notes that many of the Hales' decorations are signs of traditional upper-class gentility, but I would argue that Gaskell wants to emphasize the comfort of their decorations as well. Parker seems to exaggerate the amount of "surplus income" that the Hales have to spend on household decorations. The Hales explicitly lack, for example, the mirrors that Parker claims they possess in their Milton drawing room. As Mrs. Thornton demonstrates, too many mirrors are in bad taste, but the Hales probably cannot afford to buy any of them.

8. Judith Flanders provides a detailed description of the drawing room in her chapter "The Drawing Room" in *Inside the Victorian Home.*

9. Wallpaper was a much-discussed household good in the Victorian period and one that was, similar to draperies, associated with dirt and disease. Kate Flint notes that the Tennysons changed their wallpaper after developing "whooping-cough-like symptoms" and that the making of wallpaper put the lungs of workers in danger (*The Victorians* 45). Judith Flanders explains that the colors in wallpaper were particularly toxic: "Some wallpapers had concentrations of arsenious acid that ran as high as 59 percent. In addition, vermillion was adulterated with red lead" (190). Flanders speculates that seaside vacations may have actually improved homeowners' health, as they were temporarily removed from these toxic furnishings.

10. Likewise, notes Jenny Uglow in *Elizabeth Gaskell,* Thornton shakes hands with Nicholas Higgins as he begins to realize the worker's worth as a person: Margaret's "refusal to give her hand, in both senses, to Thornton is paralleled by his refusal to allow personality to his 'hands'—a term of disembodiment to which Margaret strongly objects" (374).

11. Joseph Kestner reads Gaskell's use of roses and nature differently, remarking that "at the novel's conclusion Thornton gives her a dead rose from Helstone, marking her assimilation to a new order, the dominance of agriculture by industry." However, the appearance of roses throughout the novel, as well as Margaret's remarks about the dead ones as connected especially with Helstone, suggest continuity rather than rupture.

CHAPTER 3

1. As an anonymous reviewer of my manuscript pointed out, the *Wellesley* does not index most art periodicals, and so Eastlake was undoubtedly not the only prolific female periodical writer on the arts. Still, her ability to focus on art writing in the periodicals indexed by the *Wellesley* is striking.

2. See, for example, Solveig Robinson for a focus on Eastlake's literary reviews (especially on *Jane Eyre*), and Rosemary Mitchell for a listing of Eastlake's art historical accomplishments.

3. See Pamela Nunn for an overview of nineteenth-century women art critics. Other good but brief studies of women's art criticism can be found in Sherman with Holcomb, *Women As Interpreters of the Visual Arts, 1820–1979.* The standard account of the professionalization of women painters in the Victorian era is Deborah Cherry's *Painting Women.* Cherry briefly discusses Dilke as a professional art historian and Jameson as a prominent intellectual writing about the arts, but does not mention Elizabeth Eastlake.

4. Julie Sheldon edited in 2009 a new version of Eastlake's letters and published an essay reevaluating her review of *Jane Eyre*. A new biography of the Eastlakes, *Art for the Nation: The Eastlakes and the Victorian Art World,* co-written by Sheldon and Susanna Avery-Quash, appeared in 2011.

5. Adele Holcomb argues that Jameson was "the first professional English art historian," beginning in the early 1840s (171). By contrast, Laurie Kane Lew describes Jameson as an "amateur in matters of art" because of her informal training and supposed reliance on other scholars (831).

6. Meaghan Clarke notes that art critics were eventually represented by journalistic organizations—the Institute of Journalists (1890) and the Society of Women Journalists (1895).

7. Please note that the names "Adele Holcomb" and "Adele Ernstrom," used throughout this chapter and listed separately in the bibliography, refer to the same scholar.

8. I am indebted to Ainslie Robinson for this quotation and for her discussion of Lady Eastlake's supposed reliance on her husband.

9. Meaghan Clarke also describes how women writers, especially those writing near the end of the century, used the preface strategically.

10. In her edition of Eastlake's letters, Julie Sheldon has reproduced Eastlake's particular use of punctuation and spelling, which I maintain in quotations used in this book.

11. See Clarke for an interesting discussion of later women critics' signing practices, especially her fifth chapter on Elizabeth Robins Pennell, whose writing was often anonymous and/or assumed to be the work of her husband, Joseph Pennell.

12. Similarly, in her *Renaissance Studies and Fancies,* Vernon Lee claims that Renaissance art progressed only as the Protestant ideal of free thought supplanted the fourteenth- and fifteenth-century Catholic practice of creating mere "mechanical aids to devotion" (91).

CHAPTER 4

1. For example, an anonymous reviewer from the July 8, 1848, *Athenaeum* remarks, "The Bells must be warned against their fancy for dwelling upon what is disagreeable (Allott 251).

2. See also Derek Stanford, Garrett Stewart, and Edward Chitham who, in their respective works, compellingly argue for Anne's originality. Stanford claims in *Anne Brontë: Her Life and Work* (co-written with Ada Harrison) that Anne is a "completely different sort" of writer who should not be compared with her sisters (230). Stewart details in "Narrative Economies" how *Tenant* should be considered a reworking of *Agnes Grey* rather than an adaptation of *Wuthering Heights.* Chitham argues in *A Life of Anne Brontë* that "Anne's artistic and moral challenge to the content of her sisters' novels comes in *Wildfell Hall*" (134), especially in the novel's parody of *Wuthering Heights.*

3. Surely contributing also to Anne's lowered reputation was Charlotte's comparing her with Emily: "[Anne] wanted the power, the fire, the originality of her sister, but was well-endowed with quiet virtues of her own" ("Biographical Notice" 57). Anne's "quiet virtues" do not seem the equal of Emily's "power," "fire," and "originality." Placing herself as the definitive interpreter of her dead sisters' works, Charlotte seems clear about which was the greater artist.

4. The contrast between Mary and Agnes suggests a connection to the Brontë sisters: Though all three Brontë sisters were accomplished drawers, Charlotte was significantly more distinguished. Charlotte never sold her art, but she did exhibit; at the Brontës' first recorded visit to an exhibition, at the Royal Northern Society for the Encouragement of the Fine Arts in Leeds in 1834, Charlotte had two paintings accepted and displayed (Alexander, "The Influence of the Visual Arts" 25–26). Through her depiction of Mary and Agnes, Anne demonstrates both her awareness that the artistic talents of siblings can differ and her desire that each be judged fairly according to her own merits.

5. By contrast, Stewart argues that Anne's decision to introduce Helen's diary into the long middle section of the novel was not a mistake, as Moore argued, but a conscious

aesthetic decision designed "to contrive a scene of reading . . . so intensely involving that no textual distance could dampen it" (84).

6. Milicent does make unsolicited comments on Helen's paintings at one point after Arthur discovers his face on the back of them, but Helen is unable to attend to Milicent's remarks because of her embarrassment (A. Brontë, *Tenant* 149).

7. Similarly, Anne Brontë, unhappy with her earlier career as a governess, sought to convince Charlotte in 1845 that her own poems were worthy for the sisters' collection and revised them nightly in order to improve them (Nash and Suess x). Anne clearly understood firsthand the difficult work of aesthetic production.

CHAPTER 5

1. Ruskin's two lectures at Manchester were originally published in 1857 under the title "The Political Economy of Art" and were reissued in 1880 under the title "A Joy Forever." In *The Complete Works*, Volume 16, they are titled, "'A Joy for Ever,' Being the Substance (with Additions) of Two Lectures on the Political Economy of Art."

2. Ruskin makes a similar argument about what he calls "the plague of cheap literature" (*Works* 16: 59) in Britain. In his lecture titled "The Accumulation and Distribution of Art," Ruskin argues that "we ought not to get books too cheaply. No book, I believe is ever worth half so much to its reader as one that has been coveted for a year at a bookstall, and bought out of saved halfpence; and perhaps a day or two's fasting" (*Works* 16: 59).

CHAPTER 6

1. For more on this representation of Cleopatra, see Jill Matus, "Confession, Secrecy, and Exhibition," in *Unstable Bodies*, 131–45.

2. As a child in the Bretton home, Lucy had unhooked this painting (hung "somewhat too high") from the wall and held it—an intimacy not available to public gallery visitors (C. Brontë, *Villette* 213, chap. 16).

CHAPTER 7

1. I cite Merrill in this chapter because she is the best source for the reconstructed transcripts of the *Whistler v. Ruskin* trial. The original transcripts were destroyed soon after the trial.

2. Several years later, these assumptions would be famously illustrated by William Powell Frith's satirical painting *A Private View at the Royal Academy, 1881* (1883), in which three women admiringly surround Oscar Wilde.

3. Modern scholars have in fact attributed the angel to Leonardo (Hill 365).

4. See Walter Seiler, ed., *Walter Pater, The Critical Heritage*.

5. Dilke's other writings make clear that the increased freedom of the artist since the Renaissance should extend to a more complete democratization for all members of society. In an unsigned article on "Art" for the *Westminster Review* in 1869, Dilke claims

that the "essentially aristocratic" nature of the arts reflects a larger problem in Victorian society (592).

6. While Whistler sought to distance himself from French impressionism—and did differ from it in some significant ways—he was often connected with that movement (Parkes 597–98). See also Anna Gruetzner Robins, *A Fragile Modernism,* and Kenneth McConkey, *Impressionism in Britain.*

7. In her own painting, Dilke depicted women engaged in serious pursuits. For example, an 1864 painting shows Lady Pauline Trevelyan absorbed in creating her own painting.

8. See also Shearer West for the function of humor during the trial. West notes that Holker's comment about the Cremorne Gardens was a "prepared . . . innuendo," which prompted "prurient giggles from the audience" (45).

CONCLUSION

1. My example is not meant to suggest that no modern studies consider the arts in their social contexts. Art historians including Susan Casteras, Lynda Nead, Leonard Bell, Joseph Kestner, Griselda Pollock, and Deborah Cherry have usefully examined Victorian art in terms of race, class, gender, and imperialism.

2. There was also a heightened public interest in the arts independent of art critical intervention. Poems discussing grief and loss were shared and reshared over the Internet. Makeshift memorials were established at Ground Zero. People visited museums hoping for a restored sense of order and beauty.

3. Similarly, a pamphlet distributed before Libeskind's speech at Indiana University highlights his individual achievements: "Designer of some of the world's most provocative buildings, including his first project, the Jewish Museum Berlin, he has virtually reinvented architecture, transforming sand and stone into spiritual structures that resonate profoundly." Nowhere in Libeskind's list of projects is his team of architects—Studio Daniel Libeskind—mentioned.

4. Muschamp's worries about emotion seem confirmed by other commentators, who have widely attributed Libeskind's success in winning the commission to the sentimental ways in which he talked about his design. "Mr. Libeskind had a moving pedigree," writes Robin Pogrebin in the *New York Times.* "His parents had survived the Holocaust; he had designed the Jewish Museum in Berlin—and [he had] a way of talking about both his own experience as an immigrant and his ideas for the site that was heavy-handed but affecting" (2).

5. Representing another interesting solution to the World Trade Center site problem, Casey Nelson Blake argues in "Mourning and Modernism After 9/11" that a modernist style should be considered for the site because it would allow visitors to express their grief individually. While the site would feature a permanent structure similar to the Hiroshima Peace Park or Vietnam Veterans Memorial, it would also allow visitors to leave their own memorials for the lost.

BIBLIOGRAPHY

Adams, James Eli. *Dandies and Desert Saints: Styles of Victorian Masculinity.* Ithaca, NY: Cornell University Press, 1995.

Alexander, Christine. "The Influence of the Visual Arts on the Brontës." In *The Art of the Brontës,* edited by Christine Alexander and Jane Sellars, 9–35. New York: Cambridge University Press, 1995.

Alexander, Christine, and Jane Sellars, eds. *The Art of the Brontës.* New York: Cambridge University Press, 1995.

Allot, Miriam, ed. *The Brontës: The Critical Heritage.* Boston: Routledge and Kegan Paul, 1974.

Altick, Richard D. *The English Common Reader: A Social History of the Mass Reading Public, 1800–1900.* Chicago: University of Chicago Press, 1957.

———. *Paintings from Books: Art and Literature in Britain, 1760–1900.* Columbus: The Ohio State University Press, 1985.

Arnold, Matthew. "The Function of Criticism at the Present Time." 1864. In *The Broadview Anthology of Victorian Poetry and Poetic Theory.* Concise ed. Edited by Thomas J. Collins and Vivienne J. Rundle, 616–32. Orchard Park, NY: Broadview Press, 2000.

———. "The Literary Influence of Academies." 1864. *Essays in Criticism.* London: Everyman's Library, 1964.

Avery-Quash, Susanna, and Julie Sheldon. *Art for the Nation: The Eastlakes and the Victorian Art World.* London: National Gallery, 2011.

Barker, Lady Mary Anne. *The Bedroom and Boudoir.* London: Macmillan and Co., 1878.

Bell, Quentin. *The Schools of Design.* London: Routledge and Kegan Paul, 1963.

Bell-Villada, Gene. *Art for Art's Sake and Literary Life.* Lincoln: University of Nebraska Press, 1996.

Berg, Margaret Mary. "*The Tenant of Wildfell Hall:* Anne Brontë's *Jane Eyre.*" *Victorian Newsletter* 71 (1987): 10–15.

Berger, John. *Ways of Seeing.* New York: Penguin Books, 1977.

Blake, Casey Nelson. "Mourning and Modernism After 9/11." *The Nation* 275.9 (September 23, 2002): 40–45. *Academic Search Premier.* EBSCO. Indiana University, Bloomington Library.

Bloom, Harold. *The Ringers in the Tower: Studies in Romantic Tradition.* Chicago: University of Chicago Press, 1971.

Booth, Alison. "The Lessons of the Medusa: Anna Jameson and Collective Biographies of Women." *Victorian Studies* 42.2 (Winter 1999–2000): 257–88.

Bourdieu, Pierre. *Distinction: A Social Critique of the Judgement of Taste.* Translated by Richard Nice. Cambridge, MA: Harvard University Press, 1984.

Bradbury, Edward. "Mr. Ruskin's Museum at Sheffield." *The Magazine of Art* 11 (1888).

Bradley, J. L. *Ruskin: The Critical Heritage.* Boston: Routledge and Kegan Paul, 1984.

Brantlinger, Patrick. "Household Taste: Industrial Art, Consumerism, and Pre-Raphaelitism." *The Journal of Pre-Raphaelite Studies* 9 (Spring 2000): 83–100.

———. *The Reading Lesson.* Bloomington: Indiana University Press, 1998.

Brontë, Anne. *Agnes Grey.* 1847. New York: Oxford University Press, 1998.

———. Preface to the second edition of *The Tenant of Wildfell Hall.* 1848. Edited by Herbert Rosengarten. New York: Oxford University Press, 1998.

———. *The Tenant of Wildfell Hall.* 1848. Edited by Herbert Rosengarten. New York: Oxford University Press, 1998.

Brontë, Charlotte. "Biographical Notice of Ellis and Acton Bell." In *Agnes Grey.* New York: Penguin Classics, 1988: 51–59.

———. *Jane Eyre.* 1847. Edited by Q. D. Leavis. New York: Penguin Classics, 1988.

———. *Villette.* 1853. Edited by Margaret Smith and Herbert Rosengarten. New York: Oxford University Press, 1990.

Broomfield, Andrea, and Sally Mitchell. *Prose by Victorian Women: An Anthology.* New York: Routledge, 1995.

Bullen, J. B. "Browning's 'Pictor Ignotus' and Nineteenth-Century 'Christian' Art." *Nineteenth-Century Contexts* 26.3 (September 2004): 273–88.

Byerly, Alison. *Realism, Representation, and the Arts in Nineteenth-Century Literature.* New York: Cambridge University Press, 1997.

Catalogue of the Art Treasures of the United Kingdom Collected at Manchester in 1857. London: Bradbury and Evans, 1857.

Chapple, J. A. V., and Arthur Pollard, eds. *The Letters of Mrs. Gaskell.* Manchester, UK: Manchester University Press, 1966.

Charlier, Gustave. "Brussels Life in *Villette.*" Translated by Phyllis Bentley. *The Brontë Society Transactions* 5 (1955): 386–90.

Cherry, Deborah. *Painting Women: Victorian Women Artists.* New York: Routledge, 1993.

Chitham, Edward. *A Life of Anne Brontë.* Cambridge: Blackwell Publishers, 1991.

Christ, Carol T. "'The Hero as Man of Letters': Masculinity and Victorian Nonfiction Prose." In *Victorian Sages and Cultural Discourse: Renegotiating Gender and Power,* edited by Thaïs E. Morgan. New Brunswick, NJ: Rutgers University Press, 1990.

Christ, Carol T., and John O. Jordan. Introduction to *Victorian Literature and the Victorian Visual Imagination,* xix–xxvii.

Christ, Carol T., and John O. Jordan, eds. *Victorian Literature and the Victorian Visual Imagination.* Berkeley: University of California Press, 1995.

Clarke, Meaghan. *Critical Voices: Women and Art Criticism in Britain 1880–1905.* Burlington, VT: Ashgate, 2005.

Colby, Vineta. *Vernon Lee: A Literary Biography.* Charlottesville: University of Virginia Press, 2003.

Cole, Henry. "Decoration of Westminster Palace." *Westminster Review* (July 1842).

———. "Modern Wood Engraving." *Westminster Review* (August 1838).

———. "The National Gallery Difficulty Solved." *Cornhill* (March 1860).

Colvin, Sidney. "Art and Criticism." *Fortnightly Review* n.s., 26 (1879): 211.

Cook, F. T. *A Popular Handbook to the National Gallery.* 5th ed. New York: Macmillan, 1897.

Cook, Jon, ed. *William Hazlitt: Selected Writings.* New York: Oxford University Press, 1991.

Crary, Jonathan. *Techniques of the Observer: On Vision and Modernity in the Nineteenth Century.* Cambridge, MA: MIT Press, 1990.

d'Albertis, Deirdre. *Dissembling Fictions: Elizabeth Gaskell and the Victorian Social Text.* New York: St. Martin's, 1997.

Daniel Libeskind: "Memory Foundations." Bloomington, IN: Borns Jewish Studies Program, 2004.

Dilke, Emilia. "Art." *Westminster Review* (April 1869): 585–98.

———. *Art in the Modern State.* London: Chapman and Hall, 1888.

———. "Contemporary Literature: Art" [review of Pater, *Studies in the History of the Renaissance,* Woltmann, *Architectural History of Berlin,* and Simons, *Culturbilder aus altrœmischerzeit*]. *Westminster Review* n.s. 43 (April 1873): 639–41.

———. "Exhibition of the Royal Academy of the Arts." *Academy* 3 (May 15, 1872): 184–85.

———. Unsigned review of *Imaginary Portraits,* by Walter Pater. *Athenaeum* (June 24, 1887): 824–25. Reprinted in *Walter Pater,* edited by R. M. Seiler, 165–67. London: Routledge and Kegan Paul, 1980.

———. Review of *Lectures on Art* and *Catalogue of Examples,* by John Ruskin. *Academy* 10 (September 10, 1870): 305–6.

———. *The Renaissance of Art in France.* 2 vols. London: Kegan Paul and Co., 1879.

———. "Summer Exhibition of the Society of French Artists." *Academy* 3 (June 1, 1872): 204–5.

Dowling, Linda. *The Vulgarization of Art: The Victorians and Aesthetic Democracy.* Charlottesville: University Press of Virginia, 1996.

Eagleton, Terry. *The Ideology of the Aesthetic.* Malden, MA: Blackwell, 1998.

Eastlake, Charles L. *Hints on Household Taste in Furniture, Upholstery, and Other Details.* London: Longmans, Green, and Co., 1869.

———. *A History of the Gothic Revival.* New York: American Life Foundation, 1975.

"Eastlake, Elizabeth." Vol. 22, *The Dictionary of National Biography: From the Earliest Times to 1900,* edited by Sir Leslie Stephen and Sir Sidney Lee, 598–99, supplement.

Eastlake, Elizabeth. "The Crystal Palace." *Quarterly Review* 96 (March 1855): 303–54.

———. *Five Great Painters: Essays Reprinted from the Edinburgh and Quarterly Reviews.* 2 vols. London: Longmans, Green, 1883.

———. "Leonardo da Vinci." In *Five Great Painters: Essays Reprinted from the Edinburgh and Quarterly Reviews.* 2 vols. London: Longmans, Green, 1875.

———. "Michael Angelo." In *Five Great Painters: Essays Reprinted from the Edinburgh and Quarterly Reviews.* 2 vols. London: Longmans, Green, 1876.

———. "Modern German Painting." *Quarterly Review* 77 (March 1846): 323–48.

———. "Modern Painters." *Quarterly Review* 98 (March 1856): 384–433.

————. "Photography." *Quarterly Review* 101 (April 1857): 442–68.

————. *"Treasures of Art in Great Britain." Quarterly Review* 94 (March 1854): 467–508.

————. *"Vanity Fair* and *Jane Eyre." Quarterly Review* (December 1848): 82–99.

Eisler, Colin. "Lady Dilke (1840–1904): The Six Lives of an Art Historian." In *Women as Interpreters of the Visual Arts*, edited by Claire Richter Sherman and Adele M. Holcomb, 147–80. Westport, CT: Greenwood, 1981.

Eliot, George. *Middlemarch.* 1874. Edited by Bert G. Hornback. New York: W. W. Norton, 1977: 53.

Ernstrom, Adele M. "'Equally Lenders and Borrowers in Turn': The Working and Married Lives of the Eastlakes." *Art History* 15.4 (December 1992): 470–85.

Flanders, Judith. *Inside the Victorian Home: A Portrait of Domestic Life in Victorian England.* New York: Norton, 2004.

Flint, Kate, ed. *Impressionists in England: The Critical Reception.* Boston: Routledge and Kegan Paul, 1984.

————. *The Victorians and the Visual Imagination.* New York: Cambridge University Press, 2000.

Fraser, Hilary. "Women and the Ends of Art History: Vision and Corporeality in Nineteenth-Century Critical Discourse." *Victorian Studies* 42.1 (Autumn 1998/1999): 77–100.

Fraser, Hilary, and Daniel Brown. *English Prose of the Nineteenth Century.* New York: Longman, 1997.

Freedman, Jonathan. *Professions of Taste: Henry James, British Aestheticism, and Commodity Culture.* Palo Alto, CA: Stanford University Press, 1990.

Fried, Michael. *Absorption and Theatricality: Painting and Beholder in the Age of Diderot.* Chicago: University of Chicago Press, 1988.

Gagnier, Regenia. *The Insatiability of Human Wants: Economics and Aesthetics in Market Society.* Chicago: University of Chicago Press, 2000.

Gallagher, Catherine. *The Industrial Reformation of English Fiction.* Chicago: University of Chicago Press, 1985.

Gardner's Art through the Ages. 8th ed. Edited by Horst de la Croix and Richard G. Tansey. Chicago: Harcourt Brace Jovanovich, 1986.

Gaskell, Elizabeth. *Cranford.* 1853. Edited by Elizabeth Porges Watson. New York: Oxford University Press, 1998.

————. *Mary Barton.* 1848. Edited by Edgar Wright. New York: Oxford University Press, 1998.

————. *North and South.* 1855. Edited by Angus Easson. New York: Oxford University Press, 1998.

————. *Wives and Daughters.* 1866. New York: Penguin, 1996.

Giebelhausen, Michaela. *Painting the Bible: Representation and Belief in Mid-Victorian Britain.* Burlington, VT: Ashgate, 2006.

Gillespie, Katharine Walke. "Introduction: Lady Elizabeth Eastlake." *Prose by Victorian Women: An Anthology.* Edited by Andrea Broomfield and Sally Mitchell, 77–80. New York: Taylor and Francis, 1995.

Gillett, Paula. *Worlds of Art: Painters in Victorian Society.* New Brunswick, NJ: Rutgers University Press, 1990.

Gourvish, T. R. "The Rise of the Professions." *Later Victorian Britain, 1867–1900.* Edited by T. R. Gourvish and Alan O'Day. New York: St. Martin's Press, 1988.

Green, Andy. *Education and State Formation: The Rise of Education Systems in England, France and the USA*. New York: St. Martin's Press, 1990.

Gunn, Peter. *Vernon Lee: Violet Paget, 1856–1935*. New York: Oxford University Press, 1964.

A Handbook to the Paintings by Ancient Masters in the Art Treasures Exhibition, Being a Reprint of Critical Notices Originally Published in the "Manchester Guardian." London: Bradbury and Evans, 1857.

Handy, Ellen. "Dust Piles and Damp Pavements: Excrement, Repression, and the Victorian City in Photography and Literature." In Christ and Jordan, *Victorian Literature and the Victorian Visual Imagination,* 111–33.

Harrison, Ada, and Derek Stanford. *Anne Brontë: Her Life and Work*. 1959. New Haven, CT: Archon Books, 1970.

Hazlitt, William. "Essays on Reynolds's *Discourses,* Written for *The Champion,* 1814–15." In Reynolds, *Discourses on Art,* 320–36.

———. "Fragments on Art. Why the Arts Are Not Progressive?" 1814. In *William Hazlitt,* edited by Jon Cook, 257–62.

———. "Originality." 1830. In *William Hazlitt,* edited by Jon Cook, 270–77.

———. "Whether the Fine Arts are Promoted by Academies." 1814. In *William Hazlitt,* edited by Jon Cook, 262–66.

Helsinger, Elizabeth K. *Ruskin and the Art of the Beholder*. Cambridge, MA: Harvard University Press, 1982.

Hill, Donald L. Notes. Pater, Walter. *The Renaissance: Studies in Art and Poetry, The 1893 Text*.

Hirsch, Pam. "Ligginitis, Three Georges, Perie-Zadeh and Spitting Critics, Or Will the Real Mr. Eliot Please Stand Up?" *Critical Survey* 13, no. 2 (2001): 78–98. EBSCO-host. September 10, 2003. 10 pages.

"The History of Our Lord." *London Quarterly Review* 23 (1864–65): 416–52.

Holcomb, Adele M. "Anna Jameson: The First Professional English Art Historian." *Art History* 6.2 (June 1983): 171–87.

Holy Bible. Revised Standard Version. New York: Thomas Nelson, Inc., 1972.

Hornback, Bert G. explanatory notes. *Middlemarch*. By George Eliot. New York: W. W. Norton, 1977. 53.

Horton, Susan R. "Were They Having Fun Yet? Victorian Optical Gadgetry, Modernist Selves." In Christ and Jordan, *Victorian Literature and the Victorian Visual Imagination,* 1–26.

Houghton, Walter E. *The Victorian Frame of Mind: 1830–1870*. New Haven, CT: Yale University Press, 1959.

Iovine, Julie V. "Turning a Competition into a Public Campaign: Finalists for Ground Zero Pull Out the Stops." *New York Times,* February 26, 2003: B1, B5.

Israel, Kali. *Names and Stories: Emilia Dilke and Victorian Culture*. New York: Oxford University Press, 1999.

Ivy, Robert. "Coming to Life." *Architectural Record* 198.10 (October 2010): 10.

Jacobs, Naomi. "Gender and Layered Narrative in *Wuthering Heights and The Tenant of Wildfell Hall.*" *Journal of Narrative Technique* 16 (1986): 204–19.

Jameson, Anna Brownell. "Althorpe." *New Monthly Magazine* (January 1829): 81–90.

———. *Characteristics of Women, Moral, Poetical and Historical*. 2nd ed. 1832. London: G. Bell and Sons, 1833.

————. *Companion to the Most Celebrated Private Galleries.* London: Saunders and Ot-
ley, 1844.

————. *Handbook to the Public Galleries of Art in and Near London.* 1845. New York:
Elibron Classics, 2005.

————. "The House of Titian." *Memoirs and Essays Illustrative of Art, Literature and So-
cial Morals.* New York: Wiley & Putnam, 1846. 2–39.

————. *Memoirs of the Early Italian Painters.* 1859. Boston: Houghton, Mifflin and Co.,
1895.

————. *Sacred and Legendary Art.* 2 vols. 1848. London: Longmans, Green, 1870.

Johnston, Judith. *Anna Jameson: Victorian Feminist, Woman of Letters.* Brookfield, VT:
Ashgate Publishing Co, 1997.

Johnston, Susan. *Women and Domestic Experience in Victorian Political Fiction.* Westport,
CT: Greenwood, 2001.

Jones, Owen. *The Grammar of Ornament.* 1856. New York: Van Nostrand Reinhold,
1972.

Journals and Correspondence of Lady Eastlake. Edited by Charles Eastlake Smith. 2 vols.
London: John Murray, 1895.

Kaiser, David Aram. *Romanticism, Aesthetics, and Nationalism.* New York: Cambridge
University Press, 1999.

Kestner, Joseph. "The Rose Image in *North and South.*" In *Protest & Reform: The British
Social Narrative by Women, 1827–1867.* Madison, WI: University of Wisconsin Press,
1985. http://www.victorianweb.org/authors/gaskell/kestner1.html (June 3, 2008).

Kimmelman, Michael. "America's Star-Spangled Impressionist." Review of Childe
Hassam. *New York Times,* June 11, 2004. www.nytimes.com.

————. "Museum Can Be a Haven from All the Anxiety of Devastating Events." *New
York Times,* September 17, 2001: D1, D5.

King, Lyndel Sanders. *The Industrialization of Taste: Victorian England and the Art Union
of London.* Ann Arbor: UMI Research Press, 1985.

Langland, Elizabeth. *Anne Brontë: The Other One.* Totowa, NJ: Barnes & Noble Books,
1989.

————. *Nobody's Angels: Middle-Class Women and Domestic Ideology in Victorian Cul-
ture.* Ithaca, NY: Cornell University Press, 1995.

Larson, Magali Sarfatti. *The Rise of Professionalism: A Sociological Analysis.* Berkeley:
University of California Press, 1977.

Layard, Sir A. H. "Manchester Exhibition." *Quarterly Review* 102 (1857): 165–204.

Lee, Vernon. Review of *The Little Schoolmaster Mark,* by J. H. Shorthouse. *Academy* 29
(December 29, 1883): 426–27.

————. *Renaissance Fancies and Studies.* New York: G. P. Putnam's Sons, 1896.

The Letters of Elizabeth Rigby, Lady Eastlake. Edited by Julie Sheldon. Liverpool, UK:
Liverpool University Press, 2009.

Levine, Caroline. "'Harmless Pleasure': Gender, Suspense, and *Jane Eyre.*" *Victorian Lit-
erature and Culture* (2000): 275–86.

————. "Visual Labor: Ruskin's Radical Realism." *Victorian Literature and Culture*
(2000): 73–86.

Levine, George. "Two Ways Not To Be a Solipsist: Art and Science, Pater and Pearson."
Victorian Studies 43.1 (Autumn 2000): 7–42.

Lew, Laurie Kane. "Cultural Anxiety in Anna Jameson's Art Criticism." *SEL: Studies in
English Literature 1500–1900* 36 (1996): 829–56.

Lewis, Mark. "What Is to Be Done? Art and Politics after the Fall." In *Ideology and Power in the Age of Lenin in Ruins,* edited and introduced by Arthur and Marilouise Kroker. New York: St. Martin's Press, 1991.

Lochhead, Marion. *Elizabeth Rigby, Lady Eastlake.* London: John Murray, 1961.

Losano, Antonia. "Anne Brontë's Aesthetics: Painting in *The Tenant of Wildfell Hall.*" In *The Brontës in the World of the Arts,* edited by Sandra Hagan and Juliette Wells, 45 66. Burlington, VT: Ashgate, 2008.

———. "The Professionalization of the Woman Artist in Anne Brontë's *The Tenant of Wildfell Hall.*" *Nineteenth-Century Literature* 58:1 (2003): 1–41.

———. *The Woman Painter in Victorian Literature.* Columbus: The Ohio State University Press, 2008.

Macdonald, Stuart. *The History and Philosophy of Art Education.* Cambridge, UK: Lutterworth Press, 2004.

"The Manchester Exhibition of Art-Treasures." *The Dublin University Magazine* 49 (1857): 608–20.

Mansfield, Elizabeth. "Articulating Authority: Emilia Dilke's Early Essays and Reviews." *Victorian Periodicals Review* 31.1 (Spring 1998): 75–86.

Matus, Jill L. "Confession, Secrecy, and Exhibition." *Unstable Bodies: Victorian Representations of Sexuality and Maternity.* New York: Manchester University Press, 1995.

———. "Looking at Cleopatra: The Expression and Exhibition of Desire in *Villette.*" *Victorian Literature and Culture* 21 (1993): 345–67.

Matz, Jesse. "Walter Pater's Literary Impressionism." *Modern Language Quarterly* 56.4 (Winter 1995): 433–56.

McConkey, Kenneth. *Impressionism in Britain.* New Haven, CT: Yale University Press, 1995.

McMaster, Juliet. "'Imbecile Laughter' and 'Desperate Earnest' in *The Tenant of Wildfell Hall.*" *Modern Language Quarterly* 43.4 (December 1982): 352–69.

Mehta, Uday Singh. *Liberalism and Empire: A Study in Nineteenth-Century British Liberal Thought.* Chicago: University of Chicago Press, 1999.

Meisel, Martin. *Realizations: Narrative, Pictorial, and Theatrical Arts in Nineteenth-Century England.* Princeton, NJ: Princeton University Press, 1983.

Merrill, Linda. *A Pot of Paint: Aesthetics on Trial in* Whistler v. Ruskin. Washington, DC: Smithsonian Institution Press, 1992.

Miller, Andrew. *Novels Behind Glass: Commodity Culture and Victorian Narrative.* New York: Cambridge University Press, 1995.

Mitchell, Charlotte. Explanatory notes to *Cranford,* by Elizabeth Gaskell, 180–94.

Mitchell, Rosemary. "'The Busy Daughters of Clio': Women Writers of History from 1820–1880." *Women's History Review* 7:1 (March 1998): 107–34.

Moore, George. *Conversations in Ebury Street.* New York: Boni and Liveright, 1924.

———. Review of *Modern Painting. Daily Chronicle* (June 10, 1893): 3.

Morris, Pam. Introduction to *Wives and Daughters,* by Elizabeth Gaskell.

Muschamp, Herbert. "Balancing Reason and Emotion in Twin Towers Void." *New York Times,* February 6, 2003: E1. 3 pages. *Academic Universe: Humanities.* Lexis-Nexis. Indiana University, Bloomington Library. http://web.lexis-nexis.com/ (July 12, 2004).

———. "Designers' Dreams, Tempered by Reality. *New York Times*, February 26, 2003: B1, B5.

Nash, Julie, and Barbara A. Suess, eds. Preface to *New Approaches to the Literary Art of the Brontës.* Burlington, VT: Ashgate, 2001.

Nunn, Pamela Gerrish. "Critically Speaking." In *Women in the Victorian Art World,* edited by Clarissa Campbell Orr. New York: Manchester University Press, 1995.

Oliphant, Margaret. Review of *Studies in the History of the Renaissance,* by Walter Pater. In *Walter Pater: The Critical Heritage,* edited by R. M. Seiler, 85–91. London: Routledge and Kegan Paul, 1980.

Ormond, Leonee. "Mines of Misinformation: George Eliot and Old Master Paintings: Berlin, Munich, Vienna, and Dresden, 1854–5 and 1858." *The George Eliot Review* 33 (2002): 33–50.

Ormond, Richard. *Daniel Maclise, 1806–1870.* Arts Council of Great Britain, 1972.

Parker, Pamela Corpron. "From 'Ladies' Business to 'Real Business': Elizabeth Gaskell's Capitalist Fantasy in *North and South.*" *Victorian Newsletter* 91 (Spring 1997): 1–3.

Parkes, Adam. "A Sense of Justice: Whistler, Ruskin, James, Impressionism." *Victorian Studies* 42.4 (Summer 1999/2000): 593–629.

Pater, Walter. *The Renaissance: Studies in Art and Poetry: The 1893 Text.* Edited by Donald L. Hill. Berkeley: University of California Press, 1980.

Perkin, Harold. *Origins of Modern English Society.* Boston: Ark Paperbacks, 1985.

Pogrebin, Robin. "The Incredible Shrinking Daniel Libeskind." *New York Times,* June 20, 2004. 5 pages. www.nytimes.com/2004/06/20/arts/design/20POGR.html.

Poovey, Mary. *Uneven Developments: The Ideological Work of Gender in Mid-Victorian England.* Chicago: University of Chicago Press, 1988.

Prettejohn, Elizabeth. "Aesthetic Value and the Professionalization of Victorian Art Criticism 1837–78." *Journal of Victorian Culture* 2.1 (Spring 1997): 71–94.

———. "Walter Pater and Aesthetic Painting." In *After the Pre-Raphaelites: Art and Aestheticism in Victorian England,* edited by Elizabeth Prettejohn. New Brunswick, NJ: Rutgers University Press, 1999.

Pugin, A. W. *The True Principles of Pointed or Christian Architecture.* London: W. Hughes, 1841.

Quinn, Malcolm. "The Political Economic Necessity of the Art School 1835–52." *iJADE* 30.1 (2011): 62–70.

Reports of the Select Committee on Arts and Manufactures 1835–36; Parliamentary Papers, V, 375 (1835).

Reynolds, Sir Joshua. *Discourses on Art.* 1797. Edited by Robert R. Wark. New Haven, CT: Yale University Press, 1997.

Rischin, Abigail S. "Beside the Reclining Statue: Ekphrasis, Narrative, and Desire in *Middlemarch.*" *PMLA* 111 (1996): 1121–32.

Robins, Anna Gruetzner. *A Fragile Modernism: Whistler and his Impressionist Followers.* New Haven, CT: Yale University Press, 2007.

Robinson, Ainslie. "*The History of Our Lord as Exemplified in Works of Art:* Anna Jameson's Coup de Grâce." *Women's Writing* 10.1 (2003): 187–200.

Robinson, Solveig C., ed. *A Serious Occupation: Literary Criticism by Victorian Women Writers.* Peterborough, ON: Broadview Press, 2003.

Romans, Mervyn. "An Analysis of the Political Complexion of the 1835/6 Select Committee on Arts and Manufactures." *iJADE* 26.2 (2007): 215–24.

Ross, Robert, ed. *The First Collected Edition of the Works of Oscar Wilde.* 14 vols. *Miscellanies,* by Oscar Wilde. London: Dawsons, 1969.

Ruskin, John. *The Complete Works of John Ruskin.* Edited by E. T. Cook and Alexander Wedderburn. 39 vols. London: George Allen, 1903–12.

Schor, Hilary M. *Scheherezade in the Marketplace: Elizabeth Gaskell and the Victorian Novel.* New York: Oxford University Press, 1992.

Seiler, Walter, ed. *Walter Pater, The Critical Heritage.* Boston: Routledge and Kegan Paul, 1980.

Sellars, Jane. "The Art of Anne Brontë." In *The Art of the Brontës,* edited by Christine Alexander and Jane Sellars, 134–52. New York: Cambridge University Press, 1995.

Sheldon, Julie. "'In her own *métier*': The *Quarterly* review of *Jane Eyre*." *Women's History Review* 18.5 (November 2009): 835–47.

———. Introduction to *The Letters of Elizabeth Rigby, Lady Eastlake.* Liverpool, UK: Liverpool University Press, 2009.

Sherman, Claire Richter, with Adele M. Holcomb, eds. *Women as Interpreters of the Visual Arts, 1820–1979.* Westport, CT: Greenwood Press, 1981.

Shuttleworth, Sally. Introduction to *North and South*, by Elizabeth Gaskell, ix–xxxiv.

Siegel, Jonah. *Desire & Excess: The Nineteenth-Century Culture of Art.* Princeton, NJ: Princeton University Press, 2000.

———. "Leonardo, Pater, and the Challenge of Attribution." *Raritan* 21 (2002): 159–87.

Sorkin, Michael. "Smoke and Mirrors." *Architectural Record* 199.9 (September 2011): 80.

Staley, Alan. "The Victorian Royal Academy." In *The Royal Academy Revisited: Victorian Paintings from the Forbes Magazine Collection*, by Christopher Forbes. New York: Forbes, 1975.

Steegman, John. *Victorian Taste: A Study of the Arts and Architecture from 1830 to 1870.* London: Thomas Nelson and Sons, 1970.

Stein, Richard L. "Street Figures: Victorian Urban Iconography." In Christ and Jordan, *Victorian Literature and the Victorian Visual Imagination,* 233–63.

Stewart, Garrett. "Narrative Economies in *The Tenant of Wildfell Hall*." In Nash and Suess, *New Approaches to the Literary Art of Anne Brontë.*

Stoddart, Judith. "Tracking the Sentimental Eye." In *Knowing the Past: Victorian Literature and Culture,* edited by Suzy Anger, 192–211. Ithaca, NY: Cornell University Press, 2001.

Stoneman, Patsy. *Elizabeth Gaskell.* 2nd ed. New York: Manchester University Press, 2006.

Strauss, Neil. "The Expression of Grief and the Power of Art." *New York Times,* September 13, 2001: E5.

Taylor, Brandon. *Art for the Nation: Exhibitions and the London Public 1747–2001.* New Brunswick, NJ: Rutgers University Press, 1999.

Thorp, Nigel, ed. *Whistler on Art: Selected Letters and Writings of James McNeill Whistler.* Washington, DC: Smithsonian Institution Press, 1994.

Treuherz, Julian. *Victorian Painting.* London: Thames and Hudson, 1993.

Uglow, Jenny. *Elizabeth Gaskell: A Habit of Stories.* New York: Farrar, Straus and Giroux, 1993.

Valéry, Paul. "The Problem of Museums." In *Degas, Manet, Morisot.* Vol. 12. Translated by David Paul, 202–7. New York: Pantheon Books, 1960.

Waagen, G. F. *The Manchester Exhibition; What to Observe: A Walk through the Art-Treasures Exhibition under the Guidance of Dr. Waagen, A Companion to the Official Catalogue.* London: John Murray, 1857.

Waterfield, Giles. *Palaces of Art: Art Galleries in Britain 1790–1990.* London: Dulwich Picture Gallery, 1991.

West, Shearer. "Laughter and the Whistler/Ruskin Trial." *Journal of Victorian Culture* 12.1 (2007): 42–63.

Westcott, Andrea. "A Matter of Strong Prejudice: Gilbert Markham's Self Portrait." In Nash and Suess, *New Approaches to the Literary Art of the Brontës*.

Wettlaufer, Alexandra K. *Portraits of the Artist as a Young Woman: Painting and the Novel in France and Britain, 1800–1860.* Columbus: The Ohio State University Press, 2011.

Whistler, James McNeill. "Propositions—No. 2, May 1884: What Constitutes a Finished Picture." In *Whistler on Art,* edited by Nigel Thorp, 78. Glasgow, UK: Centre for Whistler Studies, University of Glasgow, 1884.

———. "Ten O' Clock." In *Whistler on Art,* edited by Nigel Thorp, 79–95. Glasgow, UK: Centre for Whistler Studies, University of Glasgow, 1885.

———. "Whistler vs. Ruskin." In *Whistler on Art,* edited by Nigel Thorp, 56–62. Glasgow, UK: Centre for Whistler Studies, University of Glasgow, 1878.

Wiesenfarth, Joseph. "*Middlemarch:* The Language of Art." *PMLA* 97 (1982): 363–77.

Wilde, Oscar. "The Critic as Artist." *Intentions.* 1890. London: Methuen & Co., 1913. 93–217.

———. "The Grosvenor Gallery 1877." In Ross, *The First Collected Edition of the Works of Oscar Wilde* [*Miscellanies* volume], 5–23.

———. "The Grosvenor Gallery 1879." In Ross, *The First Collected Edition of the Works of Oscar Wilde* [*Miscellanies* volume], 24–29.

———. *The Picture of Dorian Gray.* 1890. In *The Portable Oscar Wilde,* edited by Richard Aldington, 138–91. New York: Viking Press, 1966.

Williams, Carolyn. *Transfigured World: Walter Pater's Aesthetic Historicism.* Ithaca, NY: Cornell University Press, 1989.

Williams, Raymond. *Culture & Society: 1780–1950.* New York: Columbia University Press, 1983.

Wise, Thomas, James, ed. *The Brontës: Their Lives, Friendships, and Correspondence.* 4 vols. Philadelphia: The Porcupine Press, 1980.

Witemeyer, Hugh. *George Eliot and the Visual Arts.* New Haven, CT: Yale University Press, 1979.

Wood, Christopher. *Victorian Painting.* London: Weidenfeld & Nicolson, 1999.

Wornum, Ralph N. *Descriptive and Historical Catalogue of the Pictures in the National Gallery: With Biographical Notices of the Deceased Painters. Foreign Schools.* London: Printed for H. M. Stationery Office, 1870.

Wright, Edgar. Introduction and notes to *Mary Barton*, by Elizabeth Gaskell.

INDEX

❧

"Academy Notes" (Ruskin), 68–69
"The Accumulation and Distribution of
 Art" (Ruskin), 107, 161n2
Acton, Eliza, 38
Adam Bede (Eliot), 124
Adamson, Robert, *56*
aesthetics: Anne Brontë and, 77–92; class
 concerns and, 2–3, 35–40, 43–45,
 47–49, 52, 144; criticism's educative
 function and, 16–17, 94–110; gender
 and, 31–36, 53–54, 88–92, 130–31,
 142; intellectual depth and, 6, 31–33,
 37, 40–41, 45, 50–52, 79–83, 85–86;
 politics' intersections with, 32, 40–41;
 taste and, 7, 34–40, 57, 94–103, 117,
 130–31, 149–55. *See also* art; connois-
 seurship; criticism; Kant, Immanuel
"Aesthetic Value and the Professional-
 ization of Victorian Art Criticism"
 (Prettejohn), 58
affect, 115–16, 127, 130–32, 136–38,
 142–44, 147–48, 150–53, 162n4
Agnes Grey (A. Brontë), 8, 77, 79–81, 89,
 160n4
Albert, Prince (Consort), 26, 28, 104, 154
Alexander, Christine, 78
An Allegory (Botticelli), 75

Altick, Richard, 57–58
Angelico, Giovanni, 24–25
Angerstein, John Julius, 95
Annunciation (Burne-Jones), 146
Architectural History of Berlin (Wolt-
 mann), 129
architecture, 25–30, 34–35, 37, 42–43, 78,
 131–32, 149–55, 158n6
Arnold, Matthew, 19, 68, 128
Arrangement in Grey and Black No. 1
 (Whistler), 136, *137*
Arrangement in Grey and Black No. 2
 (Whistler), 142
art: attribution of, 7–8, 21–22, 54, 59,
 64, 67–69, 89, 106, 108–9, 117, 119,
 124–25, 143–44; catalogues and,
 22–25, 28, 116–25, 135; class's intersec-
 tions with, 2–4, 7, 15–19, 23–25, 130,
 144, 146, 150–54; commercialism and,
 16–18, 28–29, 35–36, 147–48, 153–55;
 connoisseurship and, 6–7, 20–25;
 contemporary scholarship on, 1–2;
 critical styles and, 1–5, 7, 9–10, 70,
 93–110, 143, 150; difficulty of, 126–48;
 education and, 1–2, 6–7, 13, 18–25,
 34–35, 130–31; individualism and, 19,
 127, 131, 138; morality and, 17–20,